THE ITALIAN DRAWINGS AT WINDSOR CASTLE
GENERAL EDITOR: A. F. BLUNT

THE DRAWINGS OF LEONARDO DA VINCI
BY KENNETH CLARK
WITH THE ASSISTANCE OF CARLO PEDRETTI

VOLUME THREE

THREE VOLUMES

VOLUME ONE: DRAWINGS 12275–12727
TEXT

VOLUME TWO: DRAWINGS 12275–12727
ILLUSTRATIONS

VOLUME THREE: DRAWINGS 19000–19152
(ANATOMICAL MANUSCRIPTS A, B, C)
TEXT AND ILLUSTRATIONS

THE DRAWINGS OF
LEONARDO DA VINCI

IN THE COLLECTION OF
HER MAJESTY THE QUEEN

AT WINDSOR CASTLE

BY KENNETH CLARK

SECOND EDITION
REVISED WITH THE ASSISTANCE OF
CARLO PEDRETTI

VOLUME THREE

PHAIDON

PHAIDON PUBLISHERS INC · NEW YORK
DISTRIBUTORS IN THE UNITED STATES: FREDERICK A. PRAEGER INC
111 FOURTH AVENUE · NEW YORK · N.Y. 10003
LIBRARY OF CONGRESS CATALOG CARD NUMBER: 68-27415

The drawings are reproduced by gracious permission
of Her Majesty The Queen

SBN for this volume: 7148 1361 3

MADE IN GREAT BRITAIN
TEXT PRINTED BY R. & R. CLARK LTD · EDINBURGH
PLATES PRINTED BY COTSWOLD COLLOTYPE CO. LTD · WOTTON-UNDER-EDGE · GLOS.

CONTENTS

NOTE

In the preceding edition of the present catalogue the section of the Anatomical MSS. was part of the volume of text, and only a selection of anatomical drawings was included in the volume of plates.

The anatomical section is now given a separate volume, not only because the entries have been considerably expanded, but above all because all the drawings are now reproduced.

This section has been treated in the same way as that of the drawings catalogued in Volume I, with the few changes to the system as required by the fact that these drawings were originally pages of note-books. These changes are explained in the notes which precede each group of sheets (MSS. A, B, and C).

In the notes to the individual entries it is often shown that one folio was originally 'joined' to another. This represents a new approach to the study of the anatomical drawings of Leonardo. It is here employed almost exclusively for its bearing on questions of chronology and style, but it will certainly turn out to be of assistance to the interpreters of Leonardo's scientific thought. Useful as it may appear as a tool, it must however be used with great caution. The physical correlation of one fragment to another, or to a larger sheet, is easy to prove, but the proposed correlation of two sheets of identical format is open to the objection that it may represent the case of two consecutive pages of what was originally a note-book. It has been ascertained that Leonardo adopted, especially in the late period of his activity, the system of compiling his MSS. by taking one sheet at a time, folding it in half, and filling its four sides with notes and drawings. There is even evidence of his having adopted what we may call a 'printer's system', which consists of taking a large sheet, folding it twice, and writing on each of its four parts at open sheet, in such a way that one set of notes is placed upside down, i.e. the other way of paper. This is the case with the last drawing of the collection, 19149–19152. And yet it is impossible to say whether Leonardo had come to prefer any such system to that of note-books the pages of which had already been bound in signatures. Thus any proposed reassembly of anatomical sheets must remain a theory, even when it is based on a number of factors that seem to make it indisputable. The final proof could be reached only by having the originals detached from their mounts (an operation which is obviously out of question), and carefully examined in a laboratory, so as to follow Pompeo Leoni's process of 'restoration' in reverse. This cannot be done with photographs, not even with the best photographs ever made—those which have been made available for the present new edition of the catalogue. The anatomical drawings are therefore reproduced in the sequence they have in the collection, with the exception of a sheet of geometrical studies (19145) which is reproduced in Volume II together with 12658.

The anatomical index is the work of Mrs. Doreen Blake and Professor Ruth E. M. Bowden, who has also revised the descriptions of the anatomical drawings.

<div align="right">C. P.</div>

BIBLIOGRAPHY

This list of publications only includes the items that are given in abbreviated form in the bibliographies to the individual sheets. Other publications are quoted in full in the commentaries. The literature on Leonardo's anatomical studies, which has grown considerably in the last fifty years, is listed and fully discussed by Dr Sigrid Braunfels-Esche in her book quoted below (second edition, 1961) and in her article in *Raccolta Vinciana*, xviii, 1960, pp. 222–37. (For publications dating before 1930 see E. Verga, *Bibliografia Vinciana*, Bologna, 1931, 2 vols.) In the comments to the drawings the emphasis is on problems of chronology and style since the scientific aspect of Leonardo's anatomical studies has been admirably treated in the publications by Professors Favaro, McMurrich, Esche, Keele, O'Malley, Saunders and Belt. The book *Léonard de Vinci, Dessins anatomiques*, ed. by Pierre Huard, Paris, 1961, gives a selection of the Windsor drawings in a convenient form, with adequate comments and good reproductions. A three-volume edition of Leonardo's *Il Trattato della Anatomia* issued by the Istituto di Storia della Medicina dell'Università di Roma, 1962, is a valuable compilation and includes material from MSS. other than those at Windsor.

BELTRAMI. *Documenti. Documenti e memorie riguardanti la vita e le opere di Leonardo da Vinci in ordine cronologico a cura di* Luca Beltrami. Milan, 1919. (Most useful in spite of several inaccuracies and a few omissions.)

BERENSON. Bernhard Berenson, *The Drawings of the Florentine Painters, classified, criticised and studied as documents in the history and appreciation of Tuscan art.* With a copious *catalogue raisonné*. 2 vols. London, 1903. Second edition, Chicago, 1938. (The author's aim is implied in the title.)

BODMER. *Leonardo: des Meisters Gemälde und Zeichnungen*, herausgegeben und eingeleitet von Heinrich Bodmer. Klassiker der Kunst series. Stuttgart, 1931. (A convenient collection of reproductions with notes containing accurate information.)

BRIQUET. C. M. Briquet, *Les Filigranes, Dictionnaire historique des marques du papier dès leur apparition vers 1282 jusq'en 1600.* Geneva, 1907.

CALVI. *Manoscritti.* Gerolamo Calvi, *I Manoscritti di Leonardo da Vinci dal punto di vista cronologico, storico e biografico.* Bologna, 1925. (A masterpiece of scholarship, fundamental for the chronology of the manuscripts.)

CHAMBERLAINE. *Original Designs of the Most Celebrated Masters in . . . His Majesty's Collection, engraved by Bartolozzi etc. . . . ,* with biographical and historical sketches of L. da Vinci . . . by J. Chamberlaine.

London, 1812. (Chamberlaine made a curious selection, including drawings not by Leonardo, and one (plate xiv) which is no longer in the series of drawings attributed to him.

CHASTEL. *The Genius of Leonardo da Vinci. Leonardo da Vinci on Art and the Artist. The material assembled, edited and introduced by* André Chastel. New York, 1961. (Subject matter arrangement of a selection of Leonardo's notes, with fine reproductions of paintings and drawings. First published in French in 1960.)

CLARK. Kenneth Clark, *Leonardo da Vinci. An Account of his development as an artist.* Cambridge, 1952 (first edition, 1939).

Codex Huygens. See Panofsky.

Commissione Vinciana. I Manoscritti e i Disegni di Leonardo da Vinci pubblicati dalla Reale Commissione Vinciana. Disegni. Introductions to each portfolio and catalogue by Adolfo Venturi. Rome, fasc. i, 1928; fasc. ii, 1930; fasc. iii, 1934; fasc. iv, 1936; fasc. v, 1939; fasc. vi, 1948; fasc. vii, 1952; fascicolo unico (*I Disegni Geografici conservati nel Castello di Windsor*, ed. by Mario Baratta), 1941. (Sumptuous facsimiles with text by Venturi, but with many inaccuracies in the catalogue and in the reproductions, especially in the later portfolios.)

EISSLER. K. R. Eissler, *Leonardo da Vinci: Psychoanalytic Notes on The Enigma.* New York, 1961.

ESCHE. Sigrid Esche, *Leonardo da Vinci. Das anatomische Werk*. Basel, 1954. (The best study of the Anatomical MSS., based on chronology and style, with an accurate *catalogue raisonné*.)

FIRPO. Luigi Firpo, *Leonardo architetto e urbanista*.Turin, 1963.

GANTNER. Joseph Gantner, *Leonardos Visionen von der Sintflut und vom Untergang der Welt*. Bern, 1958.

GIACOMELLI. Raffaele Giacomelli, *Gli Scritti di Leonardo da Vinci sul Volo*. Rome, 1936.

GOLDSCHEIDER. Ludwig Goldscheider, *Leonardo da Vinci. Life and Work. Paintings and Drawings. With the Leonardo biography by Vasari, 1568, newly annotated*, London, 1959. (First edition, 1943.)

GOMBRICH. Ernst H. Gombrich, 'Leonardo's Grotesque Heads. Prolegomena to Their Study', in *Leonardo Saggi e Ricerche*, Rome, 1954, pp. 199–219.

HEYDENREICH. Ludwig H. Heydenreich, *Leonardo da Vinci*. London and Basel, 1954. (First produced in German in 1943, with excellent reproductions of the drawings.)

MACCURDY, *Mind*. Edward MacCurdy, *The Mind of Leonardo*. London, 1928. (Latest edition, 1952.)

MACCURDY, *Notebooks. The Notebooks of Leonardo da Vinci, Arranged, Rendered into English and Introduced by* Edward MacCurdy. 2 vols. London, 1939. (Latest edition, 1956. The most extensive selection from the note-books with the notes arranged within broad classifications in the sequence of the folios of the manuscripts.)

MALAGUZZI VALERI, *Corte*. Francesco Malaguzzi Valeri, *La corte di Lodovico il Moro*. Vol. II, *Bramante e Leonardo*. Milan, 1915.

MÖLLER, *Salai*. Emil Möller, 'Salai und Leonardo da Vinci', *Jahrbuch der Kunsthistorischen Sammlungen in Wien*, N.F. II, 1928, pp. 139–61.

MÜLLER-WALDE, *Jahrbuch*. Paul Müller-Walde, 'Beiträge zur Kenntnis des Leonardo da Vinci', *Jahrbuch der Königlichen Preussischen Kunstsammlungen*, XVIII–XX, 1897–9. (Seven articles of great value, especially with reference to the Equestrian Monuments and the Leda. For patience, observation and a scholarly sense of method they greatly surpassed all previous writing on Leonardo.)

MÜNTZ. Eugène Müntz, *Léonard de Vinci. L'Artiste, le Penseur, le Savant*. Paris, 1899. (Out of date from the point of view of connoisseurship, but useful for reproductions, and for social conditions in Milan, etc.)

O'MALLEY–SAUNDERS. *Leonardo da Vinci on the Human Body. The Anatomical, Physiological, and Embryological Drawings edited by* C. D. O'Malley *and* J. B. de C. M. Saunders. New York, 1952. (A convenient subject matter rearrangement of the Anatomical MSS., invaluable for historical and scientific commentary, but without indexes, concordances, etc.)

PANOFSKY, *Codex Huygens*. Erwin Panofsky, *The Codex Huygens and Leonardo da Vinci's Art Theory. The Pierpont Morgan Library Codex M. A. 1139*. London, 1940.

PEDRETTI, *Architectural Studies*. Carlo Pedretti, *A Chronology of Leonardo da Vinci's Architectural Studies after 1500*. Geneva, 1962.

PEDRETTI, *Gioconda*. Carlo Pedretti, 'Uno «studio» per la Gioconda', *L'Arte*, LVIII, 1959, pp. 155–97.

PEDRETTI, *Libro A. Leonardo da Vinci on Painting. A Lost Book (Libro A) reassembled from the Codex Vaticanus Urbinas 1270 and from the Codex Leicester by* Carlo Pedretti. Berkeley and Los Angeles, 1964.

PEDRETTI, *Studi Vinciani*. Carlo Pedretti, *Studi Vinciani. Documenti, Analisi e Inediti Leonardeschi*. Geneva, 1957. (A number of unpublished drawings and, in Appendix, *A Chronology of the folios of the Codex Atlanticus*).

PEDRETTI, *Villa Melzi*. Carlo Pedretti, 'Leonardo da Vinci e la Villa Melzi a Vaprio', *L'Arte*, LXII, 1963, pp. 229–39.

PEDRETTI, *Weimar*. Carlo Pedretti, 'The Windsor-Weimar Puzzle', *Raccolta Vinciana*, XX, 1964, pp. 350–357.

PEDRETTI, *Windsor Fragments. Leonardo da Vinci. Fragments at Windsor Castle from the Codex Atlanticus edited by* Carlo Pedretti. London, 1957. (Identification of fifty-five drawings extracted from sheets of the Codex Atlanticus; supplemented in *Raccolta Vinciana*, XIX, 1962, pp. 278–82.)

POGGI. *Leonardo da Vinci. La 'Vita' di Giorgio Vasari, nuovamente commentata e illustrata con 200 tavole, a cura di* Giovanni Poggi. Florence, 1919. (A thorough piece of scholarship, giving the chief documents in a convenient form.)

POPHAM. *The Drawings of Leonardo da Vinci. Compiled, introduced and annotated by* A. E. Popham. London, 1946; latest edition, 1949. (The most convenient source of reproductions, with short, sensible introduction.)

POPP. *Leonardo da Vinci. Zeichnungen, herausgegeben von* Anny E. Popp. Munich, 1928. (The best short study of the drawings, and the first to emphasise the importance of chronology.)

RICHTER. Jean Paul Richter, *The Literary Works of Leonardo da Vinci, compiled and edited from the original maunscripts*. 2 vols. London, 1883. Second edition, Oxford, 1939.

ROUVEYRE. *Léonard de Vinci. Feuillets inédits, reproduit d'après les originaux conservés à la Bibliothèque du Château de Windsor*. 23 vols. Paris, Édouard Rouveyre, 1901. (There is no text at all, not even a reference number. The reproductions are poor but

served as material for many writers on the Windsor drawings and were used to make other, even poorer, reproductions.

ROYAL ACADEMY. *Royal Academy. Diploma Gallery. Leonardo da Vinci. Quincentenary Exhibition*, 1952. (Catalogue compiled by K. R. Gilbert, C. Gould and Dr K. D. Keele.)

SEIDLITZ, *l'Arte*. Waldemar von Seidlitz, 'I disegni di Leonardo da Vinci a Windsor', *L'Arte*, XIV, 1911, pp. 269–89. (A list of the drawings at Windsor, giving summary titles, Leoni's numbers, sizes and a few references. Without inventory numbers it is of little practical use.)

UZIELLI, *Ricerche*. Gustavo Uzielli, *Ricerche intorno a Leonardo da Vinci*. Serie I, Florence, 1872; second edition, Rome, 1896; Serie II, Rome, 1884. (The first scientific study of Leonardo, still valuable for documents, biography and historical background, and for inventories of the Leonardo MSS. and drawings in European collections.)

Windsor Fragments. See Pedretti.

WINDSOR, *Selected Drawings. Selected Drawings from Windsor Castle. Leonardo da Vinci by* Kenneth Clark, London, 1954. (Reproductions of fifty-seven out of the 600 Leonardos of the Collection.)

EDITIONS OF LEONARDO'S ANATOMICAL MSS.

Anatomical MS. A. I manoscritti di Leonardo da Vinci della Reale Biblioteca di Windsor. Dell'Anatomia, Fogli A, pubblicati da Teodoro Sabachnikoff, trascritti e annotati da Giovanni Piumati. Paris, 1898. (This volume comprises Nos. 19000 to 19017 of this catalogue.)

Anatomical MS. B. I manoscritti di Leonardo da Vinci della Reale Biblioteca di Windsor. Dell'Anatomia, Fogli B, pubblicati da Teodoro Sabachnikoff, trascritti e annotati da Giovanni Piumati. Turin, 1901. (This volume comprises Nos. 19018 to 19059 of this catalogue.)

Quaderni d'Anatomia. Leonardo da Vinci, Quaderni d'Anatomia (I to VI), pubblicati da Ove C. L. Vangensten, A. Fonahn, H. Hopstock. 6 vols. Christiania, 1911 to 1916. (These volumes comprise the drawings numbered 19060 to 19152, which are bound together in a volume known as Anatomical MS. C; and several other anatomical drawings in the Collection.)

CATALOGUE OF THE DRAWINGS

ANATOMICAL MANUSCRIPT A

Numbering

This manuscript includes the drawings published under the title *I manoscritti di Leonardo da Vinci della Reale Biblioteca di Windsor. Dell'Anatomia, Fogli A, pubblicati da Teodoro Sabachnikoff, trascritti e annotati da Giovanni Piumati, Paris, 1898.* They have been bound as arranged by Sabachnikoff, and numbered from 19000 to 19017. In the following entries I give both these inventory numbers and the numbers in Sabachnikoff's publication, thus 19000 (A. 1), 19001 (A. 2), and so forth. Some of the folios have sixteenth-century marks or numbers, including the word *Leoni*, which may be the signature of Pompeo Leoni. These are given in the description of the drawings. Many of the sheets also bear a small number written on by Richter when he was compiling his anthology. Richter's system of numbering is confusing and sometimes inconsistent, but I give it in the description of those drawings on which it is visible, since it might be useful in identifying references.

Reassembling

The sheets in this series were probably compiled in pairs as were the ones in the Anatomical MS. B. There is consistency of paper, writing and style throughout folios 1–14, as well as in the double sheets 17 and 18. Folios 15–16 are of a slightly different paper, and yet they appear to belong to the same series. The possibility that one folio may have been joined to another is often suggested only by similarity of contents, the exterior evidence being negligible. My suggested reassembling is as follows: 1–12, 2–14, 3–4, 5–8, 6–9, 7–11, 10–13, 15–16.

Date

On 19016 (A. 17) is the note 'In the winter of this year, 1510, I expect to complete all this anatomy'. This sheet bears a large study of the muscles and tendons of a leg, and since most of the drawings in the book are in a similar style we may assume that they are of about the same date. Perhaps some of the studies which include the head and shoulders, 19001 (A. 2) and 19003 (A. 4), may be a little later; and those which recall the drawings for the Battle of Anghiari, such as 19014 (A. 15) *recto* and *verso* may be slightly earlier, *c.* 1509.

Size

Varies between 28·5 × 19·5 and 29 × 30.

Medium

Pen and ink, sometimes with a wash, over faint, often invisible, black chalk; on white paper. Throughout Leonardo has used two inks, a cool dark brown (bistre?) and a warm pale brown (sepia). By combining these inks in the drawings he has gained richness of modelling.

An insoluble problem is presented by the notes written in a pale sepia-coloured ink with a thick pen. Nearly all of them seem to have been added later than the drawings and the notes written with a fine pen in dark brown ink, e.g. the notes in the right margin of 19003 (A. 4) *verso* or top right of 19007 (A. 8) *verso*. The physical appearance of the notes suggests that Leonardo went over the manuscript, adding further observations at a later date. Their contents neither support nor refute this theory and of course Leonardo often uses a blunt pen on the same page as a fine one. But I am inclined to think that they represent a later revision.

19000 (A. 1)

RECTO

TO THE RIGHT

The trunk of a man, in profile to right, with the right arm extended, indicating surface muscles.

TO THE LEFT

The skeleton of a left foot, seen from above.

IN THE CENTRE

The same, seen from below obliquely.

BELOW

Six diagrammatic drawings of the skeleton of the big toe.

The bones of a left foot, in profile to left, and the corresponding leg bones, drawn upside down.

With notes on the drawings; top left in sepia, middle block in grey bistre, lower block in sepia.

VERSO

Five studies of skeleton of right upper limb, showing pronation and supination with relevant muscles.

RIGHT MARGIN

Diagram demonstrating pronation.

With notes on the drawings in sepia and bistre.

Richter's No. 222.

THE *recto* of this sheet may be placed beside the *verso* of f. 12 (19011). In this way one can follow the movements of Leonardo's mind in representing the building up of a member from bone to flesh. Bones are represented in 'exploded view' and muscles as 'wire diagrams' or as hanging flesh. The general effect is one of a lifeless style which approaches the type of illustration in Vesalius's *Fabrica*. Leonardo's intention was undoubtedly to have these drawings reproduced in plates. See note to f. 8 (19007). Drawing in two inks.

Berenson, 1209 (19000–19059). Esche, p. 102, figs. 90 (*verso*), 100 (detail of *recto*). O'Malley-Saunders, 8 (*verso*), 13. Royal Academy, 269 (*verso*).

19001 (A. 2)

RECTO

TOP RIGHT-HAND CORNER

Three small studies of the left ankle and foot, one of bones, showing movements of ankle.

IN THE CENTRE

A dissection and schematic drawing of shoulder seen from behind, and two dissections from above. All show attachment of muscles. With notes on the drawings, and other subjects.

The note on the wickedness of destroying life is given in Richter, §1140; that on the preservation of health in Richter, §856.

VERSO

ABOVE

Two studies of the head, neck and thorax of a man, facing to the right, right arm outstretched, showing superficial muscles.

IN THE CENTRE, TO THE RIGHT

Neck and thorax and right arm of a man, facing right, showing neck, chest and shoulder muscles.

IN THE CENTRE

Three-quarters front view of head, neck, thorax and arm of a man looking down, showing chest and neck muscles. Left and right, studies of shoulder.

AT THE BOTTOM

Two studies of a right shoulder, from the front.

The word *Dic* (or *Dig*) in sixteenth-century writing.

THIS is dated 1510–13 by O'Malley-Saunders, *loc. cit.*, on the assumption that the note on the wickedness of destroying life might have been written in Rome. It is not unlikely that this note was added later, but the drawings are in the same style as the others in the series. The note on the preservation of health may also be later, and is related with the sonnet of precepts of hygiene in Codex Atlanticus 78 *verso-b*, *c.* 1514, a folio which contains a small drawing of the villa of Innocent VIII in the Vatican.

This was probably joined to f. 14 (19013). Both folios deal with the muscles of the shoulder and their action. In fact O'Malley-Saunders, *loc. cit.*, consider the notes on this subject on the *recto* the continuation of those on f. 14 *verso*.

Bodmer, p. 341 (*verso*). Chastel, p. 124. Esche, pp. 102–103, figs. 86 (detail of *verso*), 89. MacCurdy, *Notebooks*, I, pl. 2 (*verso*). O'Malley-Saunders, 44 (*verso*), 50. Poggi, pl. CLXIII (*verso*). Popham, pl. 243 (*verso*). Richter, §§856, 1140 (notes on *recto*), pl. CVII (*verso*).

19002 (A. 3)

RECTO

TO THE RIGHT

A study of the left lower limb of a man, seen from the front, the muscles of thigh and calf being emphasised.

RIGHT MARGIN

Seven studies of the palate, tongue and larynx, and hyoid bone.

TOP LEFT

Studies of the tongue, mouth, larynx, trachea and pharynx.

2

BELOW

Studies of tongue, throat, larynx, trachea, main bronchi and oesophagus in profile to left. Also seven details of the larynx on a smaller scale.

Notes on the drawings. That on respiration is given in Richter, §833, and the general precept for anatomical study in Richter, §800.

The letter Δ.

VERSO

ABOVE TO RIGHT

Head and shoulders of a man, three-quarters back view, indicating the superficial muscles of the right upper arm and shoulder, head lightly indicated; and, on a smaller scale, a diagram of a skeleton seen full face, with second skull above.

IN THE MIDDLE AND TO LEFT

Two studies of the bones of the foot, shown in a left foot seen from underneath and from above (cf. 19000 *recto* and 19011 *recto*); also a small diagram demonstrating the lateral movement of the big toe.

BELOW

Three studies of the left side of a man, the left-hand study showing the superficial muscles of the neck, the right-hand study the deeper muscles; all three showing the muscles of the chest and left shoulder. A small study of muscles under the lower jaw and notes on the drawings.

The letter Δ.

Folios 3 and 4 were probably joined together. An ink spot on the *recto* of f. 4 has left a mark on the *verso* of f. 3. Both sheets have the letter Δ by a sixteenth-century hand. Such a letter was used by the compiler of the Codex Urbinas to countersign one of Leonardo's *librettini* used in his compilation. This mark also appears on f. 103 of his compilation, that is at the beginning of Part III which is devoted to the human figure. It is possible that notes on painting were on such folios of anatomy which have not come down to us. One of the notes on muscles on f. 15 *recto* (19014) is countersigned with the crossed out circle (ø) of the compiler of the Codex Urbinas, but that note is not found in the Codex Urbinas.

The study of a man's head and shoulders, L.L., on the *verso*, engraved by Hollar as 'ex Collectione Arundelianae' in 1651, Parthey 1771. This and two of the three studies of a man facing left, on the *verso*, are reproduced in a sixteenth-century copy in the Venice Academy (Esche, fig. 109).

Bodmer, p. 343 (*verso*). Esche, p. 103, figs. 8 (detail of *verso*), 110. O'Malley-Saunders, 36 (*verso*), 169. Poggi, pl. CLCVI (*verso*). Richter, §§800, 833 (notes on *recto*). Royal Academy, 305. Seidlitz, pl. LIX.

19003 (A. 4)

RECTO

ABOVE

In the centre, a careful drawing of the head and thorax of a man, front view, looking down to his right, with right arm raised horizontally. To the left a left shoulder of a man in profile to left; to the right a slight study of a man's head and shoulder region, seen full face.

CENTRE

Two studies of shoulder muscles, seen from above, the head cut off at the neck.

BELOW

Three studies of the neck and right shoulder, showing the muscles; also two smaller studies showing veins, and one of clavicle.

With notes on the drawings.

VERSO

ABOVE

In the centre, head and shoulders of a man in profile to right, showing the muscles of the neck, chest and shoulder. To left, the muscles of shoulder and neck seen from behind. To right, a wire model of shoulder muscles showing direction of fasciculi.

BELOW

To the right, a study of a man's head, chest, and raised right arm; another similar study without head, and with arm extended horizontally; both these show the muscles of the chest.

L.M.

Study of the deeper muscles of the left shoulder, seen from the back.

With notes on the drawings.

The letter Δ.

See note to preceding drawing. The head of the man at the top of the *recto* engraved by Hollar, Parthey 1578.

Chamberlaine, Supplementary plates Nos. 2, 4. Esche, pp. 103–104, fig. 87 (*verso*). Gantner, pp. 58, 156. Heydenreich, pls. 195 (detail of *recto*), 196 (*verso*). Müller-Walde, *Jahrbuch*, 1897, p. 139 (R.L. of *verso*). O'Malley-Saunders, 43, 48. Poggi, pl. CLXIV (*verso*). Popham, pls. 244, 245. Richter, §8 (note on *verso*), pl. IB (detail of *recto*), §803. Windsor, *Selected Drawings*, pl. 47.

19004 (A. 5)

RECTO

Eight drawings of the skeleton of the arm, shown in various states of flexion, and supine and prone positions of the hand.

Also two small studies, one in black chalk, of the muscles of a right shoulder, seen from above, the one below gone over with pen and ink.

IN THE CENTRE

Study of the skeleton of the pelvis and legs, seen from behind.
With notes on the drawings.

VERSO

Two studies of an old man in profile, confronted. Both show the surface muscles of the neck and upper arm.
Two studies of the right shoulder and arm, one rather slight.
The word *Leoni*.

Bᴏᴛʜ this and f. 8 (19007) have the word *Leoni*, perhaps a signature of Pompeo Leoni. On the *recto* of f. 8 are similar studies of an old man in profile. The *recto* of f. 5 and the *verso* of f. 8 contain studies of osteology. All this suggests that the two folios were originally joined together.
The drawings of the bone structure of the arm on the *recto* are related with *Libro A 108*.
The drawings of an old man in profile are in a summary style which recalls some of the caricatures, but is certainly later than the majority of them. Compare 12475A.

Bodmer, p. 342 (*verso*). Esche, p. 104, fig. 94. Heydenreich, pl. 184. Müntz, p. 348 (*verso*). O'Malley-Saunders, 9, 40. Popham, pl. 251 (*verso*).

19005 (A. 6)

RECTO

TOP LEFT

A study of muscles of a right arm seen from the front; the forearm is pronated.

BELOW IT

Two studies of a right arm in different positions, showing muscles.

TOP CENTRE

Head of an old man, almost in profile to right, with closed eyes, wearing a head-dress, and resembling a recumbent effigy, probably the subject of the dissection. To the right, a diagrammatic drawing of the region of the jaw.

BELOW THIS

Study of a left arm, showing superficial veins.

RIGHT

Study of the superficial veins of the body and right

arm, seen from the front. With two diagrammatic sketches of blood flowing out of cut veins.

BELOW THIS

Detailed diagram of the basilic vein, and tributaries. With notes on the drawings.
The letters .Ma., and the No. 3, both written by a sixteenth-century hand.

VERSO

Four studies of the muscles of the right shoulder and arm, from three-quarter and full back view. Also a slight study of an elbow, and (top right) a front view of an open mouth, showing the molar teeth, palate, uvula and throat.
With notes on the drawings.
Richter's No. 90.

Tʜɪs must be considered together with f. 9 (19008), to which it was probably joined: the *verso* of f. 9 facing the *recto* of f. 6. There are in fact diagonal lines in the texture of the paper which run through. Moreover, both folios have the sixteenth-century No. 3. See also note to 19008 (A. 9).

Esche, pp. 104–5, figs. 105 (*verso*), 159 (detail of *recto*). Heydenreich, pl. 194 (detail of *recto*). Müntz, p. 309. O'Malley-Saunders, 45, 47. Poggi, pl. ᴄʟxv.

19006 (A. 7)

RECTO

CENTRE

Right leg from thigh to toes, seen from the inner side and front.

RIGHT

Study of arrangement of fibres of intercostal muscles.

BELOW

Skeleton of the toes and metatarsals of a right foot. With notes on the intercostal nerves.
The word *Leoni*.

VERSO

Eight studies of a left foot, showing details of the muscles that control the toes; and a sketch of the of a kneeling figure, seen from behind.
With notes on the drawings.
Richter's No. 180.

Tʜɪs was probably joined to f. 11 (19010): the *recto* of f. 7 facing the *verso* of f. 11. They are related in content and style, and both have Leoni's signature. The drawing of leg resembles in style and technique

the sketch in Codex Atlanticus 289 *verso*-a, a sheet of the '1508–9 type' of geometrical studies, which contains a note on painting, crossed through, and which has on the *recto* a black chalk outline of mountain chains (see note to 12409). This strengthens the impression that the Anatomical MS. A was begun earlier than 1510. Compare the slightly earlier drawing of legs in 19035 *verso* (B. 18).

Esche, p. 105, fig. 124 (detail of *recto*). O'Malley-Saunders, 63, 80.

19007 (A. 8)

RECTO

Two studies of an old man, profile to right, one with his right arm raised before him, the other with it limp, showing the muscles of the thorax and arm.
The word *Leoni*.

BELOW

A faint black chalk drawing of the bones and muscles of a right upper limb seen from above.

VERSO

ABOVE

Two studies of the spine, one right profile, the other front view. Only half of the tenth vertebra in the profile view is indicated.

BELOW

Horizontally placed study of the spine, back view; and two detailed studies of vertebrae on a larger scale.
With numerous notes on the drawings.
Richter's No. 80.

SEE note to f. 5 (19004). In the note at the bottom of the *verso* Leonardo expresses the intention to publish these anatomical studies, and refers the reader to his instructions to do so: 'And as regards this benefit which I give to posterity I teach the method of printing it in order, and I beseech you who come after me, not to let avarice constrain you to make the prints in . . .'. The last word is missing with a small piece of the margin, but enough is left to suggest the word *legno*, i.e. wood-cut. That Leonardo had in mind the more expensive and accurate process of copper engraving reproductions is confirmed by Giovio. Cf. Pedretti, *Libro A*, p. 140.
The *verso* provides an instance of the difficulty of dating Leonardo's drawings by his writing. The sentence written under the horizontal study of the spine looks in an earlier style than e.g. the note R.U.; yet both must be of the same date, and the difference must be due to the different state of Leonardo's pen. The *recto* was clearly done at the same time as 19004, to which see note.

Esche, p. 105, fig. 96 (*verso*). Heydenreich, pl. 188 (*verso*). O'Malley-Saunders, 2 (*verso*), 41. Royal Academy, 306 (*verso*).

19008 (A. 9)

RECTO

ABOVE

Five studies of the bones of the leg and foot; left and right legs seen from front and lateral views, and right from behind; also a small drawing of the knee joint, and (?) patella.

BELOW

Two studies of bones of a right leg with the knee flexed; and the superficial muscles of right buttock, thigh and calf.
Richter's No. 69.

VERSO

ABOVE

Three studies of neck muscles, seen from the back.

BELOW

Four studies of the neck, chest and right arm in profile to right and turning to front, showing superficial muscles.

R.L.

A slight geometrical diagram demonstrating rotation of the arm.
The No. 3, in sixteenth-century writing.

THE geometrical diagram on the *verso* resembling a star represents the eight points of view from which Leonardo intended to illustrate the anatomy of the arm. Three aspects are represented in this sheet, four other aspects are shown on f. 6 *verso*, to which see note. This stelliform diagram appears in Peckham's *Perspectiva communis*, and in Leonardo's early Ashburnham MS. I, f. 6 *verso* (Richter, §63). Two of the drawings of the right arm are reproduced in a sixteenth-century copy in the Venice Academy (Esche, fig. 108).

Esche, pp. 105–106, figs. 95, 106. O'Malley-Saunders, 11, 46. Royal Academy, 265 (*verso*).

19009 (A. 10)

RECTO

Five studies of right hands, showing bones and muscles; and six smaller drawings of digits.
With notes on the drawings.

VERSO

Two studies of the skeleton of a right hand, one seen from the back, the other from the palm.

BELOW

Two studies of the skeleton of a right hand shown in profile from inner and outer sides.

ABOVE, to right

Two anatomical studies of fingers.

BELOW

A clenched fist.

With notes on the drawings.

The letter (?)P, in sixteenth-century writing.

Richter's No. 130.

THE study of the anatomy and function of muscles and tendons of the hand must have been one of Leonardo's deepest concerns from after 1508. In MS. F, f. 95 verso, is a reminder to write a section on this subject. Compare also 19061 (C. I. 2) recto: *della mano di dentro . . . e cosi nel capitolo de la mano si farà quaranta dimostrationj*. Reflexions of such programme are in Codex Atlanticus 99 verso-a, c. 1510 (*del moto delle djta delle manj*) and 208 recto-b, c. 1510–13 (list of the *26 muscolj* of the hand sorted according to their functions). See also a note not by Leonardo, but crossed out by him, in Codex Atlanticus 260 recto-a, c. 1509: *segna tuti i muscholi che moueno le dita in che parte naseno nele brace*.
This folio was probably joined to f. 13 (19012): the *recto* of f. 10 facing the *verso* of f. 13. O'Malley-Saunders, *loc. cit.*, point out that only four of the ten demonstrations mentioned in Leonardo's note ('These 10 demonstrations of the hand would be better turned upwards etc.') are found in this folio, and that the fifth and sixth are found on the *verso* of f. 13. Three demonstrations are missing. On the *verso* of this folio Leonardo explains his intended method of presenting the anatomy and motion of the hand. The 'cinematographic' theory of body motion he is referring to is the subject of a passage of the *Trattato della Pittura* from the lost *Libro A*, carta 40, which is illustrated with two diagrams similar to that on 19013 *recto* (A. 14), but with the figure of a hand in their centres. A reflexion of Leonardo's theory of *moto actionale* is in MS. E, f. 17 *recto*, and in the Codex Huygens.
Professor Winternitz, *loc. cit.*, suggests a relationship between the physiology of the human hand as treated in this sheet and Leonardo's invention of the key system of a trumpet in the Arundel MS., f. 175 *recto*.

Esche, p. 106, figs. 101 (*verso*), 102. O'Malley-Saunders, 10 (*verso*), 57. Royal Academy, 266. Winternitz, *Raccolta Vinciana*, xx, 1964, pp. 69–80, figs. 6, 7, and 8 (detail of *verso*).

19010 (A. 11)

RECTO

Four drawings, two on a large scale, of the sole of the left foot, showing muscles and tendons.

With notes on the drawings.

VERSO

A large drawing of the left leg and plantigrade foot, seen from just above the knee, showing superficial muscles.

R.U.

A smaller drawing of the left leg and foot, raised on the toes, drawn to show the action of the calf muscle.

Two small diagrams.

With notes on the drawings.

The word *Leoni*.

Richter's No. 221.

SEE note to f. 7 (19006). Compare 19094 (C. II. 24), to which see note.

Esche, p. 106, O'Malley-Saunders, 76 (*verso*), 79.

19011 (A. 12)

RECTO

Six studies of the left foot and ankle, showing the articulation of the bones; two drawings of the leg and foot, on a smaller scale, and, in the centre, a deep dissection of the right shoulder joint.

With notes on the drawings.

The letter Ō, in sixteenth-century writing.

Richter's No. 145.

VERSO

ABOVE

Two studies of right arm stretched out to the side, seen from the front, showing the superficial muscles.

BELOW

Two torsos of a man in profile to right, showing the superficial muscles of neck and right arm.

With notes on the drawings.

SEE note to f. 1 (19000).

Esche, pp. 106–107, fig. 99 (detail of *recto*). O'Malley-Saunders, 12, 53. Royal Academy, 270.

19012 (A. 13)

RECTO

ABOVE

Two studies of the bony structure of the thorax, showing spinal column and upper arm, the one to

the right almost in profile to right, the one to the left seen from behind.

BELOW, to left

The bones of a figure from the neck to the pelvis, front view, but left side not shown.

IN THE CENTRE, and to the right

Skeleton of pelvis and legs seen from in front and from the left. Between them bones of right leg, seen from the left.

With notes on the drawings.

The letter P, in sixteenth-century writing.

Richter's No. 146.

VERSO

CENTRE

Two studies of a head in profile to right, showing facial muscles.

TO THE LEFT

Study of a right arm and shoulder in profile to right, showing superficial muscles.

TO THE RIGHT

Study of a right arm and hand seen from in front, showing superficial muscles.

BELOW

Two studies of a right hand, palm towards the spectator, showing arteries and nerves.

In the bottom right-hand corner, the head of a man with curly hair in profile to right.

With notes on the drawings.

THIS was probably joined to f. 10 (19009), to which see note.

The two anatomical heads were engraved by Hollar in 1660, Parthey 1769, 1770. The head in the bottom corner was engraved by Hollar in 1645 as frontispiece of his volume (Parthey 1558). This head resembles the red chalk head of a man on 12556 and other related drawings; and suggests that these date from *c*. 1510. As Leonardo considers the action of facial muscles in the expression of emotions ('muscle of anger', 'muscle of sadness', 'muscle of biting', etc.) it is likely that the group of heads in profile was meant to illustrate such emotions. Similar studies are in 19046 *recto* (B. 29).

Chamberlaine, Supplementary plates Nos. 2, 5. Esche, pp. 107–108, figs. 97, 103. Heydenreich, pl. 201 (*verso*). Müntz, p. 467 (head in bottom right-hand corner of *verso*). O'Malley-Saunders, 1, 56. Popham, pl. 246 (*verso*).

19013 (A. 14)

RECTO

ABOVE

Three studies, one on a larger scale, of a man's right arm and shoulder, showing muscles.

BELOW

Three studies of a right arm; C.L. front view, C.M. half front, L.C. half rear.

A diagram to illustrate the pronation and supination of the hand.

With notes on the drawings.

VERSO

TOP LEFT, CENTRE AND LOWER LEFT

Three drawings showing deep dissection of the muscles of the shoulder region.

TOP RIGHT, CENTRE RIGHT

Two studies of the superficial muscles of the shoulder and right arm and a diagrammatic demonstration of the accessory muscles of respiration.

R.L.

Skeleton of a left foot with leg bones seen from left.

With notes on the drawings, and on the necessity of drawings and description in anatomical work.

The letter Ō, in sixteenth-century writing.

Richter's No. 147.

SEE note to f. 2 (19001). Notes on the action of the muscles of the shoulder in the circular motion of the arm are in *Libro A 39* and MS. E, f. 17 *recto*.

Chamberlaine, Supplementary plates Nos. 3, 6. Esche, p. 109, fig. 104 (*verso*). O'Malley-Saunders, 42, 49. Pedretti, *Libro A*, pp. 71–72 (note and diagram on *recto*).

19014 (A. 15)

RECTO

Figure of a man, facing the spectator, legs apart, head and left arm not indicated, showing leg muscles.

A study of the shoulder and extended right arm, in black chalk.

With notes on the drawings. The last three lines of centre column are written on a strip pasted down.

The No. 110, preceded by the faint trace of what seems to be the word *Leoni*.

Richter's No. 148.

VERSO

RIGHT

A study of a man in profile to right from neck to shin, showing the superficial muscles, the head not indicated. The shadows are worked up with washes of bistre.

CENTRE

A study of a man's right leg, facing the spectator, showing the superficial muscles of the thigh.

Numerous small studies, diagrams and notes on the drawings.

THESE studies of legs recall those made by Leonardo during the period of his work on the Battle of Anghiari, or soon afterwards, e.g. those on 12631 or 12633, and show how persistently he pursued this branch of anatomy. This is on the same paper as the following drawing, to which it was probably joined. One of the notes on muscles is countersigned with the mark ø. See note to f. 3 (19002).

Chastel, p. 135 (*verso*). Esche, pp. 108–109, fig. 161 (detail of *verso*). Heydenreich, pl. 182. O'Malley-Saunders, 20 (*verso*), 61.

19015 (A. 16)

RECTO

ABOVE

Two studies of the superficial muscles of back and right shoulder, deep muscles of back on left, superficial on right.

CENTRE

Three studies of deep muscles of the back and right shoulder. Sketch of tendons attached to each vertebra.

R.L.

Diagrammatic demonstration of trapezius and unidentifiable deep muscles of the back and the same on a smaller scale.

With notes on the drawings.

The No. 99, in sixteenth-century writing.

Richter's No. 91.

VERSO

Notes on the muscles of the back, with two small drawings and a diagram demonstrating either elevation of ribs by back muscles or possibly support of neck by muscles attached to shoulder blades, resembling the support of the mast of a ship.

WITH the preceding drawing, to which it was probably joined, this is perhaps the earliest of the series, *c.* 1509. Style, writing, page lay-out and ink

recall the drawings in C. 1, e.g. ff. 5 and 8 (19064 and 19067).

Esche, p. 109, figs. 107, 113 (detail of *verso*). O'Malley-Saunders, 16, 17.

19016 (A. 17)

A double sheet.

RECTO

Large study of left foot and leg from just above knee in profile to left, showing muscles of the calf and tendons.

Another small sketch of the arm and hand seen from in front, with notes on the drawings.

VERSO

Blank.

AT the end of the last paragraph but one of the notes are the words *e cquesta vernata del mille* 510 *credo spedire tutta tal notomia.* Leonardo had evidently been working at anatomy for some time, and hoped that by the spring of 1510 he would have mastered this branch of the subject. The statement, however, is open to interpretation. It is just conceivable that Leonardo uses here the Tuscan expression according to which the 'vernata' of 1510 implies 1510–11, since the Florentine year used to begin March 25th. Calvi (*loc. cit.*) notes this in conjunction with the hypothesis of a collaboration between Leonardo and Marcantonio della Torre, but still accepts the possibility of an earlier date for the beginning of the Anatomical MS. A.

Beltrami, *Documenti*, No. 205 (dated note, as being on f. 2 *verso*). Calvi, *Manoscritti*, p. 289. Esche, p. 109. O'Malley-Saunders, 75. Richter, §1376 (dated note).

19017 (A. 18)

A double sheet.

RECTO

Large study of the anatomy of the foot and left leg from just above the knee, seen from in front, showing muscles and tendons. To the left, a faint black chalk drawing of the same foot.

Small study of the big toe.

With notes on the drawings. The note on the origin of the foot muscles given in Richter, §1494; that on the study of the leg and foot given in Richter, §804.

VERSO

Blank.

Bodmer, p. 344. Esche, p. 110, fig. 18. MacCurdy, *Mind*, pl. 6. O'Malley-Saunders, 74. Poggi, pl. CLXVII. Richter, §§804, 1494.

ANATOMICAL MANUSCRIPT B

Numbering

This manuscript includes the drawings published under the title *I manoscritti di Leonardo da Vinci della Reale Biblioteca di Windsor. Dell'Anatomia, Fogli B, pubblicati da Teodoro Sabacchnikoff, trascritti e annotati da Giovanni Piumati, Torino, 1901.* They have been bound as arranged by Sabachnikoff, and numbered from 19018 to 19059. In the following entries I give both these inventory numbers and the numbers in Sabachnikoff's publication, thus 19018 (B. 1) and so forth. Most of the sheets have sixteenth-century marks, either numbers or letters, and these are given in the description of those drawings on which they appear. As they bear resemblance to the writing of the Codex Urbinas they are tentatively identified as Melzi's. It is interesting to note that ff. 3–4, 6–21, and 29–32, as given in Sabachnikoff's arrangement are in the sequence given by this sixteenth-century hand, although this is not always the sequence produced by Leonardo (see below, *Reassembling*). Many of the sheets also bear a small number written on by Richter when he was compiling his anthology. Richter's numeration is confusing and sometimes inconsistent, but I give it in a note to those drawings on which it is visible, since it might be useful in identifying references.

Reassembling

Twenty-six sheets of this series, i.e. twenty-four plus one sheet in C. 111 and one now at Weimar, were originally joined in pairs. This was in fact Leonardo's system of compilation. He was not using a book the pages of which were already bound in signatures, but was making up such a book with individual sheets, kept loose pending a definitive arrangement. The proof of the suggested correlations is given in the comments to the drawings. Sometimes a sheet shows marks produced by the contact of the still wet ink of an adjoining sheet which is no longer at Windsor. The fugitive leaf at Weimar is the only one of the missing sheets of this series that has come down to us.

Date

On 19059 *recto* (B. 42) is the date *a dj 2 d'aprile 1489* to which some twenty years later Leonardo added the inscription *libro titolato de figura vmana.* This was once thought to give a date to the whole manuscript, but the study of Leonardo's handwriting proves that only a few sheets are of this date. These sheets are ff. 1 *recto*, 2 *recto*, 40 41, 42; there is an early drawing, with late writing, on f. 1 *verso*, and some early notes on ff. 2 *verso*, 20 *recto* and *verso*, 21 *recto* and *verso*. Apart from an obvious difference in the writing and the style of the drawings, these sheets are distinguished by a grey ink. The other drawings, which make up the greater part of the manuscript, are much later and seem to be all from the period 1506–8, with some probably as late as 1509. Some of these drawings can be associated with Leonardo's activity at the time of Leda and Anghiari (e.g. f. 22 in comparison with 12642), but their style and technique suggest a period following rather than preceding his return to Milan in 1506. See Appendix C.

Size

19 × 13·3, with almost imperceptible variations due to accidental trimming.

Medium

Pen and ink, often on a light trace of black chalk.

19018 (B. 1)

RECTO

ABOVE

Two drawings showing the blood vessels of the face; to left, a preliminary outline of head and face; to right, a drawing showing the superficial veins of the face.

BELOW

A study of the torso of a man, in profile to right.
With notes.

VERSO

Left profile study of a man's head showing the blood vessels of the scalp.
List enumerating the functions of the body.
Richter's No. 37.

THE *recto* is of the early period; on the *verso*, the drawing is early, the writing is later. Cf. f. 12 *verso* (19029). O'Malley-Saunders, *loc. cit.*, mistakenly state that in the first edition I date the writing of the *recto* late.

Esche, p. 111. O'Malley-Saunders, 125, 126. Richter, §814 (list on *verso*), pl. CVIII, No. 4 (detail of *verso*). Rouvèyre, *Anat.* C, 1 (*recto* and *verso*).

19019 (B. 2)

RECTO

Notes concerning the senses and their connexion with the central nervous system.
The letter B., in sixteenth-century writing.

VERSO

Two small drawings of the alimentary system.
With notes on the nervous system, the functions of the liver, and the sexual organs.
Richter's No. 202.

THE whole of the *recto* belongs to the early period. On the *verso* the notes on the nervous system, liver and intestines are early; those on the sexual organs are late, *c.* 1506–8. Compare C. III. 4 (19098), and Anatom. MS. A, f. 18 (19017). The notes on the nervous system only are in Richter. Seven *vocabula* on the *recto* are related with those in the Trivulzian MS. Cf. Calvi, *Manoscritti*, p. 137.

Esche, pp. 111–112. O'Malley-Saunders, 182 (*verso*). Richter, §§838 (*recto*), 839 (*verso*), 1412 (*recto*). Rouvèyre, *Anat.* C, 2 (*recto* and *verso*).

19020 (B. 3)

RECTO

RIGHT

The portal veins, its tributaries and branches.

CENTRE

Two studies of the mesentery and the portal vein.

BELOW

Diagram of the portal and gastric veins.
With notes, those above being on the long nails of Eastern peoples, the remainder on the veins of the stomach.
The No. 3 in sixteenth-century writing.

VERSO

RIGHT

Drawing showing the brachial plexus.

BELOW

Diagrams of vessels, trachea and oesophagus; viewed from in front, behind, and in cross-section at the first rib.
With notes, those above on the force of the muscles in the arms and legs, those below on the structure of the neck.
Richter's No. 215.

THE style of the drawing on the *recto* is similar to that of the drawings of plants for Leda, e.g. 12423, and to that of the Rotterdam drawing of a kneeling Leda. All these drawings have in common a cross-hatching technique in addition to lines following form. O'Malley-Saunders, *loc. cit.*, point out that these studies carry out the programme outlined in 12642 *verso*, which is again a drawing related to the Leda. The notes on the *verso* are based on the dissection of the centenarian in the hospital of Sta Maria Nuova at Florence as mentioned on f. 10 (to which see note), thus confirming the date *c.* 1508. This sheet was originally joined to another which is no longer to be found in this series. There are in fact ink marks on the *verso* to which none of those on the other folios correspond. But it is certain that this and its missing companion were once kept in a group of sheets pertaining to the dissection of the old man. In fact two stains at the top margin are the exact mirror image of the stains on the top margin of f. 32 (19049), a sheet with drawings also labelled *del uechio*.

Esche, p. 112, figs. 32, 50, and 61 (detail of *recto*). O'Malley-Saunders, 156 (*verso*), 189. Rouvèyre, *Anat.* C, 3 (*recto* and *verso*).

19021 (B. 4)

RECTO

Schematic drawing of the cervical vertebrae, with the clavicle.

Three diagrammatic drawings of umbilical blood vessels, with notes on the drawings.

The No. (?) 4 in sixteenth-century writing.

Richter's No. 127.

VERSO

ABOVE

Schematic drawing of the brachial plexus.

BELOW

Two schematised drawings of the junction of skull and spinal column; with notes on the drawings.

THIS and f. 23 (19040) must be considered together as they were originally. Not only is there identity of style but also continuity of contents: on the facing folios 4 *verso*–23 *recto* the figures are numbered p°, 2°, 3°, and figure 4 is on the *recto* of f. 4. Moreover, the note *La nuca effonte de nervi etc.* in the middle of f. 23 *recto* has left an imprint on the facing f. 4 *verso*. All these drawings are based on the dissection of the centenarian (see note to f. 10) and therefore date from *c.* 1508. They are in the identical style of the drawing of diving apparatus in the Arundel MS., f. 24 *verso*, which is dated 1508. Esche, *loc. cit.*, who has already noted this, also compares the writing to that of the notes dated 1503 in the Arundel MS., f. 229 *verso*; but this is a type of formal writing adopted by Leonardo throughout the first decade of the sixteenth century. Compare the notes on the map of Imola, 12284, and those on the Anatom. MS. A. The same type of schematised drawing appears in the drawing of a wing mechanism for a flying machine in Codex Atlanticus 341 *recto*-c, *c.* 1507–8.

Esche, pp. 112–13, figs. 52, 53. O'Malley-Saunders, 131, 154. Rouvèyre, *Anat.* C, 4 (*recto* and *verso*).

19022 (B. 5)

RECTO

Three drawings showing the important nerves and blood vessels of the left leg—from the back and outer sides of the leg.

With notes on the relation of the nerves to the muscles.

Richter's No. 28.

VERSO

Five schematic drawings of the nerves and blood vessels in the leg and thigh, with some explanatory words.

THESE studies are related with 12592, 12628 and f. 17 *verso* (19034). Style and writing suggest a date *c.* 1507–8. This was probably joined to f. 7, but the correlation is only suggested by the contents and style. Compare also the following drawing.

Esche, p. 113. O'Malley-Saunders, 167 (*verso*), 168. Rouvèyre, *Anat.* C, 5 (*recto* and *verso*).

19023 (B. 6)

RECTO

Drawing of the lumbar plexus and its peripheral distribution, and, to left on a larger scale, the nerves and the spinal column.

With notes on the drawings.

The No. 9 in sixteenth-century writing.

VERSO

Drawing showing the left iliac vein and tributaries, and, to left, detail of the subcostal veins and the formation of the azygos system.

With notes on the anatomical drawings, and the list of twelve anatomical representations, either done or to be done by Leonardo.

Richter's No. 39.

THIS is related to the preceding drawing, to which see note. It may have been joined to it, or even more likely to f. 3, but there is no proof. A note on the *recto*, *taglia questa coda per lo mezo si come tu facesti il collo . . .*, may refer to such drawings as those on f. 4 *recto* (19021). A similar note is on f. 36 *verso* (19053), with the difference that there he refers to man, while here he refers to an animal. The writing of the note again shows characteristics of Leonardo's script of 1507–8. It is not strictly formal, but it recalls the formal writing of the Arundel MS. (e.g. f. 24 *verso*). The same characteristics appear in Codex Atlanticus 214 *recto*-a, a sheet of notes on flight of birds and water. This can be dated exactly in the spring of 1507 by comparison with Codex Atlanticus 77 *recto*-b, which records Leonardo's deposit of money in his account in Sta Maria Nuova at Florence (see *List of Dates*). It is in f. 214 *recto*-a of the Codex Atlanticus that Leonardo reminds himself of the system of compilation to be adopted: the original notes must be crossed through after having been copied and these

should be left in Florence, so that if he loses the copies he carries with him, the invention will not be lost.

Esche, p. 113, figs. 38 (*verso*), 48. O'Malley-Saunders, 135 (*verso*), 165. Richter, §801 (note on *verso*). Rouvèyre, *Anat.* C, 6 (*recto* and *verso*).

19024 (B. 7)

RECTO

CENTRE

Drawing showing the nerves of a left leg seen from behind; to left two diagrammatic details of the blood vessels and nerves of the popliteal space; to right, a drawing of the common peroneal nerve.
With notes on the drawings.
The No. 10 in sixteenth-century writing.
Richter's No. 42.

VERSO

Two drawings of the leg showing the lower portions of long and short saphenous veins.

THIS may have been joined to one of the preceding drawings, or perhaps to f. 5, but there is no proof of the connexion. O'Malley-Saunders, *loc. cit.*, compare it with 19113 *recto* (C. IV. 8), and 19025 *recto* (B. 8), thus suggesting a date *c.* 1508.

Esche, p. 113. O'Malley-Saunders, 138 (*verso*), 141. Rouvèyre, *Anat.* C, 7 (*recto* and *verso*).

19025 (B. 8)

RECTO

Drawing of the femur, femoral vessels and long saphenous vein.
With a note on the drawing.
The No. 11 in sixteenth-century writing.
Richter's No. 78.

VERSO

ABOVE

Drawing indicating the blood vessels of the pelvis, in black chalk.

BELOW

Drawing showing the relation between the nerves, and arteries of the left hand as seen from the palm.
With notes on the drawings.

THE evidence that this and f. 9 (12026) were originally joined together is tenuous but decisive: not only have some stains in the paper of one sheet left

imprints on the facing one (this could have been produced by the prolonged contact of the two sheets and is not an indisputable proof of correlation), but the first *e* of the last line on f. 8 *verso* has left a mark on the facing 9 *recto*, together with less conspicuous marks produced by other letters of the same note; also the word *omo* on top of f. 9 *verso* has left an imprint on f. 8 *recto*. In the sheet thus reassembled there is continuity of contents showing the branch of anatomy which concerned Leonardo around 1508. The drawing on the *recto* of f. 8 is developed in 12624 *verso*.

The study of the hand on the *verso* may be related to a note in MS. F, f. 95 *verso* (*anatomja. | Quali neruj over corde della mano sō | quelle che acchostano e djssctostano li | djti della mano e de piedj lun dallaltro.*), thus suggesting the possibility of a later date; Cf. 19009 (A. 10). The cross-hatching technique of the drawing on f. 9 *recto* recalls that of the plants for Leda, 12423, the Weimar sheet, etc. The traces of black chalk on 19025 suggest drawings of legs in the same style as 12630, 12631, 12633. All these drawings are of the Anghiari type of Herculean figure, and yet they may relate to a note on the cover of MS. F: *va ogni sabato alla stufa e uederai delli nudi.*

The drawings of the skeletons of two arms on the *verso* of f. 9 may be related to those on 19103 (C. III. 9) and 19118 *verso* (C. IV. 14).

Esche, p. 113, fig. 43 (detail of *verso*). O'Malley-Saunders, 139, 158. Rouvèyre, *Anat.* C, 8 (*recto* and *verso*).

19026 (B. 9)

RECTO

Drawing showing the ramifications of the veins and arteries of the pelvis, in ink, the right leg being outlined in black chalk.
A similar small drawing.

BELOW

Drawing of a blood vessel from groin to hip.
With two short notes on the purpose of the drawings.
The No. 12 in sixteenth-century writing.
Richter's No. 74.

VERSO

Two diagrams; to right, left arm skeleton of man, and to left, the left arm skeleton of an ape, both drawn to show the leverage obtained by the two differing attachments of muscles.

BELOW

Two very faint drawings in black chalk showing the muscles of the shoulder, and, in pen and ink, a mechanical drawing illustrating principles of leverage.

With notes on the drawings.

SEE note to preceding drawing.

Esche, pp. 113–114, fig. 112 (detail of *verso*). O'Malley-Saunders, 55 (*verso*), 134.

19027 (B. 10)

RECTO

Drawing showing the superficial veins of the left arm seen from the front.

To left, two small drawings, that on the right being the blood vessels of a young man, that on the left, those of an old man.

With notes on the drawings and one on the principles of anatomical drawing. Also a memorandum to draw the arm of a certain Francesco miniatore which shows many veins.

The No. 13 in sixteenth-century writing.

VERSO

TOP RIGHT

Small drawing of portal veins in old age.

Page of notes on the changes in the hepatic arteries and veins in old age and the results of these changes. Involution of abdominal organs in the aged, aneurisms, senile decay, its relation to changes in the arterial walls. Also the record of the death of a centenarian in the hospital of Sta Maria Nuova at Florence. All these notes done over a sketch in black chalk of the outline of a man's torso with veins indicated in the upper part and down to the arms, the one to the right being more clearly shown with the hand in the same position as in 12597.

Richter's No. 86.

AGAIN two sheets which were probably joined together: ff. 10 and 11. The proof is in the two facing pages, 10 *verso*–11 *recto*: the 4 written by Leonardo at the left-hand corner at the bottom of f. 11 *recto* has left an imprint on f. 10 *verso*. Similar imprint is produced by an ink spot half way up the inner margin. And there are other marks on both folios, especially at the bottom, produced by the ink still wet of letters of the notes.

As the sheet thus recomposed is turned around there is no such evidence of ink marks, but the note at the bottom of f. 10 *recto*, which is in different ink and bolder writing, has produced marks on the *verso* of f. 9. This means that Leonardo either added the note when the sheets were already sewn into a volume or, as seems more likely, that he simply placed one sheet over the other. Obviously all these sheets date from the same time. And it is again a reference to MS. F

that suggests the date *c.* 1508. In fact an outline of the passage on f. 10 *verso* on the changes in the hepatic arteries and veins in old age is found on f. 1 *recto* of MS. F, and is dated 12 September 1508. This also suggests that the dissection of the 'old man' Leonardo is referring to may have taken place in Florence between the second half of 1507 and the first half of 1508. It appears that the greater part of the anatomical notes in this manuscript were done in Milan after September 1508, recording findings and observations based on dissections carried out in Florence a few months before. These pages of notes and drawings neatly compiled are obviously not the notes made during the actual dissections. We have no idea of what those drawings may have looked like, and they are probably the ones referred to by the Anonimo Gaddiano: '. . . de' quali ancora ne lasciò in Firenze, nello spedale di S. Maria Nuova'.

Esche, p. 114, fig. 40 (detail of *recto*). O'Malley-Saunders, 127, 128. Rouvèyre, *Anat.* C, 9 (*recto* and *verso* interchanged). Royal Academy, 292.

19028 (B. 11)

RECTO

TOP RIGHT

Drawing of main arteries and veins of the thorax, probably bovine and not human. Schematic pulmonary vessels, probably in accordance with Galen's views.

TOP LEFT

Two small studies of the heart and its blood vessels, seen from the front and the left side; between them the drawing of a plant sprouting from a seed which resembles a heart.

With notes on the drawings. Along the top margin, to the left, a note in black chalk not transliterated by Piumati:

il djaf[ram]a e apichato alla 12ª costa.

The No. 14 in sixteenth-century writing.

VERSO

ABOVE and CENTRE

Two diagrams demonstrating the portal and coeliac veins; the kidneys, liver and spleen are illustrated only in the lower drawing.

BELOW

Drawing showing the blood vessels of the liver, spleen and kidneys.

Also two very small drawings showing the tortuous blood vessels of old age.

With notes on the blood vessels of the stomach and the causes of death in old men.

Richter's No. 87.

SEE note to preceding drawing.

Esche, p. 114, figs. 29 (*verso*), 44 (detail of *recto*). O'Malley-Saunders, 119, 129. Royal Academy, 293.

19029 (B. 12)

RECTO

ABOVE

Faint drawing of upper abdominal organs in black chalk.

BELOW

Highly schematic study of the internal structure of the left ventricle of the heart.

With notes on the drawings.

The No. 15 in sixteenth-century writing.

VERSO

ABOVE

Drawing showing the system of blood vessels of the thorax and neck.

CENTRE

Two drawings showing the blood vessels of the face and their position in the skeleton.

BELOW

In the extreme right-hand corner, the words *dellumana spetie*.

Richter's No. 160.

MOST of Leonardo's studies of the heart and stomach date from after 1508; compare C. I, ff. 1–9, C. IV., ff. 7–16. This and the following pages are therefore among the latest in the MS.

The mask of a man on the *verso* should be compared with that on f. 1 *recto* (19018) as showing the stylistic difference between early and later drawings in the book. Notice in the later drawing the cross-hatching and the shading under the chin following the direction of the forms, whereas in the early drawing all the shading is diagonal.

Esche, pp. 114–115, fig. 127 (detail of *recto*). O'Malley-Saunders, 90, 118. Popham, pl. 240 (*verso*). Rouvèyre, *Anat.* C, 10 (*recto* and *verso*).

19030 (B. 13)

RECTO

Page of notes containing a tabulation of the animal kingdom, a description of the function of some of the organs of the body, i.e. the heart, lungs, etc. A very faint black chalk sketch of the organs of the abdomen.

The No. 16 in sixteenth-century writing.

VERSO

Drawing of the left kidney, ureter and blood vessels seen from the front.

With notes on the sense organs of man compared with other animals, on sense of smell in feline species, and on the pupils of nocturnal animals. Completely covered by these, a very faint sketch in black chalk of the skeleton of the thorax from the front.

BOTH this and the following drawing must be considered together as they were originally. The note on the *verso* of f. 14 continues on the right margin of the facing 13 *verso*; Leonardo himself has indicated this with a line of reference from one folio to the other. As the sheet thus recomposed is turned around, the *recto* of f. 13 faces the *verso* of f. 14. Around the small drawing of the caecum on the *verso* of f. 14 are ink marks produced by words of the note on the facing f. 13 *recto*. This is again evidence that the folios of this note-book were compiled as individual pairs and only later bound in volume form.

This sheet is most important for chronology as it is related with the Leda drawing 12642, to which see note. In the first edition that drawing was used to date these anatomical studies *c.* 1504, but the reverse process is more accurate. Style and contents of B. 14 suggest the date of MS. F, *c.* 1508, and the studies on the excretory system are undoubtedly linked to C. III., ff. 4, 5, 6, 11, etc. The list of the function of some of the organs of the body on f. 13 *recto* is an indication of the branch of anatomy which concerned Leonardo around 1508: heart, lungs, genito-urinary system, etc. The date *c.* 1508 is also suggested by the contents of f. 13 *verso* which is reflected by the notes in MS. D, ff. 5 and 6. It must thus be the date of 12642, and proves that Leonardo continued to work on the subject of Leda after his return to Milan.

Esche, p. 115. O'Malley-Saunders, 191 (*verso*). Richter, §§816 (tabulation of animals on *recto*), 827 (first two paragraphs on *verso*). Rouvèyre, *Anat.* C, 11 (*recto* and *verso*).

19031 (B. 14)

RECTO

C.

Drawing of the alimentary tract and kidneys.

R.

Two detailed drawings of ureter.

BELOW

Drawings showing the position of urinary system in various positions of the subject.

With notes on the drawings.

The No. 17 in sixteenth-century writing.

VERSO

ABOVE

Semi-diagrammatic drawing showing the arrangement of intestines within the abdomen.

BELOW

Schematic drawing of the liver, stomach and spleen.

R.L.

Small drawing of the appendix, caecum and ileocolic junction.

With notes on the intestines and liver.
Richter's No. 173.

SEE note to preceding drawing.

Esche, pp. 115–116, figs. 33 (*verso*), 34. O'Malley-Saunders, 185 (*verso*), 192. Rouvèyre, *Anat.* C, 12 (*recto and verso*). Royal Academy, 273 (*verso*).

19032 (B. 15)

RECTO

Two drawings of a male torso showing the muscles of the anterior and lateral walls of the abdomen.
With notes on the drawings.
The No. 18 in sixteenth-century writing.

VERSO

Two drawings of the torso of a man, in profile to right, showing superficial muscles.

R.L.

Two small diagrams indicating muscle surface seen in profile and represented according to ancient and modern usages.

THE drawings and the widely spaced writing in the sheet recomposed with this and the following folio preceded the closely written notes. This does not necessarily mean that the smaller notes were added at a much later period. One set of notes is in widely spaced writing simply because Leonardo inked them in. They were in fact written first in black chalk, just as the drawings were also inked in over black chalk. Such double process technique of writing begins to appear in MS. K (vol. III, from after 1506), in which black chalk is employed. It is also used in MS. F, but with red chalk, and so it is with 12660, etc.
The torso on the *verso* of f. 15 is in a different style from most of the other late drawings in the sketchbook, being freer and less neat. It is exactly like the torsos on 12636 and also recalls such a drawing as the study of figures in action at Turin, so probably dates from the period when Leonardo was finishing his work on the Battle of Anghiari, *c.* 1506–8.

The diagram showing muscles as rendered according to ancient and modern usages (*muscolo anticho* and *moderno*) is a subject complemented by a later note in MS. G, f. 26 *recto*, in which similar diagrams occur. (Cf. Pedretti, *Libro A*, p. 135.)
In the middle of f. 16 *recto* is the ink mark produced by the word *leuato* in a note on the facing f. 15 *verso*. As the sheet thus recomposed is turned around this is not indisputable evidence of correlation; on the contrary, on the *recto* of f. 15 there are ink smudges produced by words of notes on the preceding sheet (f. 14 *verso*). This of course could have happened when Leonardo piled sheets up after compilation.
The upper drawing on the *verso* was engraved by Hollar in 1645, Parthey 1772.

Esche, p. 116, figs. 78, 80. O'Malley-Saunders, 19 (*verso*), 23. Rouvèyre, *Anat.* C, 13 (*recto and verso*).

19033 (B. 16)

RECTO

ABOVE

Rough sketch of a torso showing superficial muscles of the abdomen.

BELOW

Rough sketch of a torso showing abdominal muscle inaccurately.
With notes.
The No. 19 in sixteenth-century writing.

VERSO

ABOVE

Sketch of pectoralis minor in relation to external intercostal muscles.

L.R.

Sketch showing the superficial muscles of the anterior wall of the thorax and abdomen.
With notes on the drawings.
Richter's No. 84.

SEE note to preceding drawing.

Esche, p. 116, fig. 79 (*verso*). O'Malley-Saunders, 21 (*verso*), 22. Rouvèyre, *Anat.* C, 14 (*recto and verso*).

19034 (B. 17)

RECTO

TOP RIGHT

Drawing of lungs in the thorax, with notes on respiration.
The No. 2 [0] in sixteenth-century writing. Richter' No. 85.

VERSO

Two drawings, one back view, one in profile to left, showing brain, spinal cord and spinal nerves. Between them a human skeletal figure, which illustrates the precept that the nervous system should be represented within the outline of the body.

With three notes on the drawings.

THE writing on the *recto* is of two different dates— the block of fine writing in brownish ink is earlier than the column of coarse writing in black ink to the right. But there cannot be a long interval between them, as the drawing, which illustrates the longer note and which is also in brownish ink, is late in style. In fact the writing itself has a characteristic which appears in Leonardo's manuscripts only after 1500, i.e. the reversed hook of such letters as *b, d, h, l*. The same type of writing is on f. 25 *recto* (19042), in notes on optics which are related with those in MS. D. Moreover, in the writing of the Sforza period Leonardo uses a Q with a graceful, sinous tail; after 1500, and especially after 1505, the tail of the Q becomes a vigorous arc sweeping all the way to encompass the whole word, usually *Questo, Quanto*, etc. This difference is clearly shown in the notes on f. 20 *verso* (19037). Compare also f. 25 (19042), to which see note. It is not unlikely that this writing dates from *c.* 1507 or even later, when Leonardo seems to have adopted an extremely fine script, along with a bold one produced by a larger pen and blackish ink. This also occurs in his early period. Compare the early anatomicals in this note-book and the writing of the Paris MS. B.

The notes on the right-hand column seem to precede the studies on lungs in C. 1, ff. 5, 6, etc., and can be dated with certainty after September 1508. In fact on the first cover of MS. F (12 September 1508) Leonardo writes: *fa gonfiare il polmone | dun porcho e guarda se | cresse in largeza e in lungeza overo in largeza | e mancha in lungeza.* The experiment having been carried out Leonardo writes in this folio as follows: *lacresscimento | del polmone˄quãdo senpie daria˄he la|titudjnale e non per | la sua lungheza | come veder si po ne|l gonfiare il polmõ | dun (anjmale) po|rcho*, etc. Notice that Leonardo writes *animale* first and then he crosses the word out and specifies *d'un porcho* as if he had in mind the memorandum in MS. F. Next to that memorandum Leonardo writes: *va ogni sabato allas|stufa e uederai delli nudi,* which may suggest a date for 12593, etc.

The pose of the standing man showing surface modelling in 12593 is identical to that of the man in 12592 which shows the ramification of veins, just as the figures on the *verso* of this drawing show the ramification of nerves. These relate with those on f. 6 (19023), and 12628, to which see note.

Esche, pp. 116–117, fig. 46 (*verso*). O'Malley-Saunders, 144 (*verso*), 170. Rouvèyre, *Anat.* C, 15 (*recto* and *verso*).

19035 (B. 18)

RECTO

Drawing of the inner surface of a left leg showing vessels and nerves. Schema of the right sciatic nerve and its branches.

R.L.

Small drawing of the outer surface of a left leg, and of the bones of the same leg, front view, with dotted outline of the leg.

With notes on the drawings and on the principles of anatomical representation.

The No. 21 in sixteenth-century writing.

VERSO

Two drawings of a left leg, one front view, the other of the inner surface, both drawn to show the superficial muscles of the thigh.

With notes on the drawings.

Richter's No. 77.

THIS and the following drawing are a good example of a sheet that must be considered open flat as it was compiled by Leonardo. The drawings on f. 18 *recto* face the related ones on f. 19 *verso*; note that the four legs are all shown at the same angle, although the one on the far left (f. 19 *verso*) is slightly turned to show the attachment of the muscles of the thigh. It is one of these muscles, i.e. the sartorius, that has been resected (f. 18 *recto*) to expose the femoral nerve and one of the femoral vessels. The diagrammatic representation of the sacral plexus and the sciatic nerve relates with 19114 *recto* (C. IV. 9), to which see note. There is no doubt that these drawings were done at sheet open flat, and this may account for the absence of ink marks from one folio to the other. As the sheet thus recomposed is turned around, four legs are shown again, this time to represent the muscles of the thigh from four points of view. The writing on f. 18 *verso* has left several marks on f. 19 *recto*, thus Leonardo must have folded it back into the batch of sheets which were to be bound in note-book form.

The date is suggested by the style, writing and contents: *c.* 1508. This also applies to the marginal note on f. 18 *recto*, which is in the finer script of the preceding drawing. This note on the principles of anatomical drawing is illustrated with two sketches which are in the same style as the larger ones on the page. As a marginal note this must have been added as an afterthought, perhaps not long afterwards, but simply with a different pen. In fact its upper half follows the curve of the thigh represented in the adjoining drawing.

16

Compare the almost invisible drawing of leg in 19104 (C. iii. 10).

Esche, p. 117, fig. 49. O'Malley-Saunders, 68 (*verso*), 161. Rouvèyre, *Anat.* C, 16 (*recto and verso*).

19036 (B. 19)

RECTO

Studies of a left leg, one of the back and the other of the outer side to show the superficial muscles of the thigh.

The No. 2[2] in sixteenth-century writing.

VERSO

Two studies of a left thigh and leg showing the superficial muscles from the back and inner side.

With a note on the drawings.

Richter's No. 75.

SEE note to preceding drawing.

Esche, p. 117. O'Malley-Saunders, 69, 70. Rouvèyre, *Anat.* D, 1 (*recto and verso* interchanged).

19037 (B. 20)

RECTO

Two anatomical studies of a right leg with the knee flexed.

With notes, those above being a list of anatomical propositions, the others on movement as exemplified in the drawings.

The No. (?) 23 in sixteenth-century writing.

VERSO

Notes on the scheme of the book, to treat of prenatal life, growth in childhood, man, woman, their proportions, expressions, attitudes and senses.

Richter's No. 36.

AT either end of this note-book are folios of 1489, to some of which Leonardo added notes almost twenty years later. The sheet recomposed with this and the following drawing is of the same series. There is no indisputable evidence that the two folios were originally together, but it is at least certain that neither one joins with any other early sheet in the note-book. Moreover, the late studies in these two folios have continuity of contents and identity of style. The upper note on the *verso* of f. 20 and the first two lines on the facing f. 21 *verso* are in the writing of 1489. The remainder of the sheet is filled with two sets of later

notes. To begin with f. 20 *recto*: the drawings and two notes below were done first, then with different pen and ink Leonardo added one line to the first note and five lines to the second, a marginal note to the left, and notes in between and around the drawings. These drawings are in the style of the 1508 anatomicals, and this gives the date to the note. The additions were probably entered shortly afterwards. In the facing folio (21 *verso*), the moral maxim is in the same writing and ink as the two notes on the facing f. 20 *recto*, i.e. the ones commenting on the two drawings of legs; then comes a column of notes on the attitude in mounting stairs, which is illustrated with three sketches with two shorter notes. Finally, the note on how to check speed in running is squeezed in at the bottom and is illustrated with a drawing. These drawings with lines of shading carefully following forms are in a 'post-Anghiari' style, *c.* 1508. The style and type of figure with fairly well developed musculature are the same as in the figures of men beating in 12641 *verso*, and 19149 *verso*. The same type of man appears in the later drawing for a fountain, 12690, and its proportions can be recognised in the classical figure in the British Museum drawing (Popham-Pouncey, pl. cv), as well as in the St John the Baptist at Varese. Several chapters in the third part of the *Trattato della Pittura* are illustrated with this type of figures. (Cf. Pedretti, *Libro A*, p. 140 ff.) And very likely these notes too were destined to the book on painting. In fact an almost identical note on the action of checking speed in running, Codex Atlanticus 181 *recto*-a (Richter, §374), is headed 'pictura'. A note also headed 'pictura' in the same sheet (Richter, §271) is related with the notes on reflected colour in 19149–52: this, and the notes on the problem of Alhazen and studies of *lunulae* point to the date 1508–9, or even later.

On the other side of the reassembled sheet, to the left (f. 20 *verso*), are notes of 1489 on the scheme of the book with a bottom paragraph added about 1508. The list of subjects to be investigated (f. 21 *recto*) is also early, 1489, and again Leonardo added notes and drawings at a later time, *c.* 1508. The balance of the torso recalls drawings of the 'post-Anghiari' period, 12639, 12640, etc.

Esche, p. 117. O'Malley-Saunders, 71. Richter, §797 (the note on the *verso*). Rouvèyre, *Anat.* D, 2 (*recto and verso*). Royal Academy, 272.

19038 (B. 21)

RECTO

Five sketches of the left side of a male torso in different positions, one on a larger scale.

With notes, those to the left on the drawings, those in

the right-hand column being a list of subjects to be investigated.

The No. 24 in sixteenth-century writing.

Richter's No. 203.

VERSO

Three studies showing attitudes in mounting stairs; and a small drawing showing attitude in checking speed in running.

With notes on the drawings, and on the contrast between the perfection of the body and the grossness of spirit in certain men.

SEE note to preceding drawing.

Esche, pp. 117–118. Pedretti, *Libro A*, p. 141, pls. 22, 23. Richter, §§357 (notes on *recto*), 375 (notes on *verso*), 1178 (on contrast between body and spirit), pls. XXII, No. 1 (detail of *recto*), XXIII, No. 1 (detail of *verso*).

19039 (B. 22)

RECTO

ABOVE

The gall bladder and related blood vessels.

BELOW

Two drawings of the oesophagus, stomach and greater omentum, one on a smaller scale.

With notes on the veins and arteries, and their alteration in old age.

The No. 3(.) in sixteenth-century writing.

VERSO

Study of abdominal organs, i.e. liver, spleen, stomach and intestines, and another of the blood vessels of the anterior abdominal wall.

With notes on the drawings.

THE *recto* of f. 22 was undoubtedly facing the *verso* of f. 34 (19051), to which see note. In fact it has ink marks at the bottom produced by the note of f. 34 *verso*. It is almost possible to read the mirror image of the words *delle fecce* with which that note ends. All the drawings and notes on these facing folios are based on the dissection of the centenarian of Sta Maria Nuova, and the heading 'del uechio' is in fact repeated four times. This heading appears again on the *recto* of f. 34, and a reference to old people is in the note at the bottom of the facing f. 22 *verso*. See note to f. 10 (19027).

The drawings are all in the style of ff. 13 and 14, and deal with related subjects. Date, *c*. 1508.

Esche, p. 118, figs. 31 (*verso*), 35. O'Malley-Saunders, 183 (*verso*), 188. Rouvèyre, *Anat*. D, 3 (*recto* and *verso*).

19040 (B. 23)

RECTO

Two diagrammatic drawings of the neck and upper thorax, and origins of the brachial plexus of nerves.

TOP RIGHT

Schema of coverings of spinal cord and of roots of nerves.

With notes on the drawings.

Richter's No. 44.

VERSO

Three studies of the right arm, drawn to show the nerves.

With notes on the drawing, and a list of the examples to be presented.

The letter P. in sixteenth-century writing.

THIS was joined to f. 4 (19021), to which see note. The *verso* is in the same style as ff. 3–10, which are also based on, or inspired by, the dissection of the old man of Sta Maria Nuova. A similar but shorter list of anatomical demonstrations is on f. 6 *verso* (19023). See also f. 20 *verso* (19037). All these studies relate with 12592, and 12658, the latter being dated by its *verso*, April 30th, 1509.

Esche, p. 118, figs. 47 (*verso*), 51. O'Malley-Saunders, 155, 157. Rouvèyre, *Anat*. D, 4 (*recto* and *verso*).

19041 (B. 24)

RECTO

Small diagrammatic drawing on the right, showing the different functions and varieties of teeth in relation to the axis of the jaw.

With notes on the correct anatomical representation of the hand, and on the kinds and functions of the teeth.

The letter C (?) in sixteenth-century writing.

VERSO

Blank.

THIS is one of the best examples of Leonardo resuming the study of one subject after an interval of about twenty years. This folio was in fact joined to f. 40 (19057). The proof of the correlation is in the first note in the *verso* of the early folio. In between the lines are visible numerous ink marks produced by the first note in the late f. 24 *recto*. It is even possible to recognise some of the words of the last line: . . . *enneruj sopra delle senplici etc.* The *verso* of f. 24 is blank,

and yet there are several dots which may have been produced by the ink still wet of the fine drawing on the *recto* of f. 40. The correlation is made indisputable by one such dot near the right margin in the upper part of the blank page. This comes from the *recto*, where it is bigger, and was probably produced by the point of the pen. The same dot occurs in the corresponding position on f. 40 *recto*.

The subject of the late notes explains the juxtaposition. As Leonardo takes up an early study he seems to begin where he left off. And so he begins with a programme, *Ordjne dj notomja*, about the representation of the hand from bones to muscles. This reflects the early programmes just as the note on the kinds and functions of the teeth seems to be inspired by the facing drawing of the skull with an opening which shows the roots of the teeth. Drawings of the different kinds of teeth are in the early f. 41 (19058). Date, 1508–9. Compare f. 8 *verso* (19025), to which see note.

Esche, p. 118. O'Malley-Saunders, 181. Rouvèyre, *Anat. D*, 5.

19042 (B. 25)

RECTO

BELOW

Diagrammatic drawing indicating some optical principle.

With notes on the reactions of the eye to light, the pupil of the eye in nocturnal creatures, etc.

VERSO

Richter's No. 210.

THE writing is that of the marginal note on f. 18 *recto* (19035), *c.* 1508. Compare also f. 17 *recto* (19034), to which see note. This date is confirmed by the fact that the notes on optics, including the subject of nocturnal animals, are developed in MS. D. And it was only at the time of MS. D (1508–9) that Leonardo reached the conclusion that *la ujrtu visiva ettutta per tutta la popilla ettutta in ognj sua parte*. Cf. Pedretti, *Libro A*, p. 168.

This folio was probably joined to the following, but there is no evidence of such correlation.

Esche, pp. 118–119. Rouvèyre, *Anat. D*, 6.

19043 (B. 26)

RECTO

Richter's No. 60.

VERSO

Drawing of a man holding a club, seen from behind so as to show the muscles of the back, some stylized. The letter K in sixteenth-century writing.

THE inking in is not by Leonardo but the light black chalk certainly is. The curious, 'astigmatic' club recalls the two inked-in figures on 12646 *recto* and suggests that those figures too may have been inked in by a pupil. This is the Herculean type of figure which appears in the Anghiari sheet at Turin, No. 15577 (Popham, pl. 197) and which is turned into an anatomical model in 12625. A similar but larger drawing of Hercules and the Nemean Lion in the Turin Library, No. 15630 (Berenson, 1262A), is catalogued as a sixteenth-century anonymous, but is certainly by Leonardo.

The sixteenth-century letter K is identical to that in 19080 *recto* (C. II. 10) and therefore it is probably by Melzi, who may also be the author of the delicate inking in.

Esche, p. 119. Pedretti, *l'Arte*, LVII, 1958, pl. 2.

19044 (B. 27)

RECTO

To right, a study of a torso of a man, seen from behind, the muscles strongly marked, some stylized.

To left, a similar study, but only the right half of the body and the right arm indicated. Both drawings indicate the muscles in back and arm.

With notes on the drawings.

VERSO

Three studies of neck and thorax, showing ribs, internal intercostal muscles in one and external intercostals in two. Note serratus anterior and serratus posterior superior.

With notes on the drawings.

Richter's No. 76.

THIS and f. 30 (19047) make up a pair which is the last of a series of three pairs of folios containing extensive notes on the powers in Nature. Leonardo develops these notes out of observations on the action of the muscles in the mouth and tongue and on voice. Thus the sequence of these notes can be restored through the following sequence of sheets:

(1) ff. 29–38
(2) ff. 28–31
(3) ff. 27–30

In fact these notes start on f. 29 *recto* and develop backwards through ff. 28 *verso*, 28 *recto*, 31 *verso*, 31 *recto*, and 30 *verso*. Thus Piumati's arrangement of the pages of this note-book is again incorrect.

Folios 27 and 30 were joined together. The facing ff. 27 *verso*–30 *recto* have the subject in common, and two stains on 30 *recto* have produced marks on 27 *verso*. An ink dot at the bottom produced by the point of the pen goes through both folios. Date, *c.* 1508–9. The drawings of the intercostal muscles are related with those in the first nine folios of C. I., e.g. ff. 6 and 7 which have the heading *anathomja* exactly as on the *recto* of f. 30. The drawing showing the muscles of the back recalls the style of the horse drawings for the Trivulzio Monument, e.g. 12303, 12313, etc. The note to this drawing sets a programme of anatomical representation from the back beginning with the skeleton and gradually coming up to organs and muscles. Hints at such programme are in 19014 *recto* (C. III. 10) and 19121 *recto* (C. IV. 15) with which is related a sketch and a note in Codex Atlanticus 81 *recto*-b.

The notes on 30 *verso* are the conclusion of the long discussion begun on f. 29 *recto* and carried on to f. 31 *recto*; the notes on f. 31 *recto* end with the sign ∴, which appears again at the beginning of the notes on f. 30 *verso*.

The long discussion against necromancy and alchemy and Leonardo's questioning the existence of spirits is of the same time as Codex Atlanticus 190 *verso*-b, in which is found one such note (Richter, §1211). This folio of the Codex Atlanticus contains notes on the eye and vision which are developed in MS. D and is related to another folio in the same codex, i.e. f. 385 *verso*-b, which contains references to painting and anatomy, as well as a study for the canalisation of the Adda river (cf. Pedretti, *Libro A*, pl. 25). All this points to the same date as the first nine folios of C. I., in which are long discussions of the same literary style: *c.* 1508–9. Compare also MS. F, f. 5 *verso*: 'E molti fecero bottega con inganni e miracoli finti, ingannando la stolta moltitudine'.

The study of a back on the *recto* of f. 27 is engraved by Hollar, Parthey 1768, and dated 1645.

Esche, p. 119. O'Malley-Saunders, 15, 26. Richter, §809 pl. cviii, No. 1 (detail of *recto*). Rouvèyre, *Anat.* D, 7 (*recto* nd *verso*).

19045 (B. 28)

RECTO

R.U.

Study of a left foot, front view, showing the tendons.

BELOW

Two small drawings of the action of blood in the heart and of the aortic valve of the heart.

With notes, that above being on the relation of the fingers and toes to the hand and foot; that below to the left on the nourishment of the body; that to the right on the action of blood in the body.

VERSO

Page of notes treating of the muscles of the tongue, the mechanism of speech, the variety of languages and the tendency to an infinite number of them, the alchemists and their inventions, the impossibility of making gold, etc.

The No. 8 in sixteenth-century writing.

Richter's No. 43.

S EE note to preceding drawing. The pair formed by this and f. 31 (19048) precedes ff. 27–30 because of the backwards sequence of Leonardo's compilation. He begins on f. 28 *verso* writing the main text, *Delli musscoli che movan la lingua*, goes on to a marginal note (*seguita quel che manca di sotto*), but has still more to write, and so he turns the page (*volta carta e leggi*). His intention is to write on the *recto* of f. 28, where in fact he notes: *seguita qui*, but he must have realised that the space was not enough because of the drawing of a foot and notes to it which were already there (the notes at the bottom were probably added later). And so he goes on to the next page (f. 31 *verso*) specifying that *seguita quel che manca dirieto alla faccia del piedi*, i.e. here follows what is missing in the back of the page with the drawing of the foot. Having filled this folio too and having more to write, again he tells the reader to turn the page (*volta carta*). And so he gets to f. 31 *recto* filling the whole page with notes. This time the notes must be carried on to a separate sheet, thus he uses the symbol ∴ which is a reference to the beginning of the conclusion on f. 30 *verso*.

A drawing of the tongue with notes of its action occurs in 19115 *recto* (C. IV. 10). As in that folio, Leonardo refers to the muscles of the tongue as being 24, but specifying *senza li altri che io ho trovati*, thus suggesting that this may be later than that folio. In the same series as that folio, i.e. ff. 11 and 12 of MS. C. IV., are drawings of the action of blood in the heart similar to that on the *recto* of f. 28. Compare also C. I., ff. 6–7, in which the notes on the heart occur in conjunction with those on the action of the diaphragm and intercostal muscles as in the preceding pair of drawings. All this confirms the date of this group of sheets, *c.* 1508–9. See also note to following pair of drawings.

Esche, pp. 119–120. O'Malley-Saunders, 115. Richter, §843 (bottom left-hand column on *recto*). Rouvèyre, *Anat.* D, 8 (*recto* and *verso*).

19046 (B. 29)

RECTO

Slight sketch indicating actions of muscles of the lips.

With notes on the muscles of the mouth in various expressions and actions. These gone over two very

faint sketches in black chalk showing the uterus of a cow as in f. 38 *recto* (19055).
Richter's No. 41.

VERSO

Diagrammatic drawing showing the structure of the umbilical cord and its system of blood vessels, probably of an ox or sheep.
Small diagram of a bovine placenta.
With notes on the drawings.
The No. 7 in sixteenth-century writing.

THIS and f. 38 (19055) form a sheet which comes first in the sequence of notes that fill the two preceding drawings and related ones. This is again a good example of Leonardo's system of compilation. He fills one side of the sheet kept open flat (ff. 29 *verso*–38 *recto*) with notes on embryology. A sketch of the placenta on the right margin of f. 29 *verso* reaches the adjoining f. 38 *recto* with an almost imperceptible touch of the pen. This is perhaps too slight an evidence but taken in conjunction with the identity of contents it is convincing. The other side of the sheet thus recomposed (ff. 38 *verso*–29 *recto*) is all filled with notes on the muscles of the mouth, with the exception of a sketch of the uterus of the cow with foetus on f. 38 *verso* and a large but faint drawing in black chalk of the uterus of the cow on f. 29 *recto*, which appears to be an abortive sketch of the finished drawing on f. 38 *recto*. As the sheet was compiled and probably folded in half it was to receive in the lower margin of f. 29 *recto* the impression of the still wet ink of letters in the last two lines of f. 28 *verso*.
The drawings of the anatomy of the mouth on the *verso* of f. 38 are in the same style as the Leda head, 12518. Date, *c.* 1508–9.

Esche, p. 120, figs. 147 (*verso*), 158 (detail of *verso*). O'Malley-Saunders, 38, 208. Rouvèyre, *Anat.* D, 9 (*recto* and *verso*).

19047 (B. 30)

RECTO

Drawing of the right side of a male torso, showing ribs and intercostal structures, spinal column and left hip bone.
With notes on the drawing.
The letter M. in sixteenth-century writing.

VERSO

Page of notes discussing the possibility of the relation of the mind to production of sound and movement in air; mind and its relation to the senses, etc.
Richter's No. 201.

SEE note to f. 27 (19044).
Esche, p. 120. O'Malley-Saunders, 150. Richter, §1215 (*verso*). Rouvèyre, *Anat.* D, 10 (*recto* and *verso*).

19048 (B. 31)

RECTO

Page of notes, with discussion of the intimate and essential relation of mind and body; the conception of the weight of a body, the impossibility of disembodied mind existing, etc.
The letter N. in sixteenth-century writing.

VERSO

Page of notes treating of necromancy and alchemy, Leonardo's discussion indicating his scepticism.
Richter's No. 242.

SEE note to f. 28 (19045).
Esche, p. 120. Richter, §§1213 (*verso*), 1214 (*recto*). Rouvèyre, *Anat.* D, 11 (*recto* and *verso*).

19049 (B. 32)

RECTO

TOP RIGHT
Study of the right shoulder blade and long head of biceps muscle seen from behind.

LEFT
Three small diagrammatic studies, two showing the skull, spinal column and sterno-cleido mastoid, the third showing the spinal column only.

BELOW
Diagram showing intercommunicating arteries in front and intercommunicating veins behind (probably pelvic).
With notes on the drawings.
The letter (?) O in sixteenth-century writing.
Richter's No. 183.

VERSO

Study of arteries and veins of the right side of neck and shoulder of a man seen in profile.
With notes on the drawing, having special reference to the effect of age on the arteries.

BOTH this and the following drawing contain notes pertaining to the dissection of the old man of the hospital of Sta Maria Nuova, and in fact each drawing is labelled 'del uechio'. There is no evidence that the

two folios were joined together, but the continuity of contents and consistency of style make this a strong possibility. Along the margin at the top of the sheet is a stain of irregular contour which affects the margin of the following pair (ff. 22–34). Its greater intensity seems to be between ff. 33 *verso* and 34 *recto*. On the *recto* of f. 32 it appears smaller and with sharper contour. An identical stain, in reverse, is on f. 3 *verso*, which is also of the old man series, but apart from this there is no evidence that f. 3 rather than f. 33 was joined to f. 32. There must have been more folios in this series, one of which was joined to f. 3 to form a sheet that was once kept next to f. 32. Even if the sequence of these folios cannot be restored with certainty, there is no doubt about their date. They must have been done within a very short period of time, probably soon after Leonardo's return to Milan in the second half of 1508.

Esche, pp. 120–121, figs. 37 (*verso*), 45. O'Malley-Saunders, 121 (*verso*), 132. Rouvèyre, *Anat.* D, 12 (*recto* and *verso*).

19050 (B. 33)

RECTO

The large arteries of neck, thorax, and right upper arm with a note that they are those of an old man.

VERSO

Study of larynx, trachea, oesophagus and stomach with phrenic and right vagus nerves, brachial plexus and some blood vessels. To right, the trachea from behind.

With notes on the drawings, and on the brain.
Richter's No. 126.

SEE note to preceding drawing.

Esche, p. 121, fig. 36 (*verso*). O'Malley-Saunders, 120, 149. Rouvèyre, *Anat.* D, 13 (*recto* and *verso*). Royal Academy, 303 (*verso*).

19051 (B. 34)

RECTO

ABOVE

Drawing showing the front view of blood vessels of the neck.

BELOW

Study of the phrenic or accessory phrenic nerve running between artery and vein towards the heart. With notes on the drawings.

VERSO

C.U.

Portal vein and branches of coeliac artery.

R.L.

Portal vein and its branches.

L.L.

Detail of liver, gall bladder, pylorus, duodenum and blood vessels.

With notes that all three drawings are of 'the old man'.
Richter's No. 125.

THE *recto* has marks and stains produced by the contact with the *verso* of the preceding drawing. Yet the still wet ink of the last line on the *verso* has left an imprint on f. 22 *recto* (19039), to which see note. It is impossible to say which of the two folios, 22 or 33, was originally joined to this. These are all part of the same series based on the dissection of the old man of Sta Maria Nuova, just as ff. 3, 4, 10, 23, which contain specific references to the same subject.

Esche, pp. 121–122, fig. 30 (*verso*). O'Malley-Saunders, 122, 130. Rouvèyre, *Anat.* D, 14 (*recto* and *verso*). Royal Academy, 302 (*verso*).

19052 (B. 35)

RECTO

ABOVE

Two studies of the olfactory nerve, the optic nerve, chiasma, tract and nerves of the orbit.

BELOW

Diagram of the umbilical vessels and uterus.
With notes on the drawings above.

VERSO

Very faint outline of (?) female abdomen, in black chalk, showing some of the organs.

THE *verso* of the anatomical leaf in the Schlossmuseum at Weimar was once facing the *recto* of this folio. Stains on the *recto* and *verso* of both folios confirm that the two sheets were originally joined together. The two d's of the words *e ddone* in the last line of f. 35 *recto* have left an exact mark on the *verso* of the Weimar leaf. Moreover, there is continuity of subject matter and identity of style between the two folios. The architectural rendering on both folios of the cross-section of the head show the nerves of the olfactory and optic system: on f. 35 *recto* it is shown as a ground plan, in the *verso* of the Weimar leaf it is shown as an elevation, according to a system of 'exploded view' which Leonardo uses throughout Anatom. MS. A. The *recto* of the Weimar leaf contains a female figure in front view of the same type as that in profile on

19095 *verso* (C. III. I), which was formerly joined to f. 37 (19054).

Esche, p. 122, fig. 58 (detail of *recto*). O'Malley-Saunders, 148. Pedretti, *Raccolta Vinciana*, xx, 1964, p. 350 ff., fig. 5. Rouvèyre, *Anat.* D, 15 (*recto* only).

19053 (B. 36)

RECTO

Study in black chalk of the intestines with outline of male figure slightly indicated.

VERSO

R.U.

Small study of pelvic blood vessels.

BELOW

Two very faint drawings, in black chalk, the one on the right is unidentified. According to O'Malley-Saunders the one on the left may be of the rectum, but cf. upper right 19052 *recto*.—The roofs of the orbits are intact in 19053 *verso*.
With notes.
Richter's No. 178.

THE drawing on the *recto* is similar to those on ff. 14 *recto* and *verso* (19031), and 22 *verso* (19039); a faint outline of the intestines is also on the *verso* of the preceding drawing.
On the *verso*, the drawing and writing above are slightly earlier than those below. Notes and drawings similar to those above are on f. 6 *recto* (19023), to which see note. Date, *c.* 1508. I am not able to suggest a folio to which this may have been originally joined.

Esche, p. 122. O'Malley-Saunders, 133 (*verso*), 186. Rouvèyre, *Anat.* D, 16 (*recto* and *verso*).

19054 (B. 37)

RECTO

Two studies showing the kidneys, three views of bladder and urethra, and a detail of entry of ureter into bladder.
A faint drawing in black chalk of the same organs as in 19070 *recto* (C. I. 13).
With notes on the drawings.
The letter .I. in sixteenth-century writing.

VERSO

RIGHT

Schematic study of thoracic and abdominal organs, separated by the diaphragm and related to the spinal column, probably pig.

LEFT

Study of the structure of the lungs, probably of a pig, seen from the front.
With notes on the drawings.
Richter's No. 206.

THIS must be seen together with 19095 (C. III. I), to which it was probably joined. On its *verso* are five ink spots which have left corresponding marks on the *recto* of 19095. As the sheet thus recomposed is turned around the connexion appears obvious in terms of subject matter, but there is no physical evidence of it.
The drawings on the *verso* as well as those on 19095, are a good example of Leonardo's pen style after 1500, with square hatching, line of shading following form, etc. It may appear strange that studies of the organs of generation should come next to studies of the action of lungs, stomach and diaphragm. This, however, can be seen in folios of Anatom. MS. C. III, e.g. ff. 8 *verso*, 10 *verso*, etc. See also 19034 (B. 17). Date, *c.* 1508–9.

Esche, pp. 122–123, figs. 26 (*verso*), 67 (detail of *recto*). O'Malley-Saunders, 171 (*verso*), 190. Pedretti, *Raccolta Vinciana*, xx, 1964, p. 350 ff. Richter, §817. Rouvèyre, *Anat.* D, 17 (*recto* and *verso*).

19055 (B. 38)

RECTO

Studies of the pregnant uterus of the cow. Note the foetus in the lower one, U.L. diagram of cotyledons of placenta. R. margin foetal blood vessels and detail of placental separation from uterus.
With notes on the drawings.
The letter .S. in sixteenth-century writing.

VERSO

Nine studies of the mouth, and movements of lips.
One small drawing of the uterus of the cow with foetus. A very faint sketch of (?) embryology in black chalk.
With notes on the muscles of the mouth.
Richter's No. 128.

SEE note to f. 29 (19046).

Esche, p. 123, figs. 111 (*verso*), 148. O'Malley-Saunders, 180 (*verso*), 211. Pedretti, *Gioconda*, pl. 6a (detail of *verso*). Rouvèyre, *Anat.* D, 18 (*recto* and *verso*).

19056 (B. 39)

RECTO
Blank.

VERSO

Very faint drawing in black chalk of the muscles of the knee.

Esche, p. 123.

19057 (B. 40)

RECTO

Two drawings of the skull seen from the left, the one below squared for proportion.
With notes on the drawings.

VERSO

ABOVE

Drawing of the right side of a skull.

BELOW

Drawing of the right side of a skull, showing relation between the orbit and maxillary antrum.
With notes on the drawings.

SEE note to f. 24 (19041).
Both sides are of the earliest group, 1489.
The upper skull on the *recto* freely engraved by Hollar, Parthey 1774, the head not shown in section. Dated 1645.

Bodmer, pp. 175 (*verso*), 176. Esche, pp. 123–124, figs. 11, 12. MacCurdy, *Notebooks* 1 pl. 4. O'Malley-Saunders, 4 (*verso*), 7. Poggi, pl. CLXIX (*recto*, reproduced as if on same sheet as 19058 *verso*). Popham, pl. 217. Royal Academy, 285, 287. Windsor, *Selected Drawings*, pl. 22.

19058 (B. 41)

RECTO

A skull viewed obliquely from above and the left to show intracranial nerves and vessels.
With notes on the importance of the cranium as the seat of all nervous activities.
The letter .F. in sixteenth-century writing.

VERSO

Drawing of two halves of a skull, showing relations of the different facial cavities, orbit, and cheek, and nose seen from in front; note frontal and maxillary sinuses and naso-lacrimal canal.

TO THE LEFT

Small drawings of different kinds of teeth.
With notes.

THESE belong to the earliest period, 1489.
The *recto* was engraved by Hollar, Parthey 1773, and dated 1651.

Bodmer, p. 176 (*verso*). Clark, p. 76, pl. 29 (*verso*). Esche, p. 124, figs. 13, 14. Heydenreich, pl. 183. O'Malley-Saunders, 3 (*verso*), 6. Poggi, pl. CLXX (*verso*), and part of pl. CLXIX (*verso*). Popham, pls. 218, 219. Royal Academy, 284 (*verso*), 286.

19059 (B. 42)

RECTO

Two drawings of the cranium showing the blood vessels of the face, that above turned three-quarters to the right, that below in profile to left.
With a note in the middle concerning the veins of the face, and above the date:

a dj 2 daprile 1489

to which the inscription

(*del*) libro titolato de figura vmana

was added with a different pen and ink some twenty years later.
The letter (?). G. in sixteenth-century writing.

VERSO

Page of notes treating of different subjects for consideration in anatomy and physiology: i.e. which nerve causes movement of the eye, of the eyebrows, smiling, laughing, wondering; what are yawning, breathing, thirst, etc.

THIS was evidently one of the first leaves of the book in its original form. It is of course the note on the *recto* which gives us a date for all the notes and drawings of the earliest period in this sketch-book. Calvi, *Manoscritti*, p. 138, note 4, was the first to point out that this date only applies to a few folios. He suggested that the greater part of the drawings should be considered as dating from *c.* 1510, but the preceding entries show that 1506–9 would be accurate.

Beltrami, *Documenti*, No. 35 (dated note on *recto*). Bodmer, p. 175. Calvi, *Manoscritti*, p. 137 ff. Esche, p. 124, fig. 15. O'Malley-Saunders, 5. Popham, pl. 220. Richter, §§805 (*verso*), 1370 (dated line on *recto*).

ANATOMICAL MANUSCRIPT C

Numbering

All the anatomical drawings at Windsor, not previously published by Sabachnikoff as MSS. A and B, were published in six volumes under the following title: *Leonardo da Vinci, Quaderni d'Anatomia, fogli della Royal Library di Windsor; pubblicati da Ove C. L. Vangensten, A. Fonahn, H. Hopstock, VI vols., Christiania, 1911–1916.* I have referred to this publication as *Quaderni d'Anatomia.* In Volumes IV, V and VI the authors included a number of drawings which had already been mounted and taken their place in the series of inventory numbers 12275 to 12727. These are mentioned in the first volume of the Catalogue. But for the most part the drawings in the Norwegian publication were unmounted. These have been bound up in the order of the *Quaderni d'Anatomia* in one volume. The volume is known as Anatomical Manuscript C, and is divided into sections corresponding with the volumes of the *Quaderni d'Anatomia.* Thus C. I or II is equivalent to Volume I or II of the *Quaderni*; MS. C is also numbered throughout on the same system as MSS. A and B. Thus C. I. 1 = 19060; C. II. 1 = 19071, and so forth. Both numbers are given for each entry, and in the references to the drawings; but either by itself is sufficient for purposes of identification. Where a drawing occurs in the sequence of the *Quaderni d'Anatomia* which was previously mounted and therefore not in MS. C, the reference is given thus, *Quad. Anat.* vol. V, f. 6, i.e. 12603. The next entry will be C. V. 7, i.e. 19127.

Complicated as this system sounds, the reader will not find it at all difficult in practice.

Date

Each volume of the *Quaderni d'Anatomia* was made up of drawings dealing with the same problems of anatomy. This did not mean that the drawings were all done at the same time, and for most volumes it is impossible to give a general date. In such cases, the date of the particular drawing is given in a note to that entry. The following generalisations are possible:

Vol. I belongs entirely to the period 1508–9.

Vol. II is dated by a note on f. 7 *verso* 'on the 9th day of January, 1513'.

Vol. III contains drawings of widely different dates: e.g. ff. 2 and 3 are datable *c.* 1493–4; ff. 5, 6, 9, 10, and 11 are datable *c.* 1508 and ff. 7, 8, and 9 seem to be *c.* 1510–12.

Vol. IV. The more important drawings, ff. 1, 2, 3 are of about the same date as Vol. II, i.e. 1513; ff. 10 to 16 are of about the same date as Vol. I, i.e. 1509, or slightly later. The others are datable *c.* 1506–8.

Vols. V and VI. No general date can be given.

Size and medium vary and are given with each drawing.

C. 1

19060 (C. 1. 1)

28·5 × 19·7
Pen and ink.

RECTO

A study of blood vessels of the uterus and foetus, and a sketch of uterus, placenta and umbilical cord.

ABOVE

Notes on mechanical action and its application to human beings.

BELOW

Notes on the drawings.
The letter .A.

VERSO

Richter's No. 220.

FOLIOS 1 to 9 are marked .A. to .I. by a sixteenth-century hand, probably Melzi's. Folio 10 may also belong to this series, but has no letter. These form a group of studies on the action of the heart, lungs and diaphragm, and can be dated *c.* 1509. The notes on embryology on this sheet are developed in the slightly later sheets of C. III, i.e. 7, 8, 9 (19101, etc.). For the notes on mechanical action see note to folio 13 (19083).

Esche, p. 125, fig. 146 (detail). O'Malley-Saunders, 209. Rouvèyre, *Thor. et Abd.* 1.

19061 (C. 1. 2)

28·8 × 21·3

Pen and ink, on paper with the bull's head watermark. (Briquet, 14950–1.)

RECTO

Page of notes, transliterated in Richter, §§798, 822, on the arrangement of the book; the method of studying anatomy and physiology of the body; the study of the hand in particular and of the hands of animals.
The letter .B.

VERSO

Drawing of the spine and ribs, with an indication of some muscles used in yawning and sighing.
Two mechanical diagrams indicating how some of the power of these muscles is derived from leverage.
With notes on the muscles used in yawning and sigh-

ing, and on muscular action compared to that of levers.
Richter's No. 157.

THE notes on muscular action are developed in part in Anatom. MS. A, e.g. f. 10, etc., studies on the hand. Similar notes and programmes of representation are in the Codex Atlanticus, ff. 99 *verso*-a, 208 *recto*-b, and 260 *recto*-a, the latter not by Leonardo but crossed out by him: *segna tuti i muscholi che moueno le dita in che parte naseno nele brace.* All these folios date from *c.* 1590–10 and are certainly related with the memorandum in MS. F, f. 95 *verso*: *anatomja. Quali neruj over corde della mano sõ | quelle che acchosstano e djsscostano li | djti della mano e de piedi lun dallaltro.* See also Anatom. MS. B. 8 *verso* (19025).

Esche, pp. 125–126. O'Malley-Saunders, 27 (*verso*). Richter, §§798, 822. Rouvèyre, *Thor. et Abd.* 2 (*recto and verso*).

19062 (C. 1. 3)

29·1 × 21·5
Pen and ink.

RECTO

Above, on right, a diagram of the atria and ventricles of the heart, based on Galen.
With notes on the ventricles of the heart.
The letter .C.
Richter's No. 181.

VERSO

To the right a small diagram of a hemisection of the heart.
With notes on the properties of the blood in the heart and function of upper and lower right ventricle.

O'MALLEY-SAUNDERS, *loc. cit.*, dissociate this, the following drawing and f. 6 *recto*, from the others of the group on the basis of what they call 'every evidence of having been composed in his final period, *c.* 1513'. The authors even point out that the first lines on f. 5 (19064) show Leonardo's intention to continue his notes on the heart with which he had filled f. 4 (19063), and that, failing to do so, he had filled the rest of the page with observations on the diaphragm. And they date folio 5 *circa* 1504–9. The style of the drawings, the writing and the page lay-out leave no doubt that all the sheets in this series date from *c.* 1509. See also note to the following drawing.

Esche, p. 126, fig. 128. O'Malley-Saunders, 91, 92. Rouvèyre, *Thor. et Abd.* 3 (*recto and verso*). Royal Academy, 294.

19063 (C. 1. 4)

29·4 × 21·1

Pen and ink.

RECTO

Page of notes on problems of the blood circulation, relationship of heart and liver, comparison of temperature of lungs and heart.

The letter .D.

VERSO

Page of notes on the action of the heart and a marginal reminder to write a discourse against students who impede and abbreviate the study of anatomy.

Richter's No. 164.

BOTH *recto* and *verso* contain notes expressing Leonardo's intention to write a discourse against students who impede and abbreviate the study of anatomy. The notes in C. II. 14 (19083) may well be a draft for such discourse. It is impossible to accept the theory put forth by O'Malley-Saunders, *loc. cit.*, that these notes and related drawings should date from after 1513, and that the references to 'abbreviators' should be recognised as a reflexion of Leonardo's difficulties in the Vatican. The term 'abbreviatori' used by Leonardo simply qualify the type of students he disapproved of, not the secretaries of the Vatican chancery. E. Solmi ('Leonardo da Vinci, il Duomo, il Castello e l'università di Pavia', *Bollettino della Soc. Pavese di Storia Patria*, XI, 1911, pp. 141–203) has shown that students of this type were causing serious disturbances in Pavia at the beginning of the sixteenth century. There is no reason therefore to dissociate these remarks of Leonardo from some circumstance which may have involved his friend Marcantonio della Torre, who was in fact professor at Pavia. See also note to C. V. 26 (19128).

The style of handwriting and the type of page lay-out closely resemble those of MS. D, especially ff. 5–6, thus confirming the date *c.* 1508–9. The ink is also identical: it also appears in C. IV. 10–16.

Esche, pp. 126–127. O'Malley-Saunders, 93, 94. Rouvèyre, *Thor. et Abd.* 4 (*recto* and *verso*).

19064 (C. 1. 5)

30·5 × 20·3

Pen and ink.

RECTO

ABOVE

Three drawings of the thorax and some of its muscles, including the diaphragm.

Two diagrams of elevators of ribs and one of inlet and outlet of thorax.

BELOW

Two diagrams to show the effect of actions of muscles of the ribs and diaphragm on intestines.

With notes on the action of the lungs and diaphragm.

The letter .E.

Richter's No. 166.

VERSO

Diagram of the diaphragm and stomach.

A very faint black chalk drawing of the muscles of the ribs, seen from in front and entirely covered by the writing.

With notes on the function of the diaphragm muscle and its relation to the stomach.

ACCORDING to Leonardo's plans of anatomical representations, the action of lungs, diaphragm, heart and stomach were to be considered all at the same time, and their interrelationship investigated. This is specified in Anatom. MS. B, f. 37 *verso* (19054), a sheet which was originally joined to C. III. 1 *recto* (19095), and the style of which is identical to that of the present drawing. Hints at such plans are found in MSS. of *c.* 1508–9, e.g. MS. F, *verso* of the front cover (*fa gonfiare il polmone d'un porco etc.*) which is related to Anatom. MS. B, f. 17 *recto* (19034), to which see note.

Esche, p. 127, figs. 114, 115 (details of *recto*). O'Malley-Saunders, 176, 177. Rouvèyre, *Thor. et Abd.* 5 (*recto* and *verso*).

19065 (C. 1. 6)

29 × 21

Pen and ink.

RECTO

Three small diagrams showing heart-beat and changes in the position of a pig's heart on wounding and after death from a wound.

With notes, discussing whether the heart changes its position at death or not.

The letter .F.

Richter's No. 169.

VERSO

ABOVE

Diagram of under-surface of diaphragm, and of respiratory changes in shape of abdominal cavity.

BELOW

Drawing of oesophagus, stomach and duodenum.
With notes on the action of the diaphragm and the stomach.

SEE note to f. 3 (19062). The sketch of a stomach on the *verso* is in the same style as the ones on the *verso* of the drawing of a Pharisee, C. III. 12 (19106), and so is the writing. Similar sketches of stomachs and alimentary tract are in 12282. See also Codex Atlanticus 223 *recto*, a large sheet of the 1509 type of geometrical studies, which contains a small drawing of the alimentary tract next to the drawing of two classical profiles probably after a medal.

Esche, pp. 127–128, fig. 177 (detail of *verso*). O'Malley-Saunders, 95, 178. Rouvèyre, *Thor. et Abd.* 6 (*recto* and *verso*). Royal Academy, 295.

19066 (C. I. 7)

29·8 × 21

Pen and ink. The paper shows the bull's head watermark.

RECTO

Two drawings of intestinal tract and one of vessels in foetus, umbilical cord and placenta.
With notes on the drawings.
The letter .G.
Richter's No. 200.

VERSO

Two small diagrams of relations of diaphragm and alimentary tract.
With notes on the drawings.

SEE note to the preceding drawing. Studies of the intestinal tract are in Anatom. MS. B, f. 14 *verso* (19031), etc.

Esche, p. 128, fig. 155 (detail of *recto*). O'Malley-Saunders, 187 (*verso*). Rouvèyre, *Thor. et Abd.* 7 (*recto* and *verso*).

19067 (C. I. 8)

28·6 × 20·2

Pen and ink.

RECTO

Drawing of thorax and some muscles of respiration.
With notes on the drawing.
The letter .H.

VERSO

Richter's No. 218b.

A DRAWING of similar subject is in Anatom. MS. B, ff. 27 *verso* (19044) and 30 *recto* (19047), two sheets which were originally joined together.

Esche, p. 128, fig. 125 (detail). O'Malley-Saunders, 28. Rouvèyre, *Thor. et Abd.* 8.

19068 (C. I. 9)

28·3 × 19·9

Pen and ink on paper with the watermark of a bull's head and flower. (Briquet, 14950–1.)

RECTO

Page of notes on dilating and extending motion of muscle, with a programme of discussing the function of the trachea in the creation of the voice. At the bottom of the page the words *Il sangue* in sixteenth-century handwriting (? Melzi's).
Richter's No. 159.

VERSO

The letter .I., otherwise blank.

THE programme of discussing the function of the trachea in creating the voice is undertaken in Anatom. MS. A, f. 3 *recto* (19002).

Esche, p. 128. Rouvèyre, *Thor. et Abd.* 9.

19069 (C. I. 10)

27·3 × 20

RECTO

Pen and ink.

Three diagrams of thoracic and abdominal organs, two include the urinary system.

C.L.

A sketch of foetal liver and umbilical vessels.

C.R.

A sketch of the heart and lungs.
Bottom right-hand corner, in blacker ink, a drawing showing the superficial muscles of the neck, and a note on the intention to investigate the function of the muscles which move the larynx in the creation of the voice.
With notes on the drawings.
Richter's No. 165.

VERSO

Black chalk.
Drawing of a disproportionally tall draped figure, apparently female.
L.L. Two rectangles.

R.U.

Slight sketch of a woman's face.

R.L.

Slight sketch of a man, standing with legs apart.
Also two geometrical drawings of cubes.

C.L.

Upper part of same full face.

THE writing is bolder and more spaced out than in the preceding sheets, but this is probably part of the same series. Most of the notes are reminders as to subjects to be treated, especially embryology. Thus, same date as the preceding, c. 1509. The drawings on the *verso* are not by Leonardo.

Esche, p. 128 (erroneously given as 19080). O'Malley-Saunders, 123. Rouvèyre, *Nerfs et Viass.* 13 (*recto* only).

(C. I. 11) is 12280 (*recto* and *verso*).
(C. I. 12) is 12281.

19070 (C. I. 13)

32 × 22, a large part being torn out of the lower right-hand side.
Pen and ink on paper with watermark of the bull's head and flower. (Briquet, 14950–1.)

RECTO

Drawing of a man, rising from the ground. Sketch and three diagrams of intestines and vessels including portal veins.
Below, five drawings in black chalk of scalpels and hooks for dissection, and a pen and ink sketch of an eye.
With notes on the constitution of man, and on rising from the ground.
Richter's No. 167.

VERSO

TOP RIGHT

Small drawings of the skull, nervous system and vessels, especially with relation to the eyes; and diagrams of maternal and foetal blood vessels.
Many notes, most of them transliterated in Richter. The notes concern anatomy, memoranda, general reflexions, particularly on the difficulties which any-one but Leonardo must encounter when studying anatomy.

SIZE, writing and style are so close to C. IV. 10 (19115) that the two sheets may have been originally joined together, just as C. IV. 11–12. (On the right margin of C. IV. 10 *recto* are two tears corresponding exactly with the gap of this sheet.)

The sketch of a man rising from a sitting position and the note to it on the *recto* are developed in the lost *Libro A, 36*. The notes on the *verso* contain a number of clues pointing to a date c. 1508. These are:
(1) Drawings of the cerebral ventricles and cranial nerves with which compare 12602 and related drawings.
(2) A sketch of the heart and vascular tree which is related with 12592.
(3) Notes on the action of the lungs and diaphragm which recall the C. I. series, ff. 1 to 9.
(4) A note on the philosophy of the 'mental matters' (compare last paragraph of the first chapter of the *Treatise on Painting*) which leads to an attack against necromancers and enchanters, as in the celebrated passage in Anatom. MS. B, ff. 31 *recto*–30 *verso*.
But most important of all are the lists of memoranda given in Richter §1434. Leonardo's lists of personal effects usually occur in the proximity of a journey. As the occasion of his trip to Rome in 1513 would be too late, these probably refer to his last trip from Florence to Milan in the spring of 1508. It is impossible to say whether the item *fa tradurre Avicenna de giovamenti* was entered in Florence or in Milan. Avicenna was taught at the University of Florence by a physician of the hospital of Sta Maria Nuova, Andrea Cattaneo da Imola, whom Leonardo mentions as his opponent in the Codex Leicester, ff. 1 *verso* and 36 *verso*. Other references to Avicenna are in MS. F, *verso* of the cover, in Anatom. MS. A, f. 18 *recto* and in C. III. 3 *verso* (19097).
It is in this folio that Leonardo writes about having composed 120 books (i.e. chapters) of anatomy, a statement with which is probably related the memorandum: *fa legare li tua libri di notomia* (have your books of anatomy bound).
What O'Malley-Saunders call a cryptic statement, *da le misure colle dita del morto*, is explained by a note in Anatom. MS. B, f. 37 *verso* (19054): *desscriuj tutte le altezze ellarghezze delle intesstine elle mjsura addjta e mezzi e tterzi djtj della mano del morto* . . . See also note on f. 11 *verso* (19028).
Another item of importance is the reminder: *Il libro della scienzia delle machine va inanzi al libro de' giovamenti.* This is repeated in Anatom. MS. A, f. 10 *recto*: *fa che 'l libro delli elementi machinali colla sua praticha vada inanti ala dimostratione del moto e forza dell'omo e altri animali e mediante quelli tu potrai provare ogni tua propositione.* An early plan for such book of *elementi machinali* is in Codex Atlanticus 155 *verso*-b, c. 1500, on the *recto* of which is a similar plan for a treatise of anatomy and painting: *la qualita delle menbra | rilievo | attitudine | conponimento | sito*, each item with ramifications of subdivisions into related subjects not yet written in. Finally, a note in Codex Atlanticus 81 *verso*-b, c. 1508, headed *Elementi machinali*, deals with the relationship impetus-resistance and ends with the remark: *e di questo si*

farà un trattato. This is also of importance for the chronology of Leonardo's anatomical studies. In fact the *recto* of this folio of the Codex Atlanticus contains the anatomical sketch of a human torso seen from behind, with the spine removed, just as in C. III. 10 *recto* (19104) and C. IV. 15 *recto* (19121).

Esche, p. 130, fig. 59 (detail of *verso*). O'Malley-Saunders, 146 (*verso*). Pedretti, *Libro A*, p. 48, and *Studi Vinciani*, p. 155. Richter, §§7, 796, 1434 (*verso*). Rouvèyre, *Anat. B*, 7 (*recto* and *verso*).

C. II

19071 (C. II. 1)

28·6 × 20·2

Pen and ink on blue paper.

RECTO

Semi-schematic drawing of bovine heart, great vessels and bronchial tree. Details of trachea and effects of respiration on it.
With numerous notes on the action of the heart.
The letter .A.

VERSO

Sketch of human heart and main vessels, in black chalk.
Richter's No. 229.

THE letter .A. on the *recto* is in the same hand as the letters .B.B. on 12613, etc. (to which see note), which shows that these two sets of anatomical drawings on blue paper were at one time regarded as complementary parts of a series. They are, of course, widely different in date, the 12613 series being the earliest (*c.* 1486) and this being the latest (1513) of all Leonardo's anatomies. The same hand (probably Melzi's) has also written the letters .A. to .I. in the first nine sheets of C. I.

It would be interesting to ascertain whether this type of blue paper, which seems to be of Venetian origin, was produced before *c.* 1510; as there is in fact no evidence of its having been employed before this time not only by Leonardo but by any artist. And yet it was soon to become very popular with Giovanni da Udine and was used by Venetian artists, e.g. Tiepolo, throughout the eighteenth century.

Esche, p. 132, figs. 129, 160 (detail). Heydenreich, pl. 197. O'Malley-Saunders, 173. Rouvèyre, *Cœur*, 1 (*recto* and *verso* interchanged). Royal Academy, 301.

19072 (C. II. 2)

28·1 × 20·7

Pen and ink on blue paper.

RECTO

U.C.

Faint outline in black chalk of trachea and bronchi.
Six studies of trachea and blood vessels.
Diagrams of effects of respiration on bronchi.
With notes on function.
The letter .B.
Richter's No. 115.

VERSO

Schematic drawing of bovine heart and pulmonary vessels from behind. To right, a rough sketch of the trachea and right bronchus.

TOP RIGHT

Rough sketch of lungs and heart with open ventricles.
With notes on the heart and its ventricles.
Both are based on Galen's views.

ABOVE the drawing of the heart on the *verso* is scribbled an asterisk. In the first edition of this catalogue I referred to this as Leonardo's own mark, but it is more likely to be a reader's mark, probably Melzi's, as it occurs in other anatomical MSS., sometimes in a simpler form. See Volume I, Table IV, *Sixteenth Century Reader's Marks to Anatomical Texts*. As it was with a similar mark (i.e. ø) used by the compiler of the Codex Urbinas to countersign Leonardo's original notes on painting, it might be that a compilation of Leonardo's anatomical studies was also envisaged in the sixteenth century.

Below the asterisk is written: *fa prima la chassula*. In the *Quaderni* edition *chassula* is translated 'cardiac purse' and in O'Malley-Saunders, *loc. cit.*, 'capsule'. G. Favaro, *loc. cit.*, has shown that although Leonardo's predecessors (Mondino) and contemporaries (De Zerbi) used this term to indicate the cardiac purse (*c. cordis, pericardia*), Leonardo may have identified cassula with ventricle; compare C. IV. 14 *verso* (19118): *. . . panjchulo che vesste la cassula over ventrichulo*. See also Anatom. MS. B, f. 37 *verso* (19054): *richordati di fighurare il mediasste cholla chassola del chore cō 4 dimostrationj*, etc.

Esche, p. 132, figs. 132 (detail of *verso*), 156 (detail of *recto*). Favaro, *Atti del Reale Istituto Veneto di Scienze, Lettere ed Arti*, LXXIV, Pt. II, 1914–15, pp. 898–899. O'Malley-Saunders, 88 (*verso*), 174. Rouvèyre, *Cœur*, 2 (*recto* and *verso* interchanged).

19074 and 19073 (C. II. 3 and C. II. 4)

41 × 28

Pen and ink on blue paper.

19074 (C. II. 3)

RECTO

Twelve diagrams illustrating the mechanism of the ventricles of the heart, with notes on the drawings.
The letter .C.

VERSO

Two drawings of the heart, probably of an ox, one from the left, the other from the right, and three diagrams demonstrating the function of the ventricles and one of a branched structure (? bronchial tree).
With notes on the drawings.

19073 (C. II. 4)
RECTO (C. II. 4, *verso*)

Four sections of ventricles of the heart, with notes on the drawings.

R.L.

Diagram demonstrating cardiac impulse, according to Galen's theory of ebb and flow.

VERSO (C. II. 4, *recto*)

Ten drawings on varying size of the heart, and details of semilunar valves, with notes on the drawings.
The letter .D.

THIS, which was originally folded, is now mounted as one sheet, but is treated as two in the *Quaderni d'Anatomia*. See also ff. 19 and 20 (19089).
In the middle of f. 4 *recto*, i.e. 19073 *verso*, near the left margin, are two sketches in pen and ink, almost invisible in the original, which at first may appear anatomical details. Professor Pedretti believes that they represent the first two emblems of 12701, i.e. the one of the plough and that of the compass. Their presence on a sheet of *c.* 1513 would confirm the later date now given to 12700, '701, etc. Compare also 12282, which contains two anatomical sketches.

Chastel, p. 45 (reproduced open flat). Esche, pp. 132–135, figs. 130 (4 *recto*), 131 (detail of 3 *verso*), 138 (detail of 4 *verso*), 141 (3 *recto*), 168 (detail of 3 *verso*). O'Malley-Saunders, 86 (3 *verso*), 87 (4 *recto*), 96 (4 *verso*), 106 (3 *recto*). Popham, pl. 249 (3 *verso*). Rouvèyre, *Cœur*, 3 (*recto* and *verso* interchanged), 4 (*recto* and *verso* interchanged). Royal Academy, 300 (3 *verso*).

19075 (C. II. 5)
27·4 × 20·4
Pen and ink on blue paper.

RECTO

The letter .E.
Richter's No. 117.

VERSO

Highly schematic drawing of skeleton and posterior muscles of head, neck and shoulder girdles; two diagrams of muscles attached to spines of vertebrae; and two small studies of skull and cervical spine. Notes on the drawings and on the majesty of anatomical studies.

A GOOD example of Leonardo's latest pen style. See p. xxix of the Introduction to Vol. I.
According to Esche and Heydenreich (*loc. cit.*) this should be considered as Leonardo's latest anatomical drawing, probably done in France, when Leonardo was still using this type of blue paper and a very broad pen as in 12470, to which see note. But there is really no difference of style, and the ink and paper are of the same type as in the other sheets of the series. Compare 19085 (II. 15), which contains notes on related subjects. See also note to 19082 (II. 12).

Clark, p. 160, pl. 59. Esche, p. 134, fig. 175. Heydenreich, pl. 200. MacCurdy, *Notebooks*, I, pl. 7. O'Malley-Saunders, 18. Popham, pl. 252. Rouvèyre, *Cœur*, 5. Windsor, *Selected Drawings*, pl. 52.

19076 (C. II. 6)
27 × 19·4
Pen and ink on blue paper.

RECTO

Sheet of notes on the art of painting.
Other way of paper: the letter F.

VERSO (upside down)

Studies of the thorax of man and ox, with details on a larger scale, and notes on the drawings. Five geometrical figures of movements of ribs and a note on light and shade.
Unidentified object upper right, cf. drawing of sphincter, 19095r.
Richter's No. 232.

THE notes on painting on the *recto* are in a smaller and neater hand than those in the rest of the book. But this is no reason to give this drawing a date other than 1513. O'Malley-Saunders, *loc. cit.*, date the *verso* *c.* 1504–6, because its figures and notes 'appear to be preliminary studies leading to the ideas expressed on 27 [i.e. C. I. 2 *verso*] and 32 [i.e. C. IV. I *recto*]'. But this is not the case. In their comment to a related drawing, C. I. 2 *verso* (19061), the authors remark that Leonardo's opinions on the action of the muscles involved in the respiration 'were very uncertain and changed from time to time'. Thus it is impossible to suggest any sort of logical development in his discussions on the subject. Again, a date must be suggested on the ground of style alone, and in this case

on the consideration that this drawing is part of a series dated 1513.

Notes on painting, in particular on light and shade, appear in other folios of this series, e.g. ff. 16 *recto*, 17 *recto* and 18 *verso*, and are related with those on a large series of blue sheets in the Codex Atlanticus and with those in MS. E. Cf. Pedretti, *Libro A*, pp. 19, 146–51. It is in one of these notes that Leonardo reminds himself to reserve to the last chapter of his Book on Light and Shade *le figure che apariano nello scriptoio di Gherardo miniatore in San Marco a Firenze*. The specification 'a Firenze' suggests that this reference to one of the cells decorated by Fra Angelico was written when Leonardo was still in Lombardy. See also note to 19092 (II. 22).

Esche, pp. 134–135. O'Malley-Saunders, 25 (*verso*). Rouvèyre, *Cœur*, 6 (*recto* and *verso* interchanged).

19077 (C. II. 7)

27·5 × 20·7

Pen and ink on blue paper.

RECTO

The letter .G.

Richter's No. 217.

VERSO

Three studies of the diaphragm, one in outline, and one of posterior wall of thorax of ox. Three left side views of human, one male, drawn to show the organs, in particular the intestines.

To left, the plan of a fortress at the bend of a river, from the banks of which several artillery posts are firing against it; almost indistinguishable from an anatomical study.

To right, various architectural studies, including the plan and elevation of a turret.

With notes on the action of the lungs on abdominal viscera, one note on the architecture mentioning a chamber in the turret of *Vaueri*, i.e. Vaprio.

At the top of the page a note which reads:

addj 9 dj giennaro 1513.

THE inscription on the *verso* gives us the last date found on any of Leonardo's anatomical drawings, and is most important for the chronology of his later work. See vol. I, Introduction, p. xxviii.

With the date January 9th, 1513 is associated an historical event which is recorded in the sketch of a besieged fortress. This is in fact the castle of Trezzo, near Vaprio d'Adda, and Leonardo even shows the trajectory of the besieging artillery of the Venetians, who overcame the defence of the fortress on January

5th, 1513. Beltrami, *loc. cit.*, reports the pertinent passage in Sanudo's *Diarii*, and juxtaposes the Leonardo sketch to an eighteenth-century drawing of the castle of Trezzo, which shows the winding of the Adda river in the identical S form as in Leonardo's drawing. The other architectural studies have been identified as related with the projects or ideas of an enlargement of the Villa Melzi at Vaprio as found in the Codex Atlanticus. Cf. Pedretti, *loc. cit.* On the *verso* of 19107 (C. IV. 1), to which see note, are architectural drawings pertaining to the same project.

Other references to Vaprio, again given wrongly in the *Quaderni* edition (i.e. *Vaneri* instead of the vernacular *Vaueri* or *Vavri* used by Leonardo) are on f. 22 *verso* (19092). Compare also 12667 *recto*, to which see note.

Beltrami, *Miscellanea Vinciana*, I. *L'espugnazione del castello di Trezzo nel gennaio 1513, in uno schizzo di Leonardo*, Milan, 1923. Esche, p. 135, figs. 122, 123 (details). O'Malley-Saunders, 179. Pedretti, *Architectural Studies*, pp. 66–70, figs. 30, 31 (details), and *Villa Melzi*, p. 233 ff., fig. 2. Richter, §§1376A, 1423 (the note with the date, and the note on architecture respectively). Rouvèyre, *Cœur*, 7.

19078 (C. II. 8)

28·3 × 20·7

Pen and ink on blue paper.

RECTO

The letter .H.

Richter's No. 118.

VERSO

A number of stylized drawings of the valves and ventricles of the heart, with many notes which Leonardo has headed 'The geography of the heart'.

THE ink has a greenish tone as in many notes of Leonardo's late period. The heading is reminiscent of his intention to organise his anatomy as Ptolomy's Cosmography. Compare 19061 *recto* (C. I. 2). These drawings and especially those on 19080 (II. 10) suggest an architectural system of representation, which is stressed by the use of architectural terms: 'pariete di mezzo', 'porta del core', etc.

Esche, pp. 135–136, fig. 142. O'Malley-Saunders, 105. Rouvèyre, *Cœur*, 8. Royal Academy, 296.

19079 (C. II. 9)

27·9 × 20·4

Pen and ink on blue paper.

RECTO

The letter .I., and a small calculation.

VERSO

Seven drawings of semilunar aortic and pulmonary valves with notes on their action; and a sketch of a figure seated in a portable Turkish bath, with a note below. Just above the drawings of the valves, the other way of paper, is a black chalk drawing of the head of a man seen three-quarters to left.

ABOVE

Numerous calculations, in Leonardo's handwriting, but written from left to right, and the geometrical diagram of the slope of a river bed.
Richter's No. 161.

THE calculations and diagram may refer to Leonardo's studies on the canalisation of the Adda river, just as the similar but not identical ones in Codex Atlanticus 141 *recto*-c, 335 *recto*-a and 345 *recto*-b. Notes and drawings related with this problem are found on several sheets of blue paper in the same codex, e.g. f. 236 *recto*-b.

Esche, p. 136, fig. 134 (detail of *verso*, valves of the heart). Favaro, *Leonardo da Vinci, i Medici e la Medicina*, Rome, 1923, p. 55, fig. 6 (detail of *verso*, the Turkish bath). O'Malley-Saunders, 109. Rouvèyre, *Cœur*, 9 (*recto* and *verso* interchanged). Royal Academy, 297.

19080 (C. II. 10)

28·3 × 20·2

Pen and ink on blue paper.

RECTO

Studies, some architecturally stylized, of heart, probably ox, its valves, atria and ventricular orifaces; with notes on drawings.
The letter .K.

VERSO

On the lower right-hand corner a black chalk sketch of a human figure running to left.
Richter's No. 116.

THE scribble on the *verso* recalls Leonardo's illustrations to notes on painting. A similar figure is in the early MS. A at Paris, f. 28 *verso* (Pedretti, *Studi Vinciani*, p. 186).
See also note to 19078 (II. 8).

Esche, p. 136, figs. 145, 167 (detail). O'Malley-Saunders, 104, Rouvèyre, *Cœur*, 10 (*recto* and *verso* interchanged).

19081 (C. II. 11)

28·3 × 20·3

Pen and ink on blue paper.

RECTO

U.L.
Congenital defect of interatrial septum.

C.L.
Interior of right ventricle.

U.R.
Closed mitral and open aortic valves from above.

Notes on muscles of the heart, and its motion.
Below, a few words in red chalk.
The letter .L.

VERSO

The letter .H.
Richter's No. 227.

Esche, pp. 136–137, figs. 133, 139 (details). O'Malley-Saunders, 100. Rouvèyre, *Cœur*, 11 (as *verso*).

19082 (C. II. 12)

28·3 × 20·7

Pen and ink on blue paper.

RECTO

Notes on the valves of the heart and flow of blood within it, with illustrative drawings.
Drawing of a mould for the making of a glass model of the pulmonary or aortic valves.
Other way of paper: the letter .M.

VERSO

Richter's No. 226.

A REFERENCE to the construction of a glass model of the valves of the heart is in 19116 *verso* (C. IV. 11). See also f. 6 *verso* (19076).
Esche, *loc. cit.*, compares the style and technique of this drawing with those of f. 5 (19075) to suggest a later date, in Leonardo's Roman or French periods. This is closely related to the following drawing, to which it was probably joined: f. 12 *recto* being on the right and 13 *verso* on the left, so as to give the sequence .M. to .N. the other way of paper. The *verso* of f. 13 contains a small calculation as the *recto* of 19079, thus suggesting a relation with Leonardo's studies on the canalisation of the Adda river.

Esche, p. 137, fig. 139 (detail). O'Malley-Saunders, 110. Richter, §850. Rouvèyre, *Cœur*, 12 (as *verso*). Royal Academy, 290.

19083 (C. II. 13)

28·3 × 20·7

Pen and ink on blue paper.

RECTO

The letter .N., and a small calculation.
Richter's No. 225.

VERSO

Drawings of flow and eddies of blood in the heart, with notes on the drawings.

THE drawings recall those of the action of water and show Leonardo's continual delight in this sort of movement.

Chastel, p. 151 (*verso*). Esche, p. 137, fig. 143 (*verso*). Heydenreich, pl. 198 (*verso*). O'Malley-Saunders, 111 (*verso*). Rouvèyre, *Cœur*, 13 (*recto* and *verso* interchanged).

19084 (C. II. 14)

28·3 × 20·4

Pen and ink on blue paper.

RECTO

Two drawings of dissections of the heart and its ventricles, with numerous notes on the supremacy of mathematics, and on human weaknesses and folly, transliterated in Richter.
The letter .O.
Richter's No. 161.

VERSO

Blank.

Esche, pp. 137–138, fig. 135 (detail). O'Malley-Saunders, 97. Richter, §§844, 1157, 1210, 1358. Rouvèyre, *Cour*, 14 (as *verso*). Royal Academy, 291.

19085 (C. II. 15)

26·6 × 20·7

Pen and ink on blue paper, with traces of red chalk on the drawing of a man.

RECTO

Notes on the muscles of the heart.
Sketches of: heart and liver; small and large intestines; ? heart; trunk with thoracic and abdominal viscera; bones of right upper limb.
Below, a note on trajectories of an arrow and cannon ball, and a study of the back of head and shoulders of a man to show neck muscles.
The letter .P.

VERSO

Richter's No. 196.

ESCHE, *loc. cit.*, notes affinities between these studies on the action of the arm and those in other late MSS., such as Anatom. MS. A in general and C. III. 9 *verso* (19103) and C. IV. 14 *recto* (19118) in particular. Compare also C. V. 26 *recto*, to which see note. The head and shoulders of a man is drawn over red chalk with a black ink, similar to that on the afterthought head and neck in profile on C. I. 10 *recto* (19069).

Esche, p. 138. Rouvèyre, *Cœur*, 15 (as *verso*).

19086 (C. II. 16)

39·9 × 28·9

Pen and ink on blue paper.

RECTO

Notes mainly on the alimentary tract with illustrative diagram.
Below, to left, a diagram of the action of a bird flying, with a note to it; also two small sketches of the bird's bones; a faint sketch of dividing trachea amongst sketches on left. Notes on light and shade, one of which headed 'pictura' and illustrated by a diagram. A note on water.
The letter .Q.

VERSO

Inverted sketches: on left, of ribs and muscles; centre, attachments of quadratus lumborum; a male torso in flexion; two figures, one with flexed and other with extended knees; on right, outline of flexed abdominal wall.

Notes on the respiratory system, and a note on water.

THIS double sheet well reflects Leonardo's preoccupations at the time, the notes on painting, water and flight of birds being characteristic of MS. E, which is dated 1513–14.

Esche, p. 138. O'Malley-Saunders, 175 (*verso*).

19087 (C. II. 17)

28·6 × 21

Pen and ink on blue paper.

RECTO

Above, a note on light and shade.
Below, notes on anatomy, especially on the action of the heart, with illustrative sketches; and on right a three-quarters back view of standing nude male, facing to his right, with right arm raised.
The letter .R.

VERSO

Notes on the action of the heart, with four illustrative sketches of heart.
Richter's No. 228.

THE proportions of the Herculean figure on the *recto* are unusual for Leonardo; but this could be the same model as 12721 (a fragment out of 12671), and possibly 12658, to which see notes.

Esche, p. 139. O'Malley-Saunders, 98 (*verso*), 99. Rouvèyre, *Cœur*, 17 (*recto* and *verso* interchanged).

19088 (C. II. 18)

28 × 20·4

Pen and ink on blue paper.

RECTO

Very slight and faint sketch in black chalk of the blood passing through the ventricles of the heart.
The letter .S.
Richter's No. 230.

VERSO

A list of the components of the body, e.g. nerves, muscles, tendons, cartilages, etc. Description of the character of each, headed by Leonardo *definitione delli instrumenti*, the whole scored through with vertical lines in red chalk. Also slight sketch, perhaps illustrative of some problem of light and shade. A note on the origin of tears.

Esche, p. 139. Richter, §815 (two notes on the *verso*, erroneously given as *recto*). Rouvèyre, *Cœur*, 18 (*verso* only, as *recto*).

19089 (C. II. 19 and 20)

26·8 × 20·1

Pen and ink on blue paper.

RECTO

TOP

A right arm with elbow flexed, hand roughly sketched seen from the inner side showing muscles: above, a small back view of a seated figure.

BOTTOM

A note on the saltness of the sea, not in Leonardo's handwriting.
The letter .T.

VERSO

Blank.

IN the first edition the note on the saltness of the sea was said to be in Melzi's handwriting on the basis of a comparison with the draft of a letter in Codex Atlanticus 342 *verso*-d. (Cf. Calvi, *Manoscritti*, fig. 54). A note on human proportion in Codex Atlanticus 375 *recto*-c (a sheet of blue paper of identical format but with lacunae produced by the extraction of drawings) is written by the same hand. Pedretti (*Libro A*, p. 65, note 74) has shown that this is the handwriting of an assistant or pupil of Leonardo who kept the record of household expenses, beginning from *c*. 1505. This is also the author of the draft of a letter to *Cara mia diletta madre* in Codex Atlanticus 132 *recto*-a, dated July 5th, 1507: someone who writes from Milan to his family in Florence. This could not be Salai, whose family was in Milan. The only Tuscans in Leonardo's studio were Tomaso Masini, nicknamed Zoroastro, and Lorenzo, who entered Leonardo's studio in 1505, aged 17. All we know of this Lorenzo is that he followed Leonardo to Rome in 1513.

Esche, p. 139, fig. 93 (19 *recto*). O'Malley-Saunders, 54 (19 *recto*). Rouvèyre, *Cœur*, 19 (*recto* only, as *verso*), 20 (*verso* only, as *recto*).

19090 (not in *Quad. Anat.*)

26·2 × 19·4

Pen and ink on blue paper.

RECTO

The letter .V.
Richter's No. 193.

VERSO

A note on the motion of the winds.

THE note is summary and less scientific than those on 12671 and 12672, and so must be presumed to be slightly earlier.
This is wrongly given in *Quad. Anat.* as being on the *verso* of C. II. 19 (19089).

19091 (C. II. 21)

27·4 × 19

Pen and ink on blue paper.

RECTO

The letter .X.

VERSO

A feeble drawing of a clean-shaven classical head in profile to right, and a piece of machinery.

THE drawings on the *verso* are poor but authentic. The profile shows how little the contents of Leonardo's subconscious mind had changed during his lifetime.

The piece of machinery represents a simple device for the polishing of concave mirrors, and is to be found in Leonardo's earliest drawings (cf. Calvi, *Manoscritti*, figs. 8–11). The same machine appears to be developed in a large series of studies in the Codex Atlanticus, all on blue paper, e.g. ff. 364 *recto*-c, 371 *recto* and *verso*, etc. These are undoubtedly related with notes and drawings in MS. G, but the explanation of the device seems to be deliberately avoided. And yet it is possible to see that it must have something to do with the making of a burning mirror which utilises solar energy (cf. Codex Atlanticus 371 *verso*-a: *con questo si fara bollire ogni gran chaldara di tintoria . . .*), thus for industrial purposes. It appears that Leonardo carried on in Rome some project he had already undertaken in Lombardy, probably the mysterious *sagoma* for which he had the assistance of two German mirror-makers in the Belvedere of the Vatican.

Esche, p. 139.

19092 (C. II. 22)

26·3 × 26·2

Pen and ink on blue paper.

RECTO

The letter .Y.

VERSO

A list of memoranda, including a balance and flux of water at the mill of Vaprio (*vaurio*), these two items being illustrated by slight sketches. Below to left a note on dynamics.

THE memoranda are of special importance for the chronology of the series. The item *fa fare due casse dassoma* (have two baggage trunks made) is a hint that Leonardo is getting ready for a trip. Thus this should date shortly before September 25th, 1513, when Leonardo left Milan for Rome. The first item *andare in provisione per il mio giardino* is wrongly translated by Richter as 'To make some provision for my garden'. Under the French governorship Milan had an office of *provvisione*, i.e. an excise office, in charge of which was a Vicario. Cf. Codex Arundel, f. 74 *recto*, c. 1513: *sēpre intēdo avuer cōtradetto | 4 dj ināti al tēpo della s/spiratione al ujcario del/la provisione.* Leonardo's *giardino* was not a garden, but the vineyard at Porta Vercellina which he had received as a present from Lodovico Sforza and which he had leased to Salai's father. Concerning that property he must have had

some difficulties with the excise office. In a blue sheet of the Codex Atlanticus, f. 378 *verso*-a, b he writes: *va vedi se alla provisione effatta | altra grida sopra la tua vigna* (go, see whether at the excise office has been posted any other deliberation concerning your vineyard). The item referring to an experiment to be carried out at the mill of Vaprio and the mention of Boltraffio's lathe prove that Leonardo is still in Lombardy.

Esche, p. 139, Richter, §1436.

19093 (C. II. 23)

25·8 × 19·8

Pen and ink on blue paper.

RECTO

Notes on the heart, with four illustrative diagrams. Below to right, head and shoulders of a young man of the usual Leonardesque type in profile to right.

VERSO

Blank.

THE profile is carelessly drawn but is certainly authentic; except for a general coarsening of technique it is exactly like those of 12276 which must have been drawn over thirty years before. This is another proof of how difficult it is to associate this type with any individual, e.g. Salai, as Möller has done.

Berenson, 1163. Esche, pp. 139-140. Mal. Val. *Corte*, II, fig. 452. Möller, *Salai*, p. 149, fig. 206. O'Malley-Saunders, 103. Rouvèyre, *Cœur*, 16. Seidlitz, *l'Arte*, 155.

19094 (C. II. 24)

10 × 5·9

Pen and ink on blue paper.

RECTO

A drawing of a left foot, and a left foot and calf showing the muscles and tendons, with a note on their action.

VERSO

Richter's No. 215.

O'MALLEY-SAUNDERS, *loc. cit.*, suggest that this fragment may date earlier than the sheets of this blue series, because of a striking resemblance with the contents of Anatom. MS. A, f. 11 *verso* (19028). This is not impossible, since the fragment may have been cut out of one of the several blue sheets in the Codex

Atlanticus, which date from 1510 to 1515. But the problem here illustrated is also related with that of MS. E, f. 1 *recto*, which is dated September 25th, 1513. Compare also *Libro A 109*.

Esche, p. 140 (given as 'fol. 24—Windsor 1510–15', lapsus for 19094). O'Malley-Saunders, 77. Richter, §358, pl. xxii, No. 2. Rouvèyre *Anat.* E, 4.

C. III

19095 (C. III. 1)

19 × 13·7

Pen and ink over traces of black chalk.

RECTO

Above, drawing of external genitalia and vagina, with notes. Below, notes on the anal sphincter and diagrams of suggested arrangement of its fibres and its mode of action.

Richter's No. 156.

VERSO

To right: left side of standing female showing uterus in early pregnancy. Centre: rough and inaccurate anterior view of female genito-urinary system. Six small and inaccurate drawings of left side of male and female genitalia.

With notes on the drawings.

THIS sheet is out of MS. B, omitted by Piumati when he put that MS. together. In fact it was originally next to f. 37 (19055), to which see note. Female figures occur so rarely in Leonardo's drawings that it is worth noticing the type used in this purely scientific drawing. The carriage of the torso and the high, full breasts recall the proportions of the Leda. Compare also the Weimar sheet. Date, *c.* 1508–9.

Berenson, 1208 (19095–19103). Esche, pp. 140–141, figs. 63, 66. Eissler, pl. 39. O'Malley-Saunders, 200, 201. Pedretti, *Raccolta Vinciana*, xx, 1964, pp. 350–357, figs. 3, 4. Rouvèyre, *Génération*, 13 (*recto* and *verso*).

19096 (C. III. 2)

28·4 × 20·2

RECTO

Three sketches of coition of a man and woman. The two on the left, in red chalk, are small and slight. The red chalk has been gone over in black ink on the third, so that the details are clearer.

Above, sketches of weights and wheels, and calculations in a fainter, yellowish ink.

Richter's No. 155.

VERSO

Slight drawings of machinery for the excavation of canals, with details of its various parts, and two diagrams of the semi-circular excavation as seen from above. On the upper left, a topographical sketch of the canal stemming out of a winding river, and a diagram of optics; in a faint yellowish ink.

Below to right, two sketches of male and female sexual organs in coition: red chalk.

STUDIES of machinery for the excavation of canals occur at various periods of Leonardo's activity. appears in the Forster MS. iii, ff. 14 *verso* and 15 *recto*, the latter together with a draft of a letter concerning the Navilio di Martesana (Richter, §1343). See also ff. 17 *recto*, 18 *recto*, 23 *verso* of the same manuscript. Throughout this manuscript there are notes on the mechanics of levers, optics, and anatomical drawings (ff. 27, 23) related to 12603. See also note to the following drawing.

Esche, p. 141. Eissler, pls. 35 (*verso*), 36. O'Malley-Saunders, 205, 206. Rouvèyre, *Génération*, 6 (*recto* and *verso*).

19097 (C. III. 3)

27·3 × 20·2

Pen and ink.

RECTO

Anterior view of arteries, veins and genito-urinary system of an animal, probably horse; to left, a faint chalk drawing of spinal column with notes on dissection, and a note which reads:

quādo tu . aj finjto dj | cressciere lomo . ettu | faraj . lasstatua . chō tu|tte . sue . mjsure —— | superfitialj ——

Given in Richter, §802.

Richter's No. 151.

VERSO

Drawing of coition of hemisected man and woman. On the left, drawing of left side of a youth, showing the alimentary tract. Also two sections of the penis and a male torso squared for enlargement. Details of genitalia and nerves based on Galenic theories.

Many notes on generation.

THE writing suggests a date between that of MS. A (1492) and MS. H (1494). It is one of the very few anatomical drawings of this period which have come down to us. Compare 12597. The note on the *recto* transliterated above does not necessarily refer to the statue of Francesco Sforza as was suggested in the first edition, but is probably a reference to the building up of an anatomical model, or a series of such models. These would reproduce the various phases of human growth from childhood to manhood, recording the changes of proportion. There is no evidence that Leonardo ever built such 'statues', but there are early references to his intention to represent the various phases of human growth. Compare Anatom. MS. B, 20 *verso, c.* 1489: *Questa opera si debe principiare alla concezione dell'omo . . . e 'l suo accrescimento . . . da un grado d'acrescimento a un altro . . . quali membra sieno quelle che crescano . . . Poi descrivi l'omo cresciuto e la femina, e sue misure . . .* See also Codex Atlanticus 119 *verso-a, c.* 1490–2: *Del crescere dell'omo. L'omo in 3 anni arà conposta la metà della sua altezza . . .*

Evidence that Leonardo constructed anatomical models is in 12619: *fa questa ganba | dj rilieuo tonda he|ffa le corde dj fili dj | rame ricotto e poi | li piegha secondo | il naturale.* See also his note in the Ashburnham MS. of Francesco di Giorgio, f. 15b, *c.* 1508: *Nathomia. Il modello debbe esser facto chon bussto di ciera.* Cf. 12597.

The *verso*, which was engraved among Chamberlaine's *Original Designs* in 1812, has achieved considerable notoriety, and is certainly a remarkable instance of the way in which Leonardo struck at the centre of any problem which interested him. Soon after he seems to have abandoned his researches into the origin of life, and when he took them up again he concentrated more on the problem of embryonic life in the womb, cf. 19101 (III. 7), etc.

Esche, *loc. cit.*, suggests a comparison of the notes on the *verso* with a note in the Forster MS. III, f. 75 *recto* (Richter §1491), on Hippocrates' opinion about the cerebral origin of the human semen. O'Malley-Saunders date *recto* and *verso* respectively 1493 and 1500 without giving the reason for their dating the *verso* later. Handwriting and ink are identical on both sides of the sheet.

Agassiz, *De l'espèce et de la classification en zoologie*, Paris, 1869, p. 105. Broek, *Janus*, XXIV, 1919, pp. 85–100 (with repr.). Chamberlaine, Supplementary plate No. 4. Eissler, p. 142, pl. 28. Esche, p. 141, figs. 19 (*verso*), 20. Freud, *Un Souvenir d'enfance de Léonard de Vinci* (French transl. by M. Bonaparte), Paris, 1927, pp. 31–38, pls. I, II. O'Malley-Saunders, 117, 204. Peillon, *Etudes historiques sur les organes génitaux de la femme*, Paris, 1891, pp. 171–3 (with repr.). Reitler, *Intern. Zeitschrift für aertzliche Psychoanalyse*, IV, 1916–17, pp. 205–7 (with repr.). Richter, §§802 (note on *recto*), 841, 1482 (two notes on *verso*). Rouvèyre, *Génération*, 7 (*recto* and *verso*). Solmi, *Reale Accademia delle Scienze di Torino*, LIX, serie II, 1908, pp. 33–70. *Tabula Anatomica Leonardi da Vinci summi quondam e Bibliotheca Augustissimi Magnae Britanniae regis*, Lunaeburgi, 1830, plate. Uzielli, *Ricerche*, II, 1884, p. 24.

19098 (C. III. 4)

27·7 × 18·9

Pen and ink over black chalk.

RECTO

Blank.

VERSO

Study of lungs and heart, ? pig; pelvic blood vessels; arteries; a light sketch of vertebral column and right side of pelvis, and four studies of male reproductive organs, with notes on their action.
The letter .P.

THIS and the two following drawings are part of the same series as 12602, 12624, 19112 (IV. 7), and perhaps 19103 (III. 3), to which see note. Originally, this and f. 10 (19104) were joined together: the last word of the note in the middle of the page to right and the drawing above it have left an imprint on the *verso* of f. 10, thus the two sheets are reproduced together, folio 4 being on the left according to a trace of stitch indentation. Folio 10 *verso* now becomes 10 *recto*. Both sheets are marked with the letter .P. in sixteenth-century writing (Melzi's?). These drawings are related with several sheets of the Anatom. MS. B, e.g. f. 37 *verso*, to which 19095 (III. 1) was originally joined. They all date from *c.* 1508–9. See also the Weimar sheet, and Codex Atlanticus 249 *recto*-c.

Esche, pp. 141–142, fig. 65 (detail). Eissler, pl. 43. O'Malley-Saunders, 194. Rouvèyre, *Génération*, 5 (as *recto*).

19099 (C. III. 5)

26·2 × 18·7

Pen and ink over traces of black chalk, on white paper, with the watermark of a fleur de lys.

RECTO

Anterior view of a male torso showing genito-urinary system, liver, spleen and stomach.

To right, light sketch illustrating principle of fertilisation.

Below, bladder, penis, and right ureter and testis.
The letter .I.

Light sketch of the vertebral column, oesophagus and trachea, with a few notes on the drawing; and an unidentified sketch, perhaps a plant breaking out of a seed.

Richter's No. 174.

See note to preceding drawing. It is likely that this was also joined to another drawing. It would be interesting to ascertain that it was joined to 19114 (C. IV. 9), but all they have in common, besides paper and style, is the sixteenth-century mark .I. Date, *c.* 1508–9. A sketch resembling the one on the *verso* is in Codex Atlanticus 89 *recto*-a, a sheet of geometrical studies of *c.* 1510–13.

Esche, p. 142, fig. 28. O'Malley-Saunders, 195. Rouvèyre, *Génération*, 8 (*recto* and *verso*).

19100 (C. III. 6)

26·9 × 19

Pen and ink over traces of black chalk.

RECTO

Drawing of male reproductive organs; slight study and two details of testis, duct and vessel.

VERSO

Richter's No. 212.

See note to 19098 (III. 4). This must be considered together with f. 11 *verso* (19105), to which it was originally joined. The proof that the two sheets were together is not only in the identity of style and subject, but also in ink marks and compass holes produced by the geometrical figures on f. 11 *verso*. These belong to the 1509 series of geometrical studies. Compare 12658–19145, 12700, etc.

Esche, p. 142. O'Malley-Saunders, 196. Rouvèyre, *Génération*, 12.

19101 (C. III. 7)

30·1 × 21·7

Pen and ink, and as described.

RECTO

ABOVE

Two drawings of female external genitalia, seen from the front, the one to the right shows the supposed arrangement of abdominal muscles.

Two drawings of foetuses from the front, in pen and ink coloured with red chalk; below them, one shaded with black chalk, over pen and ink, shows the left side and indicates the uterus, and another much slighter in lighter ink, the right side.

To right, a small sketch of a foetus in uterine position, seen from in front.

Many notes on the drawings, on how a capon hatches eggs, and on the functions of the poet as opposed to the painter.

Richter's No. 152.

VERSO

Sections of the umbilical cord; a foetus in profile to right, and, below it, two drawings of the bones and tendons of right elbow and forearm.

BELOW

Seven drawings of foetal viscera, blood vessels and umbilical cord.

This and the following drawing must be considered together. They were probably joined together originally: the *recto* of 7 facing the *recto* of 8, since only in these two pages the child in the womb is shown coloured with red chalk. The notes and drawings on both *versos* are also identical in style. The only evidence of a correlation other than stylistical is an ink spot on top left which seems to have been produced by a darker one on top right of 8 *recto*. Sketches of embryology to be related with details in these sheets are found in folios of the Codex Atlanticus dating from 1513–14, i.e. ff. 95 *recto*-a (parent sheet of 19125 and 19126), 119 *recto*-b (archaeological studies at Civitavecchia, *c.* 1514), and 385 *recto*-a (blue paper). But these large drawings cannot be dated in Leonardo's Roman period, after 1513, because a memorandum on top of f. 7 *recto*, inscribed in a classical tablet, refers to a Milanese person: *Dimanda la moglie di biagin Crivelli come il cappone alleva le oua della ghallina essendo lui inbriacato.* (Cf. G. Favaro, 'Leonardo e l'embriologia degli uccelli', *Raccolta Vinciana*, x, 1919, pp. 141–151.) Compare 19069 (C. I. 10): *ma farai prima la notomia delle ova covate.*

The notes transliterated in Richter are at the top and bottom of the *recto*. That at the bottom, which concerns painting, has two lines which Richter, §658, had not given in his first edition, one because it is almost illegible, the other because it is is in a different column. These add greatly to the force of the passage. In the passage on proportion, in the middle of the page to left, the text is mutilated and given in the *Quaderni* edition as *. . .fontanella dell-u . . . | la allanulo . . .* and translated by O'Malley-Saunders, *loc. cit.*:

... from the fontanelle of the [. . .? costal angle] to the anus . . . It should be corrected as follows: 'fontanella della [go]/la allanulo'.

Datable *c.* 1510–12, see Vol. I, Appendix C, p. xlviii.

Esche, pp. 142–143, figs. 92 (detail of *verso*), 152 (*recto*), 153 (*verso*), 157 (detail of *verso*). Eissler, pl. 40. O'Malley-Saunders, 213, 214. Panofsky, *Renaissance-Dämmerung*, p. 153, fig. 13. Pedretti, *Libro A*, p. 124 (the note on the *Paragone*). Popp, p. 52, pl. 71 (detail of *recto*). Richter, §§658, 1432 (two notes on *recto*). Rouvèyre, *Génération*, 1 (*recto* and *verso*).

19102 (C. III. 8)

30·1 × 21·4

Pen and ink, and as described.

RECTO

A large drawing of an embryo within a human uterus with a cow's placenta, in pen and ink and red chalk, and a smaller sketch of the same. Numerous notes on this subject and some illustrative drawings in detail of the placenta and uterus, one of which is in red chalk gone over with pen and ink.

R.L.

Diagram demonstrating binocular vision.

Also a note on relief in painting and a note on mechanics.

Richter's No. 153.

VERSO

ABOVE

A note on light and shade, not in Leonardo's hand, illustrated by two coarsely drawn diagrams.

IN THE CENTRE

Numerous notes on reproduction; with sketches of a foetus in utero; left side of a foetus with cord; three drawings of foetal liver, stomach and umbilical vein; to the right, sketches of chick embryo and membranes and front view of a small male figure.

BELOW TO RIGHT

A note on generation in yet another hand.

DATABLE *c.* 1510–12. See note to preceding drawing. If the memorandum on the *recto*: *libro dell'acqua a messer Marcho antonio* refers to Della Torre, these drawings should be dated before 1511, the year of his death. The note on the effect of relief in painting, bottom right, may be related with the studies of binocular vision in MS. D (cf. Pedretti, *Libro A*, p. 139).

The four lines and two diagrams on top of the *verso*

are by Melzi. It would be interesting to identify the writer of the note at the bottom of the *verso*, as we have no other evidence that Leonardo's pupils made so deep a study of anatomy. Pedretti, *loc. cit.*, suggests the possibility that this was written by the anonymous author of the Codex Huygens.

Clark, p. 160, pl. 59. Esche, pp. 143–144, figs. 151, 154. Eissler, pl. 31 (detail of *verso*). Heydenreich, pl. 199. MacCurdy, *Notebooks*, 1, pl. 8. O'Malley-Saunders, 210, 215. Pedretti, *Libro A*, p. 105, pl. 19 (*verso*). Popham, pl. 248. Richter, §§29, 818, 1433. Rouvèyre, *Génération*, 2 (*recto* and *verso*). Royal Academy, 298.

19103 (C. III. 9)

28·5 × 20·6

Pen and ink over traces of black chalk, on dirty white paper, frayed at bottom.

RECTO

Blank.

VERSO

Studies of bones of a right arm, one half raised, forearm pronated in upper one, with notes on muscular action; to left, a black chalk study of the skeleton and vessels of a right leg, entirely covered by two studies of an embryo within the uterus, with notes comparing its nourishment to that of seeds in plants, a chicken in an egg, etc. Also numerous sketches of uterine wall and cotyledons of (cow's) placenta.

Richter's No. 154.

THE studies of an embryo are clearly of the same date as those on the preceding pages (*c.* 1510–12); those of a skeleton arm appear earlier, and O'Malley-Saunders date them *c.* 1505. There is evidence that around 1513 Leonardo was still considering both subjects concurrently. See note to 19128 (C. v. 26). The handwriting of the note on muscular action also looks earlier than 1513, and although Leonardo often uses two different types of handwriting at about the same time, I am inclined to think that it must date from *c.* 1510. Compare Anatom. MS. A, f. 8 *verso* (19007).

Esche, pp. 144–145, figs. 91, 149 (details of *verso*). O'Malley-Saunders, 212. Rouvèyre, *Génération*, 3 (as *recto*).

19104 (C. III. 10)

28·2 × 21·6

Pen and ink over traces of black chalk, on dirty white paper, frayed at bottom.

RECTO

A note on how to draw the lungs, in pen and ink, with an illustrative sketch in black chalk, this being a tracing from the *verso* to show the organs from behind. To the right, a black chalk drawing of a left thigh and leg seen from the back at the same angle as the one on the left in 19036 *verso* (B. 19).
Richter's No. 129.

VERSO

Two highly schematic drawings of heart and pulmonary vessels, one with liver and spleen; diagram of trachea and intra-pulmonary bronchi, and one of great vessels, heart, liver, spleen and male genitourinary system. The pulmonary circulation is erroneous and attributable to Galen's teaching.

Also numerous explanatory notes, that c.u. in black chalk.

The letter .P.

ORIGINALLY joined to 19098 (III. 4), to which see note.

Esche, pp. 145-146, fig. 25 (*verso*). Favaro, *Emporium*, XLIX, 1919, pp. 280-281, fig. 1 (detail of *recto*). O'Malley-Saunders, 172 (*verso*). Rouvèyre, *Génération*, 4 (*recto* and *verso*).

19105 (C. III. 11)

27·5 × 20·8

Pen and ink, over traces of black chalk, on white paper, with a fleur-de-lys mark.

RECTO

Richter's No. 213.

VERSO

Notes on geometry, with illustrative diagrams. Below, six sketches of the male bladder and one of penis, with a note.

ORIGINALLY joined to 19100 (III. 6), to which see note.

Esche, p. 146. Eissler, pl. 38. O'Malley-Saunders, 197. Rouvèyre, *Génération*, 9.

19106 (C. III. 12)

14·5 × 20·5

Pen and ink on dirty white paper, with accidental touches of red on the man's beard.

RECTO

To right, the head and shoulders of a bearded man wearing a sort of turban, in profile to right.

To left, five sketches of interlaced twigs apparently designed as decoration for the hem of a bodice. In three instances these are oak twigs with leaves and acorns. Also some small diagrams, and notes on physics and loading ships.

VERSO

Sketches of reproductive organs; lower right corner there are four inverted drawings of oesophagus, stomach, duodenum and jejunum; a ground plan of a house; notes and diagrams on the waves of water and sound; sketches of machinery; three sketches of an emblem, showing the sun and a sun-dial. All the notes correctly transliterated in *Quaderni d'Anatomia*, with the exception of the motto for the emblem, which is given as *o sparto le mie ore* instead of *sol per te le mie ore son generate*.

IN the first edition of this Catalogue I suggested that the head on the *recto* could be a study for one of the Pharisees in the cartoon of Christ in the Temple which Leonardo seems to have undertaken for Isabella d'Este in 1504 (see note to '524). This theory is accepted by Goldscheider, who reproduces the head pl. 7 of the Phaidon Press *Leonardo*. But the style resembles that of 19102 (III. 8), etc., which would give a later date, *c.* 1510. It is interesting, although perhaps no more than coincidence, that an entry in a memorandum on the *verso* reads: *lunedì in domo*. A document of the fabrica of Milan Cathedral (Beltrami, *Documenti*, no. 215) proves that Leonardo was at a meeting held on October 21st, 1510, to discuss the projected stalls in the choir of the cathedral. The document specifies that that day was a Monday.

Both the sketches of interlaced twigs on the *recto* and the emblem on the *verso* may relate to the series '700, '701, etc., especially as the motto, in its correct reading, underlies the concept of desire for service. Esche (*loc. cit.*) relates the small sketches of the stomach on the *verso* to similar ones in 12282 *verso*, thus suggesting a relationship between the two drawings also by the way of the vegetal motifs of decoration occurring in both. Such motifs also occur in the emblems in Codex Atlanticus 68 *verso*-b (*i pensieri si voltano alla speranza*), again a folio dating from *c.* 1508.

The notes on ships, water and air on the *recto* relate to MS. G and to 12654, 12667, etc. Diagrams of the circular propagation of waves in water similar to the ones on the *verso* are in Codex Atlanticus 83 *verso*-b, the parent sheet of the Trivulzio fragment 12353 (*Windsor Fragments*, pl. 6). According to O'Malley-Saunders (*loc. cit.*) the sketches of the male and female organs of generation are similar, and likely preliminary to those on 19095 *verso* (III. 1), i.e. the sheet originally of Anatom. MS. B which contains the Leda-type profile of female figure.

Comm. Vinc. fasc. v, pl. 204, i (*recto* only). Esche, p. 146. Goldscheider, pl. 7 (detail of *recto*). Mal. Val. *Corte*, ii, fig. 551. O'Malley-Saunders, 207 (*verso*). Pedretti, *Architectural Studies*, pp. 64–65, fig. 28 (detail of *verso*). Popham, pl. 153. Richter, §1411. Rouvèyre, *Génération*, 10, 11 (treated as two, *recto* and *verso* of each).

C. IV

19107 (C. iv. 1)

27·5 × 20·1

RECTO

Pen and brown ink on coarse yellowish paper.

To the right a drawing of ribs, and above them a diagram of levels of the diaphragm in respiration, with a note on its action.

Richter's No. 190.

VERSO

Red chalk, gone over with pen, except as noted.

ABOVE

A note on hydrostatics, upside down, illustrated by a red chalk sketch of a boat. An elevation of a fountain, in red chalk.

TO RIGHT

The ground-plan of two courtyards, showing two spiral staircases. Red chalk, the bottom of the drawing touched in ink.

TO LEFT

A detailed study and two sketches of a bird's wing, with a note on its action.

BELOW, to left

Slight architectural studies.

TO RIGHT

Two drawings of a pulley, with notes on its action. Two architectural elevations, one of a tower and one of the same fountain. A note on the action of water on the earth.

THE anatomy of a bird's wing immediately suggests Leonardo's MS. on the Flight of Birds, which is dated March and April 1505. But the drawings and writings on this sheet and on 12656–7 are in Leonardo's later style, and this sheet must be part of the same series as the three following. Now the writing and drawings on these are very like those in Anatom. MS. C. ii, which are dated January 1513. Compare, for example, the drawings of diaphragms on C. iv. 3 *recto* (19109), with those on C. ii. 7 *verso* (19077), which

also contains studies of architecture similar to those on C. iv. 1 *verso*. The style of these latest anatomical drawings is so unlike that of the earlier that we must give this resemblance more weight than any resemblance to the MS. of 1505. This date is confirmed by the numerous studies for the Flight of Birds which occur between folios 35 and 63 of MS. E, dated 1513–14. This MS. also contains studies of pulleys, e.g. f. 59 *verso*. The architectural studies are now identified as referring to some project of enlargement of the Villa Melzi at Vaprio d'Adda. They are related with studies in the Codex Atlanticus, ff. 61 *recto*-b (in blue paper), 153 *recto*-d, *recto*-c and 395 *recto*-b, the last three in the same type of coarse yellowish paper as the present drawing and 12656–7 as well. Those on C. ii. 7 *verso*, mentioned above, also refer to the same project, as probably those on 12579 *verso*, to which see note. All these drawings are reproduced by Pedretti, *loc. cit.*

Esche, p. 147, fig. 116 (detail of *recto*). Giacomelli, pp. 185–186, fig. 181. O'Malley-Saunders, 32, 85. Pedretti, *Architectural Studies*, p. 73, fig. 35, and *Villa Melzi*, pp. 235–236, fig. 6. Rouvèyre, *Nerfs et Vaiss.* 2 (*recto* and *verso*).

19108 (C. iv. 2)

28·7 × 20·6

RECTO

Pen and ink, on coarse yellowish paper.

Notes on floats and the action of water on the earth. An unidentifiable drawing on right.

VERSO

Pen and ink, partly over red chalk.

Studies of the thorax, trunk and diaphragm of an ox, with notes on the drawings, and, upside down, on the action of water. A slight sketch of architecture. Richter's No. 199.

DATE, *c.* 1513. See note to the preceding drawing. The curious objects represented on the *verso* (*obbietti menati dal corso dell'acqua* . . .) are floats of various shapes used for the experience described on the *recto*. A large number of notes on this subject from Leonardo's late MSS. are found in the seventh book of the compilation *Del Moto e Misura dell'Acqua*, 1643.

Esche, pp. 147–148, fig. 118 (*verso*). O'Malley-Saunders, 30 (*verso*). Rouvèyre, *Nerfs et Vaiss.* 3 (*recto* and *verso*).

19109 (C. iv. 3)

28 × 20·7

Pen and ink and other media as indicated, on coarse yellowish paper.

RECTO

Studies of thorax and diaphragm, with notes. One note on the colour of smoke, headed *pictura*. Near the bottom a sketch of military architecture. [Six drawings probably of an ox.]

The drawings in pen and sepia, coloured with red chalk; the notes originally written in sepia, and carefully gone over, letter by letter, with black ink.

VERSO

Richter's No. 218a.

DATE, *c.* 1513. See note to f. 1 (19107). Leonardo was evidently afraid that his notes in faint ink on the absorbent paper would become indistinct with time—a fear justified by the preceding drawing. This is evidence that Leonardo intended his notes to be read by posterity. See also note to Anatom. MS. A, f. 8 *verso* (19007).

The sketch of military architecture represents the system of placing mines by means of an underground passage leading to a fortress. Elaborate drawings of this subject are in Codex Atlanticus 130 *verso*-b and 134 *verso*-b (with a red ground prepared *verso*, not visible in reproduction) which also contain notes on aerial perspective. Cf. Pedretti, *loc. cit.*

Esche, p. 148, fig. 119. O'Malley-Saunders, 31. Pedretti, *Libro A*, p. 155. Richter, §570 (note on the colour of smoke). Rouvèyre, *Nerfs et Vaiss.* 4.

19110 (C. IV. 4)

5·1 × 13·1

Pen and light ink.

RECTO

Drawing of right side of a torso, showing the action of the lungs on the intestines, with note on the drawing.

VERSO

Richter's No. 170.

THIS and the following two fragments are in the same type of thick, stout paper and must date from about the same time, *c.* 1508. See note to f. 6 (12636).

O'Malley-Saunders, *loc. cit.*, say that Leonardo contradicts a previous conclusion as to the function of the diaphragm, but they do not specify where such conclusion is to be found. Notes on the same subject in later sheets are not at variance with these. Compare f. 3 *recto* (19109) and C. II. 16 *verso* (19086). The

following fragment, which was probably part of the same sheet, contains a note which clarifies Leonardo's thinking on this subject.

Esche, p. 148, fig. 126. O'Malley-Saunders, 29. Rouvèyre, *Anat.* E, 3.

19111 (C. IV. 5)

6·7 × 7·6

Pen and ink.

RECTO

A note on the action of the lungs and the intestines.

VERSO

Richter's No. 133.

SEE note to the preceding drawing.

Esche, p. 148.

(C. IV. 6) is 12636.

19112 (C. IV. 7)

27·5 × 19

RECTO

Pen and ink over black chalk.

CENTRE

Drawing of the heart, lungs, liver, spleen and kidneys, with blood vessels.

ABOVE

Drawing in black chalk of the stomach, entirely covered by the writing of the note at the top. Notes on the action of the heart, and, R.L., a note in black chalk, almost obliterated, on the flight of birds.

VERSO

Pen and ink.

A small drawing of a figure in profile to left, showing the position of the lungs, with a note on the drawing. Richter's No. 185.

SIMILAR to C. III. 10 (19104), and C. IV. 9 (19114). Compare also C. III. 5 and 6 (19099–100) which are related with C. III., f. 11 *verso*, a sheet of geometrical studies and notes on the theory of balance as in 12602 *verso*. Thus it is likely later than it would appear to be. According to O'Malley-Saunders, *loc. cit.*, the black chalk note on the flight of birds points to a period

around 1505, the later period 1513–14 in which such notes would occur being excluded on the ground of characteristics of handwriting. Notes in black chalk occur in other folios of this series (e.g. in C. III., f. 10 *verso*) and these notes cannot be much earlier than the black chalk outlines of the pen and ink drawings. Compare 12624 *verso*, which has again one such note, and which is in a style close to that of Anatom. MS. A (see Vol. I, Introduction, p. xlvii). This style results from a system of cross-hatching which is not quite as lifeless as that of the drawings of 1510. And yet this can hardly be earlier than 1507. A drawing of a fortress in this identical style, Codex Atlanticus 41 *verso*-b, was certainly done later, because the note to it refers to the capture of Simon Arrigoni in 1507. The date 1508–1509 is in fact confirmed by 19127 (C. V. 7), to which it was originally joined.

Esche, pp. 148–149, fig. 27. O'Malley-Saunders, 89. Rouvèyre, *Nerfs et Vaiss.* 5 (*recto* and *verso*).

19113 (C. IV. 8)

20 × 9·4

Pen and ink over black chalk, on white paper, with a watermark of a fleur-de-lys with a barbed arrow.

RECTO

Anterior views of blood vessels of a man's left thigh, with a note on the veins, and, to right, on a much smaller scale, of a man's waist and thighs. Down to the left, partly cut off by the margin of the sheet, a scheme of a standing figure somewhat resembling a geometrical scribble.

Richter's No. 182.

VERSO

Blank.

Similar to 12636, and probably datable *c.* 1508. Compare also C. VI. 21 *recto* (19143–4) which contains similar drawings of man's torso. The illustration of the femoral artery and vein is carried out in greater detail in Anatom. MS. B, f. 8 *recto* (19025), and in 12624 *recto*. The note: *Quando tu figuri le uene sopra delle ossa djmostra quali uene son dj qua o dj la da esse ossa* is likely a reference to such finished drawings. The geometrical scheme of a standing man recalls Leonardo's advice to the painter as to represent human motion by means of such convention, Codex Atlanticus 199 *verso*-a (cf. *Libro A*, pl. 24). This type of representation also occurs in a sketch which shows the position of man in a flying machine, Codex Atlanticus 129 *verso*-a, *c.* 1507.

Esche, p. 149. O'Malley-Saunders, 136. Rouvèyre, *Anat. E*, 5.

19114 (C. IV. 9)

28·2 × 20·5

RECTO

Pen and ink over black chalk.

Section of a standing male, viewed from right showing spine; spinal cord; right side of thorax with thirteen ribs, intercostal nerves, internal intercostal muscles; inner surface of left half of pelvis; schematic left sciatic nerve; blood vessels of trunk, pelvis and thigh. To the left, level with upper ribs there is a faint drawing of right side of a woman's face and below this a faint outline, possible right side of lower half of male trunk. Note marks where 19113 was formerly pasted on.

VERSO

Pen and ink over black chalk, the left-hand note being written in blacker ink than the rest.

ABOVE

Main blood vessels of thorax and superficial veins of arm, partially drawn from animal, ? ox.

R.U. and C.M.

Left side of tongue, larynx and palate; front of larynx; under-surface of tongue. Small arch, ? feline tongue, according to O'Malley-Saunders.

BELOW

The superficial veins of the right arm.

With notes on the tongue, the word *continuo* being added on the margin by a sixteenth-century hand (? Melzi's) to correct Leonardo's misspelling *cōtine*. The letter .I.

Richter's No. 149.

O'MALLEY-SAUNDERS, *loc. cit.*, state that in the first edition this drawing was dated *c.* 1490. This is a misunderstanding. In fact it was compared with C. III. 10 (19104) and C. IV. 7 (19112). The suggested date was, and still is, from after 1507. See note to folio 7 (19112). This, as the others in this series, is related to a group of sheets and pairs of sheets in the Anatom. MS. B, e.g. 10–11, 18–19, 36 and especially 27–30, which may suggest that its date should be well advanced into the time of the drawings of the Trivulzio horse (e.g. 12303), not long before Anatom. MS. C, I., f. 8, etc.

Both the *verso* of this sheet and C. III. 5 *recto* (19099) have a sixteenth-century mark: .I. The word corrected, on the *verso*, is evidence that these notes were read in the sixteenth century.

Esche, pp. 149–150, fig. 41 (detail of *recto*). O'Malley-Saunders, 37 (*verso*), 166. Rouvèyre, *Nerfs et Vaiss.* 7 (*recto* and *verso*).

19115 (C. IV. 10)

31·6 × 21·8

Pen and ink, and wash on the drawing of the tongue.

RECTO

ABOVE

Left half of nasal and oral cavities with pharynx; three studies of lips and below a detailed right oblique view of the tongue, with notes on phonation and the action of the tongue in speech, lists of syllables with notes on their pronunciation, leading on to a panegyric of Nature.

VERSO

A plan of Milan, with names of gates written in; and a note on the articulation of the voice.

L.L.

A diagrammatic drawing of a flame, with a note on its colour.

R.L.

A wheel with weights, and a note on movement.

BELOW IT

The ground plan of a building, and the diagram of a parade of carriages, with a note to it.

Richter's No. 184.

OTHER notes on the tongue occur in Anatom. MS. B, f. 28 *verso*, and on the preceding drawing. A similar rough plan of Milan with the names of the gates is in Codex Atlanticus 73 *verso*-a, cf. Richter, §1016, pl. cix. The style of the *recto* suggests a date around 1510, possibly 1509 as the first 9 folios of Anatom. MS. C. 1. It must be borne in mind that this drawing, and the following ones up to f. 16, are on the same type of rather thick paper, with wire-marks and chain-marks hardly visible. They all have in common the same type of ink: a brown ink with certain greenish reflexes, slightly changing in tone and intensity from one sheet to the other. It may well be the same ink as in 12282. A clue as to the date of this series is in the note on the *verso* about the articulation of the human voice, and the intention to experiment with the inflated lungs of an animal, so as to reproduce its voice by squeezing them. In Anatom. MS. A, f. 3 *recto*, the programme is about to be carried out (*scrivi le cause delle voci acute e gravi*) and the experiment with a dead animal (swan or goose) is mentioned.

The map of Milan has been related to the project of canals in connexion with the plan of a residence for Charles d'Amboise, thus it is unlikely later than 1511, the year of Charles' death. Studies for this architectural project in Codex Atlanticus 207 and 305 are indirectly related to f. 15 (19121), to which see note. (Cf. Pedretti, *loc. cit.*) As for the note on the colour of the flame, Esche, *loc. cit.*, suggests to relate it to MS. G, but neither that MS. nor MSS. F and E have such notes on the flame. They are found instead in Codex Atlanticus 260 *recto*-a, the handwriting of which is identical to that of the notes in this drawing. The Codex Atlanticus folio, which is related to the long notes on flame and smoke in f. 270 *recto*-a, *verso*-a, contains a memorandum written not by Leonardo but crossed through by him: *segnia tuti i mu/scholi che moue/no le dita in | che parte nase/no nele bra/ce*, a programme which is carried out in Anatom. MS. A, f. 10, etc. Finally, this folio of the Codex Atlanticus contains a note on the flow and ebb of the Mediterranean sea compared to the action of the lungs and ventricles of the heart: . . . *cresscie capacita come fā li uentriculi del | core overo il polmō* . . . This Codex Atlanticus folio is one of the few which can be singled out as particularly untidy, with ink splashed all over, and a characteristic type of handwriting made up of squat and bold letters, leaning backwards and considerably spaced so that they convey the impression of having been jotted down at a great speed. Some of these characteristics are present on the *verso* of this drawing, but the best examples are Codex Atlanticus 353 *recto*-c, *verso*-c, with notes by Melzi on both sides, and f. 342 *recto*-c, *verso*-d, with a draft of letter in Melzi's handwriting which Calvi (*Manoscritti*, p. 262) dates *c.* 1508–9. Compare also Codex Atlanticus 132 *recto*-a, *verso*-a, which contains the draft of a letter, not in Leonardo's hand, dated July 5th, 1507.

Finally, the note and diagram on the arrangement of carriages in a parade (*ghirlanda dj carri*) may refer to any of the several festivities which took place in Milan following the descent of Louis XII in 1507, and drawings in our collection do in fact reflect the activity of Leonardo as an *arrangeur des fêtes* in the service of Charles d'Amboise (cf. *Raccolta Vinciana*, xx, 1964, pp. 381–2).

Esche, p. 150. Gantner, p. 201. O'Malley-Saunders, 39. Pedretti, *Raccolta Vinciana*, xviii, 1960, p. 80, fig. 8 (detail of the Map of Milan). Richter, §§832, 837. *Raccolta Vinciana*, iv, 1907–8, p. 67, fig. 1. Rouvèyre, *Anat.* B, 8 (*recto* and *verso* interchanged).

19116 and 19117 (C. IV. 11 and C. IV. 12)

31 × 43·6

19116 (C. IV. 11)

Pen and ink.

RECTO

Diagrams of semilunar valves of the heart; and of streaming and expulsion of blood from the heart. With

numerous notes on the action of the nerves and muscles in general, and those of the heart in particular. Richter's No. 234.

VERSO

Studies of the movement of the blood, with notes on the action of the heart, and diagrams of the valves. A memorandum incorrectly transliterated in the *Quaderni d'Anatomia* is written next to the diagram of a glass model of the valve of the heart and reads as follows:

fa quessta | prova dj | uetro e | moujci dẽtro a|cqᵃ e panicho.

('Make this trial in the glass [model] and have water and millet move into it.')

19117 (C. IV. 12)
Pen and two inks, one faint sepia, one bistre.

RECTO (C. IV. 12 *verso*)

Geometrical figures, explanatory of numerous notes on optics.

Five diagrams of the valves of the heart and a note of explanation.

VERSO (C. IV. 12 *recto*)

Numerous drawings of the circulation of the blood, and of the heart, with notes on the action of the heart.

THESE two drawings form one large sheet. They are wrongly given in *Quaderni d'Anatomia*, the *recto* and *verso* of C. IV. 12 being reversed. Leonardo's studies of the heart and circulation were amongst the last of his anatomical investigations and form the bulk of C. II, dated 1513. But the ones on this sheet must be earlier, *c.* 1509, and are related to the first 10 sheets of C. I, just as the preceding drawing (19115), to which see note. The style of the drawing of blood flowing through the valves of the heart is similar to that of the studies of water in MS. F (1508) and in the 12660 series (1508–1509). In one instance, f. 11 *recto*, the writing and arrangement of the page recalls the compilation of notes on water in the Codex Leicester, which is made up of sheets of identical format. O'Malley-Saunders, *loc. cit.*, point out a reference (f. 11 *verso*) to the 3rd book of the treatise on water, which would be the one headed *delle vene* in the list in the Codex Leicester, f. 15 *verso*. Folio 11 *recto* contains a list of topics to be treated, and these not only concern the heart but also the genito-

urinary system, brain, sphincter muscles, nerves of the voice, and even water. For the programme of an investigation of the function of the nerves of the voice compare C. I. 9 and 10 (19068–9), *c.* 1509. A relation with C. I is also suggested by a note on f. 11 *verso*: *figura e djfinjsscj il portinaro dello stomacho*, a programme which is in fact carried out in C. I, ff. 6 *verso* and 7 *verso*. Again on the *verso* of f. 11 Leonardo mentions the intention of making a glass model of the aortic orifice and valves in order to study the closure of the cusps and the formatation of blood eddies. The correct transliteration of the note is given above. In C. II. 6 *verso* (19076) and 12 *recto* (19082), *c.* 1513, Leonardo still writes such reminders and gives instructions on how to construct such a glass model.

Finally, an important clue as to the date of this series is in the page of notes on optics on the *recto* of f. 12 (given as *verso* in the *Quaderni* edition). There is no doubt that these notes were done at the same time as the notes on the action of the heart: amongst the diagrams of optics there are in fact diagrams of the cross-section of the aorta, somewhat resembling a geometrical figure. Several of these notes and diagrams of optics are copied or developed in MS. D, e.g. the note crossed through on the upper left corner, which is copied in MS. D, f. 8 *verso*, together with the surrounding diagrams. MS. D is usually dated *c.* 1508. Corbeau suggests a date *c.* 1513 on the assumption that Leonardo's studies on optics were related to his preoccupation in Rome with the production of mirrors (cf. introduction to an edition of MS. D, Grenoble, 1964). Mr. Strong (dissertation, University of California, 1966) has shown that MS. D cannot be dissociated from MS. K, vol. III, and MS. F, and that therefore it should be dated *c.* 1508–9. Two folios in the Codex Atlanticus 190 *recto*-b, *verso*-b and 345 *recto*-b, *verso*-b, also contain similar notes on optics and the eye. A note on f. 190 *verso*-b (Richter, §1211) is an invocation to have mathematicians throw light on the error of those who believe in the existence of spirits, and is related to the long sections on the same subject in Anatom. MS. B, given by Richter, §§1212 to 1215. Folio 345 *verso*-b (cf. *Libro A*, pl. 25) contains a study for the canalisation of the Adda river to be associated with a group of sheets which Calvi, *Manoscritti*, pp. 294–304, dates around 1510. It would be impossible to date all this material later than 1508–1509, since a related sheet, 19149–52, contains notes on optics of the very same type as well as figures illustrating the action of a man beating which is related to several drawings in the collection, e.g. 12641, 12644, 12654, etc.

Esche, pp. 150–151. O'Malley-Saunders, 112, 113 (*recto* and *verso* of 19116), 114 (*verso*, i.e. *recto*, of 19117). Rouvèyre, *Anat.* B, 5 (19116, *recto* and *verso*), 6 (19117, *recto* and *verso* interchanged).

19119 and 19118 (C. IV. 13 and C. IV. 14)

21·7 × 30·7

19119 (C. IV. 13)

Pen and ink.

RECTO

Three semi-schematic drawings and two diagrams of the ventricles of the heart, with notes on their action.

VERSO

Two drawings of a section of the right ventricle of the heart with notes on its action.

ABOVE

Light preliminary sketch of a dissection of the heart.

TOP RIGHT

A small drawing and a diagram of a ventricle of the heart.

19118 (C. IV. 14)

Pen and ink.

RECTO (C. IV. 14 *verso*)

Notes on the pulmonary valves of the heart, with three sketches; coronary vessels seen from apex of heart and the heading:

nõ mj leggha chinone matematicho | nelli mja prīcipi.

VERSO (C. IV. 14 *recto*)

Five studies of the ventricle of the heart, seen from the side and from underneath.

R.L.

Two skeletal studies of right arm, seen from inner side, demonstrating pronation and supination, with notes. Richter's No. 163.

THE two numbers form one sheet, which was formerly folded but has now been mounted flat. Hence the confusion of references to the *Quaderni d'Anatomia*. The drawings are in the same style as C. II, which is dated 1513. Although it would be impossible to overlook the evidence of style, the following considerations point to an earlier date, *c.* 1509:

(*a*) Paper and ink are identical to those of the preceding ff. 10, 11, 12. In fact it is possible that the two pairs, ff. 13–14 and 15–16, were originally joined together to form a large sheet as ff. 11–12, in a way similar to 19149–52.

(*b*) Studies on the heart and blood circulation are found in the preceding ff. 11 and 12, as well as in the related series of C. I, which cannot be dated later than

1510. See also Anatom. MS. B, f. 12 *recto*, which has on the *verso* drawings related to the dissection of the 'old man'. Drawings of the heart, with notes, are in MS. G, f. 1 *verso*, which is dated 1511. (But these may have been added later as they occupy the space left available by the dated note.)

(*c*) Notes and drawings of geometry and mechanics in the related ff. 15–16 can be compared to notes in manuscripts dating from *c.* 1508–10.

The *dictum* 'Let no one who is not a mathematician read my principles' refers to the intention of organising this anatomical material in the form of a treatise according to the Aristotelian system which requires that the presentation be preceded by the 'first principles', i.e. the basic elements of the science. This Leonardo had already planned to do in his treatises on water and on painting, just as it was done by Alberti and Piero della Francesca. A reference to mathematical principles is in Anatom. MS. B, f. 29 *recto*, in a passage on the action of the muscles of the mouth in the generation of the smile: '. . . and these it is my intention to describe and represent in full, proving these movements by means of my mathematical principles'. And it is certainly with an observation based on mathematical principles that Leonardo explains the triangular form of the valves of the heart. See f. 12 *verso* (*recto* of 19117). But nowhere else is to be found a complete section of *principi matematici* for the treatise on Anatomy.

Esche, pp. 151–152, figs. 137 (14 *recto*, i.e. 19118 *recto*), 140 (detail of 13 *verso*, i.e. 19119 *verso*). O'Malley-Saunders, 101, 102 (*recto* and *verso* of 19119), 107, 108 (*recto* and *verso* of f. 14, i.e. *verso* and *recto* of 19118). Richter, §3 (top line on 14 *verso*). Rouvèyre, *Anat.* E, 1 (19118, *recto* and *verso* interchanged), 2 (19119, *recto* and *verso* interchanged). Royal Academy, 304 (*recto* of 19119).

19121 and 19120 (C. IV. 15 and C. IV. 16)

21·8 × 31·6

19121 (C. IV. 15)

Pen and ink.

RECTO

Drawing of a male torso from behind, showing thoracic and abdominal organs, five sketches of organs and five geometrical figures.

Numerous notes on the art of painting, in particular of drawing drapery.

VERSO

Problems connected with circles and spheres. The head of an old man in profile to right badly drawn. In the centre, a small sketch of the reflexion of the sun

in the waves of water, and a few microscopic doodles incorrectly transliterated in *Quad. Anat.*:

djmmj che se māj fu fatto cosa simjle
tu ītendi ebbasta lecose per (?)parte.

With notes on the geometrical problems.

19120 (C. IV. 16)
Pen and ink.

RECTO (C. IV. 16 *verso*)

A long note on mechanics, crossed through, illustrated by four diagrams.
Richter's No. 214.

VERSO (C. IV. 16 *recto*)

Geometrical figure of a problem of optics with the note that every action of nature is made along the shortest possible line. Above, two sketches of the same problem and a circle.

THIS pair, related to the preceding drawing, is one of the most problematic sheets in the collection, and no satisfactory verdict can be reached as to its date. Several elements seem to confirm the date *c.* 1513 which has been suggested by the evidence of style of the preceding drawing. And yet there are hints pointing to an earlier date, *c.* 1508–9.
The main anatomical drawing, f. 15 *recto*, is a representation of the organs in the torso, seen from behind, the spine and all the dorsal muscles being removed for this purpose. Professor Favaro, *loc. cit.*, relates this to a sketch in Codex Atlanticus 81 *recto*-b, which has the note: *fa quj tutte le uene | e poi le budella | e leva las/pina——*. This reminder is jotted down amid studies of mechanics similar to those on f. 16 *verso* (*recto* of 19120). The only other example of such anatomical representation is a black chalk sketch in C. III. 10 *recto* (19104), for which a date *c.* 1509 can be suggested on the basis of style. Compare, however, 19044 *recto* (B. 27).
The numerous notes on painting, especially on drapery, are all crossed through, as evidence that they had been developed elsewhere. The original compilation is lost, but at least one passage is found in the *Trattato della Pittura* (cf. *Libro A*, pp. 144–145). There are also notes on the representation of plants and verdures, which would likely precede the ones in MS. G, *c.* 1510–11. Such notes on plants in form of topics to be developed are found in Codex Atlanticus 207 *recto*-a, *verso*-a and 305 *recto*-a, *verso*-a, two folios containing architectural studies for the Milanese residence of Charles d'Amboise. A link with f. 207 *recto*-a is also confirmed by the slight geometrical sketches. These in fact are copiously developed in f. 207 *recto*-a.

and there is no doubt that the problem of conical sections is identical in both. Compare also the Arundel MS., ff. 73–8 and 244–52, which make it clear that all these studies were related to the problem of the caustic of reflexion in curved mirrors. Some of the notes in f. 207 *recto*-a are undoubtedly developed in MS. E, e.g. f. 30 *recto*, and these have perhaps a bearing on the subject of curvilinear perspective as treated in the same MS., ff. 4 *recto* and 16 *verso* (the latter with a diagram which Esche had already related to one in C. IV. 10 *recto*). It is easy to see a connexion between these studies on perspective and the squaring of the sphere, which is in fact the subject of some notes on the *verso* of C. IV. 15. Here again is a reference to MS. E: compare ff. 24, 25, etc., and even to MS. G, e.g. f. 42. But this characteristic scheme of the geometric structure of the sphere also occurs in a folio of the Arundel MS., 43 *verso*, which dates from *c.* 1508. And a note to a diagram in the Arundel MS., f. 180 *recto* (*spoglia della spera*) occurs next to studies for the 'Neron da Sancto Andrea', i.e. the Milanese canal for the new residence of Charles d'Amboise.
A scribble in the centre of C. IV. 15 *verso* represents the reflexion of the sun in the waves of water. This is a subject which is extensively treated from the time of MS. F to that of Leonardo's sojourn in Vaprio, 1513. The 'microscopic doodles' transcribed above are in the same style of handwriting as the sentence in MS. E, f. 31 *verso*: 'non si debbe desiderare lo impossibile'. Finally, the three diagrams at the bottom of the sheet, partly cut off by the margin, can be explained as pertaining to the problem of squaring the sphere. They appear again in this context in Codex Atlanticus 190 *verso*-a, a folio which contains a tracing (not by Leonardo) of the Budapest head of the Florentine warrior of the Battle of Anghiari. Leonardo's notes are obviously later, especially as one of them on the other side of the sheet is written by Melzi, and could have been added at any time after 1508. Sketches of polyhedra can be compared to those in MS. E, f. 50 *recto*.
The sheet attached to this, C. IV. 16, only contains diagrams of the direction of rays reflecting from the curved surface of a mirror (the so-called problem of Alhazen), and a quotation from Aristotle as specified in MS. D, f. 10 *verso*. Similar quotation is in MS. G, f. 75 *recto*.
Last to be considered is the page of notes on mechanics, f. 16 *verso*, on the action of the balance, with diagrams which characterise a large series of such studies in the Codex Atlanticus and Arundel MS., all dating from after 1508. The opening paragraph (*multiplicha il braccio per tante volte* 4, *etc.*) occurs innumerable times in this series, and makes it hopeless the effort of tracing the text developed from this crossed-out note. As a clue to the date of these studies

I only mention Codex Atlanticus 288 *verso*-b which contains the memorandum: *fatiche derchole a pier fr[ancescho] | ginori — | lorto de medjci*——, and the related f. 188 *verso*-a with similar memoranda: *serãtonio pacini* and *mõsignor de paçi*. It is known that Monsignor de'Pazzi became Archbishop of Florence in September 1508 (Landucci's *Diary*).

And so the problem of dating these anatomical sheets with certainty must remain unsolved. While the evidence of style points to a late date, *c.* 1513, there is strong circumstantial evidence pointing to an earlier date, *c.* 1508–9.

Esche, p. 152. Favaro, *Emporium*, XLIX, 1919, pp. 280–281, fig. 2 (19121 *recto*). Gombrich, pl. CXII, fig. 15 (detail of *verso* of 19121). O'Malley-Saunders, 124 (19121 *recto*). Pedretti, *Libro A*, pl. 26 (19121 *recto*).

19122 (C. IV. 17)

26 × 13

Pen and ink.

RECTO

ABOVE

Head of a young man, with a close-fitting cap over long, flowing hair, in profile to left. Above the head, in red chalk, the word *atacato*. The number (?L.'s) 12.

BELOW (other way of paper)

A mathematical calculation and a note upon it.

VERSO

Richter's No. 127.

THE profile is probably by Leonardo. The line is unusual for him, but it appears to be drawn with the left hand. The writing is the same as that of the note in the following fragment, which is also on a mathematical problem. Marinoni, *loc. cit.*, relates these calculations and notes to a series of mathematical exercises in MS. L (f. 22 *recto*), Codex Atlanticus and Arundel MS., all dating from *c.* 1502. See also 12686 *verso*.

Marinoni, *Raccolta Vinciana*, XX, 1964, p. 164. Rouvèyre, *Physiog.* 6.

19123 (C. IV. 18)

7·2 × 6·5

Pen and ink.

RECTO

A note giving a mathematical proposition—that of the sum found by the rule of three.

VERSO

Richter's No. 140.

SIMILAR notes occur in the MS. L and related folios of the Codex Atlanticus as well as on the *verso* of 12686 with reference to Bartolomeo della Gatta (1418–1501). See also the preceding drawing. Date, *c.* 1502.

19124 (C. IV. 19)

6·3 × 3·3

Pen and ink.

RECTO

The male genito-urinary system with blood vessels.

VERSO

Richter's No. 224.

THIS is in the same type of thin paper and same colour of ink as the 'bell ringer fragments' 12688–12716, and it may come from the same sheet. Date, *c.* 1508–9, when Leonardo seems to have adopted this system of perfectly horizontal hatching. Compare 12331, '363, '402, '644 *recto*, '700 *recto* and *verso*, '701, etc. See also Codex Atlanticus 362 *verso*-a, one of the clepsydra series as 12282. There is a possibility that this was its parent sheet, because it is identical in style, paper and ink, and has a lacuna in which the upper half of the fragment would fit; the missing section at the bottom would have contained an explanatory note.

Esche, p. 152. O'Malley-Saunders, 193. Rouvèyre, *Anat.* E, 8.

19125 (C. IV. 20)

9·8 × 4

Pen and ink on coarse paper.

RECTO

Diagrammatic drawing of the kidneys, ureters and bladder, and possibly part of diaphragm.

VERSO

Richter's No. 175.

THIS and the following fragment were cut out oɪ Codex Atlanticus 95 *recto*-a, a sheet of geometrical studies and lunulae dating from *c.* 1513. It also contains slight topographical sketches, including a ground

plan of a castle identified as that of the Sforza castle in Milan (cf. Ignazio Calvi, *L'architettura militare di Leonardo da Vinci*, Milan, 1943, fig. 40). The only portion of the *verso* of the parent sheet that can be seen contains the itinerary Fiorenzuola-Bologna. On September 25th, 1513, Leonardo left Milan for Rome, and this note may refer to a portion of that journey. But it may also refer to a Leonardo sojourn in Emilia in 1514 or 1515.

According to Dr Keele, *loc. cit.*, the crudity of the drawing in this fragment suggests that it is a copy of a contemporary manuscript rather than the result of Leonardo's own observation. It had not been possible hitherto to explain the circular form high up on the heart: this is evidently a geometrical figure similar to those in the neighbourhood of the hole on the parent sheet.

Esche, p. 152. Keele, *Leonardo da Vinci on Movement of the Heart and Blood*, London, 1952, fig. 3. O'Malley-Saunders, 199. Pedretti, *Windsor Fragments*, pl. 7. Rouvèyre, *Anat. E*, 10.

19126 (C. IV. 21)

5·9 × 3·9

Pen and ink on coarse paper.

RECTO

A scribble of the right lung, heart and kidneys.

VERSO

Richter's No. 176.

DATE, *c.* 1513. It comes from the same parent sheet as the preceding fragment, to which see note. The lower part of the fragment has various marks corresponding with some of the drawing on the lower part of the parent sheet. The drawing thus completed represents a tank mounted on a stand, surrounded by ladders of access and a gangway suspended like a bridge. The folio contains two further anatomical sketches which escaped Leoni's scissors. They contain embryology and may be compared with analogous details in 19060 *recto*, 19102 *recto* and *verso*, and 19103 *verso*. See also Codex Atlanticus 113 *recto*-b, which was originally part of a sheet of archaeological studies at Civitavecchia (*c.* 1514), and which may therefore suggest that Leonardo was still working on this subject at the beginning of his Roman period (cf. Pedretti, *Architectural Studies*, fig. 48).

Esche, p. 152. Pedretti, *Windsor Fragments*, pl. 7. Rouvèyre, *Anat.* E, 9.

C. V

(C. v. 1) is 12597.
(C. v. 2) is 12592.
(C. v. 3) is 12624.
(C. v. 4) is 12619.
(C. v. 5) is 12612.
(C. v. 6) is 12603.

19127 (C. v. 7)

26·4 × 20·1

RECTO

Pen and ink over black chalk.

U.L. Faint detailed study of upper surface of human brain with gyri in black chalk.

U.C.⎫ Diagrams of floor of cranium seen from above,
L.C.⎭ showing fossae.

U.R.⎫ Schematic drawings of ventricles of brain seen
L.L.⎭ from left.

C.R. ? part of cerebellum, ? floor of fourth ventricle.

C.L. Under-surface of brain, dissected to show ventricles.

L.L. Bold and faint drawings of under-surface of brain with *rete mirabile* in upper one.

Notes on making wax cast of brain and ventricles.

VERSO

Pen and ink.

Richter's No. 177.

THIS is similar in style and paper to C. III. 10 (19104), C. IV. 7 (19112) and C. IV. 9 (19114), and is probably part of the same sketch-book. In fact it was originally joined to 19112: not only is the paper identical and both have an identical water stain at the top margin, but the ink of the note on 19112 *recto*, at the top, has left an imprint on the 'blank' verso of 19127. In subject matter and again in style it is related to 12602 *recto* and Anatom. MS. B, 35 *recto* (19052) and the Weimar leaf. See also C. I. 13 *verso* (19076). Date, *c.* 1508–9. Similar sketches of the cerebral ventricles are in 12669 *verso* and Codex Atlanticus 42 *verso*-b, the latter being related to the water series, i.e. 12666, to which see note.

Esche, p. 152, fig. 56. O'Malley-Saunders, 147. Panofsky, *Renaissance-Dämmerung*, p. 157, fig. 18. Rouvèyre, *Nerfs et Vaiss.* 6. Royal Academy, 288.

(C. v. 8) is 12602.
(C. v. 9) is 12628.

19128 (C. v. 26)

21·8 × 30·1

Pen and ink.

RECTO

LEFT

Sketches of bones and veins of right arm.

CENTRE

Scribble of a child's head in profile to right, like a wind-god in the act of blowing air through tight lips, the cheeks enflated, and the hair swept back by wind. Two diagrams of perspective.

BELOW

Notes and diagrams on stereometry.

With many notes on the action of the lungs, and on the life of the child in the womb.

L.'s No. 17.

Richter's No. 141.

VERSO

Two diagrams of the same problem of stereometry as on the *recto*, with the letters *b*, *c*, *d*.

THIS drawing is important for the chronology of Leonardo's anatomical studies in general and for those of embryology in particular. In style, format, and content it relates to other drawings in the collection, and can be dated 1513. The scribble of a child's head, which is certainly Leonardo's, recalls the forerunner of the Deluge series, 12376, in which wind-gods are shown in the clouds, and which I had already compared to the style of the Anatom. MS. C, 11 (1513). The notes and diagrams on stereometry belong to a series of studies in the Codex Atlanticus, many of which were transcribed by Leonardo himself in MS. E. From one such sheet was extracted the fragment 12485, to which see note.

Not only is the paper and ink of our folio identical to those of this series, but there is a sheet of identical format, Codex Atlanticus 303 *recto*-b, which contains notes and a diagram on the same problem of stereometry, the diagram being on exactly the same scale as the one on our sheet. This suggests that the two drawings were probably joined together. And just as the Windsor one contains marginal sketches of anatomy, so the Codex Atlanticus one has a group of six such sketches showing the action of the sphincter muscles. This is most revealing as it reflects the subject of Leonardo's anatomical studies at this time: notes on the heart and lungs which develop into observations on the life of the child in the womb; sketches of the action of the muscles of the arm, and drawings of the sphincter muscles. This should be enough to prove that all the notes and drawings in such sheets as 19103 (C. iii. 9) were done at about the same time. The association of studies on the genital organs and sphincter muscles with studies on the lungs is also evident when 19095 and 19054 are considered together, as they were originally.

The date 1513 proposed for this folio and the related ones is confirmed by another hint: the passage on the function of the heart and lungs of the child in the womb is interrupted by the sentence *horigliano il djscorso per lo contrario* ('they are twisting the discourse around'), which probably refer to the same situation mentioned in 19063 (C. i. 4): *fa vn discorso della reprensione che si richiede alli scolari inpeditori delle notomie e abbreviatori di quelle.*

Rouvèyre, *Géom.* 1 (*recto* and *verso*).

C. VI

19129 (C. vi. 5)

14·9 × 16·8

Pen and grey ink on grey-white paper.

RECTO

A note on the proportions of the face in relation to the foot, and an illustrative sketch.

Sketch of the proportions of the lower part of the face, and below it, of the proportions of the face, seen full face, with a note on this subject.

Note on the proportions of the nose with an illustrative sketch of the eye.

Each note and drawing marked: ø.

VERSO

Blank.

THE writing and colour of the ink are those of the earliest sheets in MS. B, and so datable 1489.

Esche, p. 161. Richter, §§321 (two sentences below), 327 (sentence above), pl. VII, No. 4. Rouvèyre, *Corps*, 3 (*recto* and *verso*).

19130 (C. VI. 6)

14·7 × 21·7

Pen and ink.

RECTO

Three notes on human proportion, illustrated by drawings—a man's head in profile to right, a man's body seen down to the waist facing the spectator, a man's shoulders.

The notes and drawings marked: ø.

VERSO

Two studies of a male torso, and at right angles of a man's shoulders; to the right, studies of a left and a right leg, the left leg being on a larger scale.

Above, notes on the proportions of the chest.

The notes and drawings marked: ø.

THIS and the three following drawings, with 12304, seem to have formed part of the same note-book dealing with the human proportions. They all have on their *versos*, a vertical line in pen and ink near the right margin which must have been drawn when the fragments were still joined together. They must be dated *c.* 1490, perhaps in that year, as the sketch of a horse on 12304 would suggest, perhaps rather earlier, as is suggested by the drawing of a domed church on 19134-5 *verso* (VI. 10), to which see note.

The notes on the *recto* were copied in the Codex Huygens, ff. 55, 56 (respectively texts II–III and I in the *Quaderni* edition).

Bodmer, pp. 215 (*verso*), 216. Esche, p. 161. Panofsky, *Codex Huygens*, p. 45. Richter, §§334, pl. XIV, No. 2 (*recto*), 335, pl. XVI, No. 1 (*verso*). Rouvèyre, *Corps*, 10 (*recto* and *verso*).

19131 (C. VI. 7)

12·5 × 20·7

Pen and ink.

RECTO

Studies of the proportions of upper limbs with notes on the drawings.

The mark: ø.

VERSO

Study of the proportion of the foot in relation to the face, and a note on this.

SEE note to 19130.

Esche, p. 161. Richter, §§325 (*verso*), 347, pl. XIX (*recto*).

19132 (C. VI. 8)

15·9 × 20·8

Pen and ink.

RECTO

A nude man standing, facing the spectator, with arms outstretched. Another is kneeling beside him, to his right, in profile to right, so that his head just fits under the standing man's arm.

TO THE RIGHT

A nude man, seated in profile to right, measured for proportion.

TO THE LEFT

Notes on human proportion.

Notes and drawings marked: ø.

VERSO

A four-line note on proportion.

SEE note to 19130. Heydenreich (Introduction to McMahon's edition of the *Treatise on Painting*, fig. 3) maintains that this sheet was intended for inclusion in the Codex Urbinas because the notes are marked ø. But this mark was used by the compiler of the Codex Huygens as well. Compare 19130, 19136-9, etc.

Bodmer, p. 214. Chastel, p. 131. *Comm. Vinc.* fasc. VI, pl. 289, ii (*recto* only). Esche, p. 161. Popham, pl. 224. Richter, §§332, 333 (*verso*), 334, pl. VIII, No. 2 (*recto*). Rouvèyre, *Corps*, 11 (*recto* and *verso*). *Trattato della Pittura*, pl. 3.

19133 (C. VI. 9)

30·3 × 25

Pen and ink.

RECTO

Ten notes on the proportions of the foot and hand, with an illustrative sketch to each, each marked: o.

VERSO

Two more notes on the proportions of the foot, with drawings, also marked: o.

SEE note to 19130.

Chastel, p. 127. Esche, p. 161. Richter, §§322 (*verso*), 324 (*recto*). Rouvèyre, *Corps*, 4 (*recto and verso*).

19134–19135 (C. VI. 10)

44·3 × 32
Pen and ink.

RECTO

Notes on proportion, illustrated by numerous studies, four of whole upper limb held by the side; one with the elbow flexed and arm rotated to show palm of hand, and palm shown in relation to shoulder; standing male left and front views; right side of head, neck and chest; two rough sketches of flexed elbow and laterally rotated shoulder, hand half drawn in one and omitted in other; four sketches of humerus and ulna; and diagram of double cone and flat object with rounded ends.

L.'s No. 248.

VERSO

Plan and elevation of a domed church, and two drawings of arcading. Not reproduced in *Quaderni d'Anatomia*.

THIS drawing was originally folded in the middle, and for that reason is numbered as two drawings in the Windsor inventory. Richter's transliterations are taken in no order. The drawings for a church on the *verso* are similar to those in MS. B, but so badly drawn that they seem to be copies. It is perhaps part of the same series as the four preceding drawings. See note to 19130. If so, they may be datable before 1490, as this drawing has the closest relation to MS. B, both through the architectural drawing on the *verso* and the writing.

Some of the notes in this folio as well as in 19138–19139 are inscribed 'trezo' and 'caravazo'. These are the names of two towns in Lombardy, and they were taken by Solmi (*Nuovo Archivio Veneto*, Vol. XXIII, p. 22) as evidence of Leonardo's involvement with the military operations of Louis XII in the war against Venice in 1509. This is not the case. They designate the names of two persons used by Leonardo as models for his studies of proportions. Compare 19135 *recto*: 'il trezo'.

Bodmer, p. 202 (*verso*). *Comm. Vinc.* fasc. v, pl. 175 (*verso* only). Esche, p. 161. Firpo, p. 37 (*verso*). Richter, §§317, 336, 341, 348, 625, 707, pls. XVII, No. 2, XXXV, No. 1 (all applying to the *recto*), and vol. II, p. 32 (first ed. p. 44), fig. 1 (ground plan of church on *verso*). Rouvèyre, *Corps*, 12 (*recto* and *verso*). Venturi, *Storia*, XI, i, fig. 16 (*verso*).

19136–19139 (C. VI. 11)

40 × 28

Pen and ink on paper with the watermark of a lobed flower. (Briquet, 6560, 6596–7, etc.)

RECTO

Notes on proportion, three drawings of right arms, one flexed, across the chest two hanging straight. A man standing in profile to right, and a male torso, seen back and front. Each note marked: ø.

VERSO

LEFT

Very detailed notes on the proportion of the leg, illustrated by a right leg, seen from front and outer side.

RIGHT

Note on the proportions of the foot, illustrated by drawings of a left foot; and of the leg, illustrated by the leg of a man seated in profile to right.

Study of pulleys with notes on dynamics.

The notes on proportion marked: ø.

L.'s No. 16.

THIS drawing was originally folded twice, and so is numbered as four drawings in the Windsor inventory. See note to preceding drawing.

The notes and drawings on both *recto* and *verso* were copied in the Codex Huygens: those on the *recto* on ff. 57, 58, 68; those on the *verso* on ff. 64, 65, 66 (respectively texts VI, IV–V, VII, III, II, VIII on the *recto*, and I, VIII, VI on the *verso*, in the *Quaderni* edition).

Bodmer, p. 213 (upper half of *verso*). Esche, p. 161. Panofsky, *Codex Huygens*, pp. 45, 49, 51, fig. 33 (copy of lower half of *verso*). Richter, §§314, 326, 328, 330, 338, 1410, pls. XIII, XIV, No. 1 (*verso*), 339, 342, 349, pls. XVI, No. 2, XX (*recto*). Rouvèyre, *Corps*, 9 (*recto* and *verso* interchanged). Seidlitz, 1, 292 (repr. of top left-hand corner of *verso*).

19140 (C. VI. 12)

28 × 20·3
Pen and ink.

RECTO

Notes on proportions of the leg, with sketches of front view of standing, right, and outer sides of kneeling and lunging left legs.

Centre R. margin. Back of left arm, rotated outwards at shoulder, flexed at elbow with forearm pronated.

LEFT

Note on proportions of the ankle, with two illustrative sketches of a left and right foot.

OTHER WAY OF PAPER

Profile of a young man turned to right, and two other studies of the eyes and nose in profile. Also a geometrical figure resembling a wheel with curved blades like a turbine, carefully incised on the paper and carelessly gone over with ink.

The notes on proportion marked: ø.

VERSO

Small sketch of a spiked finial.

THE profile, eyes, and inking in of the geometrical figure are not by Leonardo. See note to 19134–5. Professor Favaro, *loc. cit.*, refers to the profile as that of a female and compares it to the later one in C. II. 23 *recto* (19093) pointing out how a vertical line connecting forehead and chin is shown in both.

The slight sketch on the *verso* recalls some of the elaborate weapons on the fugitive leaves inserted in the Paris MS. B, which were reproduced by Ravaisson-Mollien in appendix to his publication. They date from *c.* 1485–7.

Esche, p. 161. Favaro, *Atti del Reale Istituto Veneto di Scienze, Lettere ed Arti*, LXXVIII, Pt. 2, 1918, p. 142. Richter, §§323, 331, 345, pl. xv. Rouvèyre, *Corps*, 8 (*recto* and *verso*).

(C. VI. 13) is 12640.
(C. VI. 14) is 12632.
(C. VI. 15) is 12633.
(C. VI. 16) is 12634.
(C. VI. 17) is 12623.
(C. VI. 18) is 12639.
(C. VI. 19) is 12586.
(C. VI. 20) is 12614.

19141–19142 (C. VI. 22)

39·8 × 28·4

Pen and ink.

RECTO

Notes and questions concerning the human form and its representation in painting; and notes on painting generally, illustrated by a drawing of the skeleton of a right leg.

Nos. (?L.'s) 11 (19141) and 12 (19142).

Richter's Nos. 240 (19141) and 239 (19142).

VERSO (erroneously published in *Quaderni d'Anatomia* as 21 *verso*, i.e. as the *verso* of 19143–19144)

A column of notes on the actions of levers, pulleys and capstans.

THIS and the following numbers were originally four separate slips, which have been stuck together, side by side, to form one sheet. It is likely that the slips were originally joined together as they are now, or to similar ones which are no longer identifiable. This format was not unusual in Leonardo's time, and there were books the leaves of which were just as oblong as these slips. Italians call them *vacchette* after the parchment of their binding. They were used to keep records of the activity of public or ecclesiastic institutions, and in fact the *Libri dei Morti* of the hospital of Sta Maria Nuova in Florence are of this type. Leonardo used this system of compilation quite frequently from after 1504, although there is no evidence that he ever had such sheets bound in volume form. Folios 190–1 of the Arundel MS. and several others in the same MS. were originally *vacchetta* sheets, and the columns and memoranda should be considered as they run from one folio to the other. See also '602 which is certainly of the same category, although it is kept open flat.

The notes on painting are related to those in *Libro A* (*loc. cit.*) just as the programmes of anatomical representations in the adjoining slips (19143–4) are related to the middle sheets in the Anatom. MS. B, e.g. f. 15 *recto* and seg. Compare also '636 and '642 *verso*. Thus these slips can be dated *c.* 1506–8.

Similar notes on levers, water and the measurement of the curvature of the surface of the earth (19143–4) are found in manuscripts dating from *c.* 1507–8, e.g. MS. K, vol. III, f. 79 and seg., and MS. F, ff. 69, 82, 83 and *passim*. The diagrams have the same neatness and precision as those in MS. D, *c.* 1508.

Pedretti, *Libro A*, p. 34, note 8. Richter, §§269, 365 (both 19141 *recto*), 811 (19142 *recto*). Rouvèyre, *Peint.* 12 (*recto* and *verso* interchanged).

19143–19144 (C. VI. 21 *recto*)

10·4 × 28 and 10·2 × 28

Pen and ink.

RECTO

LEFT

Three anatomical studies of a male torso with viscera and a note thereon.

A column of notes on the nature and action of screws, and on dynamics.

The skeleton of a left foot with a note on its mechanism and on balance.

Nos. (?L.'s) 13 (19143) and 14 (19144).

VERSO (not given in *Quaderni d'Anatomia*)

Notes and diagrams on the measurement of the curvature of the earth at sea level, on water, and on weight transliterated below.

No. (?L.'s) 10 (19144).

Richter's Nos. 237 (19144) and 238 (19143).

The notes read as follows:

19143

per mjsurare quanto la superfitie dellacq^a cha|La per mjglo ——

S p q t sia larcho della spera | dellacq^a o p sia lo stile delljuello po|sto per (*p*) djritto a pionbo al centro | del modo .r. / b̲ a̲ sia .il piano del | liuello elliangoli c̲ o̲ sieno ret|tj stabilito che e cquesto alto 2 | br (*fe*) o circha sopra la pelle inmo|bile dellacqua morta ettu met|ti vnaste lontana vn 4 dj mjglio | posta per djritto al centro del mondo | sopra la pelle della medesima acq^a | morta

e cosi arai $\frac{1}{4}$ dj mjglio | (*che*) dal pie dellaste delliuello alpi|e dellaste possta a riscōtro a esso | liuello ecquesto 4° dj mjglio e br | 750 essendo il mjglo 3000 br | el br sintende dalla guntura della mano alla gūtura della spalla | Ora tornādo al nostro intēto | piantato che ttu aj tale aste | a riscontro alliuello ettu tolli la | linja retta chessifara col foco po|i la notte ma pure per ora fara|i dj dj cōnelegere omjnj dj bona | vista e guada collordjne del | liuellare doue lalinja visua|le batte nellaste antiposta ellj fa | fermare la tua mjra . la qual | sanza dubbio sara piu alta da|la pelle dellacq^a che nō fu lal|teza della mjra nelliuello come mostra la rettjtudjne a b d che | (*la*) si taglia nellaste n̄ p̄ nel pū|to n il quale n̲ e piu alto da|la pelle dellacq^a (*tutto los*) che nō | fu o̲ mjra delliuello tutto losspa|tio (*m*) m̲ n̲ e esso spatio ella | vera mjsura quāto (*ca*) djscēde | la volta della(*cqu*) spera dellac|qua in tal sito per ognj 4° dj mj|glio esse(*lla*) voj fare tal liue|lamēto a vno spatio dū mjglio | coe 3000 br fallo dj notte efe|rma illiuello e fattj porre illu|me duna medjocle candela aris|sconto lontana dal pie delliuello | vno mjgljo effa inessa aste alza|re o abassare illume sopra dellas|ste eltuo segnare dellalzare eaba|sare acquel che ttiene illume faraj tu col mouere vn lume | chettu tienj inmano . (*e tu*) ettu torai la mjra nel centro | dj tale lume posto per mjra el quale debbe essere tō|.do .el quale tondo faraj conuno (*pe*) spiracol tondo fa|to nvna piastra dj ferro allato a esso lume —— 4

[*following Leonardo's reference*, '4,' *to a marginal note*]

Essappi chelleccesso | dello spatio (*che a o*) | nel quale lalteza del. | centro dellume eccede | lalteza della mjra del|liuello ellauera quā|tita della declinatione | cheffa la

pella dellacqua | morta inognj spatio | dj mjglio ancora aj | a intendere chessettale | eccesso fussi vnōca | vna liuellata dj due mj|glia nō sarebbe dj pun|to due once ma al|quanto piu e vna li|vellatura dj 4 mjglia. | nō farebbe 2 volte | quello alquāto piu | mallo uarierebbe i|nacresscimēto in mo|do che in cinque mjla|500 mjglia fatte nuna | medesima liuellatura | lultimo mjglio areb|be tanto dj calo dal tuo liuello quasi quato es|so ellūgho.

19144

acqua

come lacq^a delle cime de mōti ne ne|suna altra acq^a (*p*) che sia piu alta | chella spera dellacq^a cene congunta | conessa spera dacqua ——

prouasi sella bilāca dellacq^a a c d e epie|na dacq^a nel a c ēnel d̲ e̲ (*do*) leccesso del | a̲ c̲ che glia sopra d̲ e̲ coe tutta la parte a̲ b̲ | dellacq^a usscira per d̲ e̲ e cosi restera rāo [=resteranno] le | superfitie dellacq^a b̲ d̲ nelsito delle equalita.

sol quella cosa mostra sua graueza che e sanza | sostentaculo ——

Lacq^a d̲ n̲ della cāna d̲ e̲ nona sostētaculo perche | sel c̄ ḡ suo sostētaculo nona potētia senō per 4 | ella potentia del d̲ e̲ he b eujresta 2 sanza | sostentaculo il quale subita djscēde effugesi del | (*la sua*) suo sito ——

Jl polo della bilanca dellacq^a unjta e posto nel | centro del mōdo e cosi e dj tutta la graujta na|turale dj qualūche peso nellaltre bilance ——

BELOW two diagrams:

cētro del | mondo.
centro del | mondo.

AND, to the left, the note

Li pesi naturalj stanno equalmēte djstantj dal | centro del mōdo e dal polo della lor bilanca coe | dalla linj centrale dellj due pesi insieme pres[i].

BELOW this two diagrams and the note:

Jl peso acidentale nelle bilance nonesta e|qualmēte djstante (*dal cētro del*) col ceso natura|le al cētro del mōdo matanto piu lontano in | proportione arismetrice quanto (*il*) li pesi | naturalj postj nelle bilance (*sono mag*) eve|dano luno laltro —— come sel peso a fu|si 8 el peso b̲ fussj leccesso sarebbe 7 ad|dunque lecesso delle djstantie che ano li 2 pesi | a̲ b̲ dal centro del mōdo d̲ cheson liecciessi m̄ ā | el f̲ p̲ adunque la djstantia f p . riceuera inse | 7 volte le djstantia m̲ a̲.

O'MALLEY-SAUNDERS (*loc. cit.*) maintain, without giving any reason, that the anatomical notes are later than the notes on mechanics, and that should be dated *c.* 1513. The notes on the *verso* of both slips are translitered here for the first time. See note to the preceding numbers.

Esche, p. 163, fig. 162 (detail of 19143 *recto*). O'Malley-Saunders, 78. Richter, §807 (note on 19143 *recto*). Rouvèyre, *Peint.* 12 (*recto* and *verso* interchanged).

(C. VI. 23) is 12637.

The following sheets are not reproduced in the *Quaderni d'Anatomia*, but are bound into the end of the same volume as the Anatomical MS. C and numbered to follow on.

19145

SEE entry under 12658.

19146

6·7 × 13

Pen and ink.

Sheet of pinkish paper, with a few numbers scribbled on. Richter's No. 25.

19147–19148

29·4 × 41·5

Pen and ink on white paper, with the watermark of a lobed flower. (Briquet, 6560, etc.)

RECTO

Sheet of notes on the geometry of optics, illustrated with diagrams.

L.L.

A right profile squared for enlargement, and at right angles to it a left profile. Not by Leonardo.
The notes read as follows:

TO THE LEFT (19147)

se vo mensura laltezza duna mõtagnja sapi chesse nella superiore fighura tu troveraj /a/b/ | entrare 4 volte ī /b/e/ e po djssosstãdoti truovj /c/d/ entrare j̄ /d/o/z/ sapi | che la mõtagnja cioe da /n/f/ saralta quãto e da /d. o //.

TO THE RIGHT (19148 above)

se volessi mjsurare quãto e dalla superfizie della terra | al ciẽtro della terra abbi losstremẽte /b/ e djrizza la linja | /b/r/chollochio alla tramõtana e nota il pionbo dove bate | nella faccia (ch) dello sstrumẽte che ssimosstra alla terra equjvi nota | dove qujvi batte dj poj muta vn altro paese e rjfa quel medesimo | e rimarra segnjato chomel triangholo /g/ e quello nota che quãto | /n/o/ entra jn /o/f/ tãto aqu ẽtra el paese che ttu aj ciercho dalla | superfizie della terra al ciẽtro della terra e quãto /f/t/ẽtra j̄ /t/g | tanto ẽra jl paese chetti djsschosstassti (f). dalla superficie della terra | alla tramõtana.

BELOW

per sapere che djsstãzia over longitudjne sia dalla super-fizie | della terresste macchina al suo ciẽtro se jtẽderaj | jl chõchorso delle piramjdate linje partite dalla | issteriore e ssuperfiziale basa echõgivnte allo infe|riore e dequjdjs-stãte ciẽtro chiaro e chapacie re|ssteraj della lõgitudjne dj dette linje.

e chõ quessta medesima reghola troveraj quãto sia | djntervallo dalla terra al settãtrionale polo efferma|mẽto

(*che*) benche dagli ochj vmanj maj fussi veduto | pervre se noteraj il ciẽtro del mjnor cierchio fatto dalla | piv propinchua stella facillissimamẽte araj la djsstãzia | dj detta altitudjne.

Ma quãdo tu mjsuri ilciẽtro nel mutar paese riosserva | losschontro della tramõtana Esse uoraj misurare lal|teza della tramõtana nel mutato sito rischõtra il piõbino al primo segnjo del cientro della terra.

VERSO

A sheet of notes on the geometry of optics, illustrated by diagrams; also a drawing of a vice.

The notes are transliterated in Richter, §130, except for two paragraphs on the right-hand side which are in Richter, §62, and three other paragraphs, which read as follows:

Ōnie qualūque chosa e atta (*a vedersi*)ʌa dar dj se allochio alchuna formaʌī seʌeʌchausa | Jnfinjtj (*linje*) āgholiʌe linje ecqualiʌequalj issparti per laria perissp[a]zio dj duplicha|-da chagione ciasschuno degli oppositi anghola givntj acchio (*per*) | gli danno vera chapacita dj tutta lor deri-vazione.

cio che chognjosscivto | nelle peramjde | a derivazione da|le loro base.

lapriete /a/b/e tutta nellaltra / c/d/| ede tutta in ognj minjma parte dj quella.

DATABLE, *c.* 1483–5. The writing is even earlier than that in the MS. B, and yet it is identical with that on the *verso* of the drawing in the Royal Library at Turin, no. 15578, which is related to '632 and '634, and to metal-point drawings (invisible in reproduction) in the Trivulzio MS., ff. 3 *recto* and 4 *recto*. It is the type of writing that occurs in several folios of the Codex Atlanticus dating from the first years of Leonardo's activity in Milan, e.g. f. 324 *recto*, which is also of identical format and type of paper, and which contains the famous list of works which Leonardo had taken along as he moved to Milan. The author of the profiles and scribbles (note the words *Jo faro*, with the *J* turned into a grotesque profile) is probably the same who did the classical heads on f. 324 *recto*. Notes on how to discover the breadth of a river, similar to that on the *recto*, are in MS. B, f. 56 *recto*, and in folios of the Codex Atlanticus dating from *c.* 1485, e.g. f. 329 *recto*-b (see *Windsor Fragments*, pl. 23). Notes on optics similar to the ones on the *verso* are found in the earliest sheets of the Codex Atlanticus, e.g. f. 353 *recto*-b, *verso*-b, which also contains a drawing of a mechanism related to the vice on the the *verso*. In the Codex Atlanticus, f. 269 *verso*-a, *c.* 1485, Leo-nardo describes an instrument of his own invention to measure the distance from the surface to the centre of the earth. (Cf. M. Baratta, *Leonardo da Vinci e i problemi della terra*, Turin, 1903, pp. 53–5.) The same instru-

ment, in a preliminary stage, is referred to in the notes and diagrams on the *recto*.

Richter, §§62, 130 (notes on *verso*). Rouvèyre, *Géom.* 9 (*recto* and *verso*).

19149–19152

43·7 × 31·4

Pen and ink.

The sheet was originally folded twice, and is now opened out, so that the writing on 19149 and 19150 is the other way up to that on 19151 and 19152. Watermark resembling a bull's head.

RECTO (19149)

Notes on the geometry of optics, illustrated by drawings. The notes given in Richter, §77, except for one line between lines 8 and 9, which reads as follows:

del moto delle spetie delli obbietti (*nj*) ĩmobilj.

R.U. (19150)

Notes on the colours of the rainbow, illustrated by an eye looking through a spectrum, and light falling through a glass of water. The notes given in Richter, §288.

L.L. (19151)

Notes on the geometry of optics, illustrated by two diagrams. The upper paragraph given in Richter, §80, the lower in Richter, §47, except for five lines at the bottom, which read as follows:

come ognj grā quātita manda | fuor dj se le sue spetie le quali sono | inpotentia dj djmjnuire injfinjto ——

Lesspetie dognj grā quātita essendo djuisibile injfinjto son dj|mjnuitiue injfinito.

R.L. (19152)

Notes on the same with diagrams. Drawn over the notes in red and black chalk is a nude man, bending down to the left, as if pulling a rope, drawn from behind and right.

The notes given in Richter as follows: main column, top paragraph, §79, two central paragraphs, §274, bottom paragraph, §81; right-hand column, above, §73, below, §79.

VERSO

L.U. (19150 *verso*)

Notes on the geometry of optics, with illustrative diagrams. The notes are given in Richter as follows: top paragraph, §66, central paragraph, §270, bottom paragraph and two small notes in right-hand column, §78. Vertically to these, and drawn over in red chalk, a sketch of right side of a nude man in the same attitude as that on the *recto*, and traced through (or vice versa) when the paper was folded.

R.U. (19149 *verso*)

Above. Sequence of five postures of man using an ax or a chopper seen from left, two smudged sketches seen from front and right side, with a short note.
Below. Notes on the geometry of optics, with a large illustrative diagram; the notes given in Richter, §183.

L.L. (19152 *verso*)

Notes on the geometry of optics, with three large diagrams showing the interruptions of rays of light, and notes, given in Richter, §81, except a paragraph at the bottom of the centre column which is §120.

R.L. (19151 *verso*)

Notes on optics, especially concerning the interaction of colours, with a diagram showing balls of coloured light and their rays acting on one another. Another smaller diagram, similar to that on R.U. The notes given in Richter, §276.

THE men beating should be compared with 12641 *verso*, which is datable *c.* 1508. The red chalk figure does not appear to be by Leonardo, either in the original or in the tracing. It might be by the same pupil who did the red chalk heads on '639 *verso*, '654 *recto*, and '663 *verso*, i.e. Melzi.

The notes on optics and on light and shade all connect with notes and drawings in folios of the Codex Atlanticus dating from *c.* 1508. Compare particularly folios 190 and 345 (*Libro A*, p. 146, and pl. 25). The notes on the eye and problems of vision are related to MS. D and to 19117 *recto* (*Quad. Anat.* IV, 12 *verso*). It was out of such sheets folded twice, so as to form four pages, that Leonardo was making note-book signatures. He compiled these sheets according to a printer's system, i.e. the notes in the upper half of the sheet are on the other way to those in the lower half.

Berenson, 1192. Richter, pl. V (19149 *verso*), and as noted. Rouvèyre, *Peint.* 8, 9, 10, 11 (each half reproduced separately). Steinitz, *Leonardo da Vinci's Trattato della Pittura . . . A Bibliography*, Copenhagen, 1958, p. 20 (19149 *verso*).

PLATES

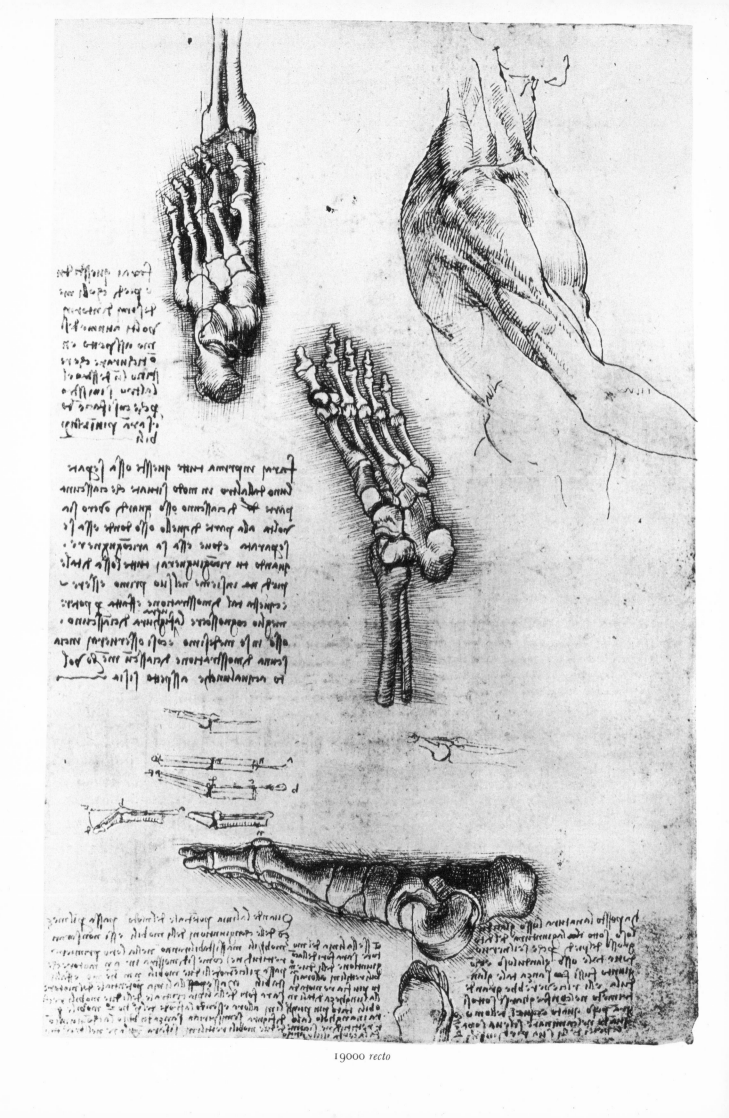

19000 *recto*

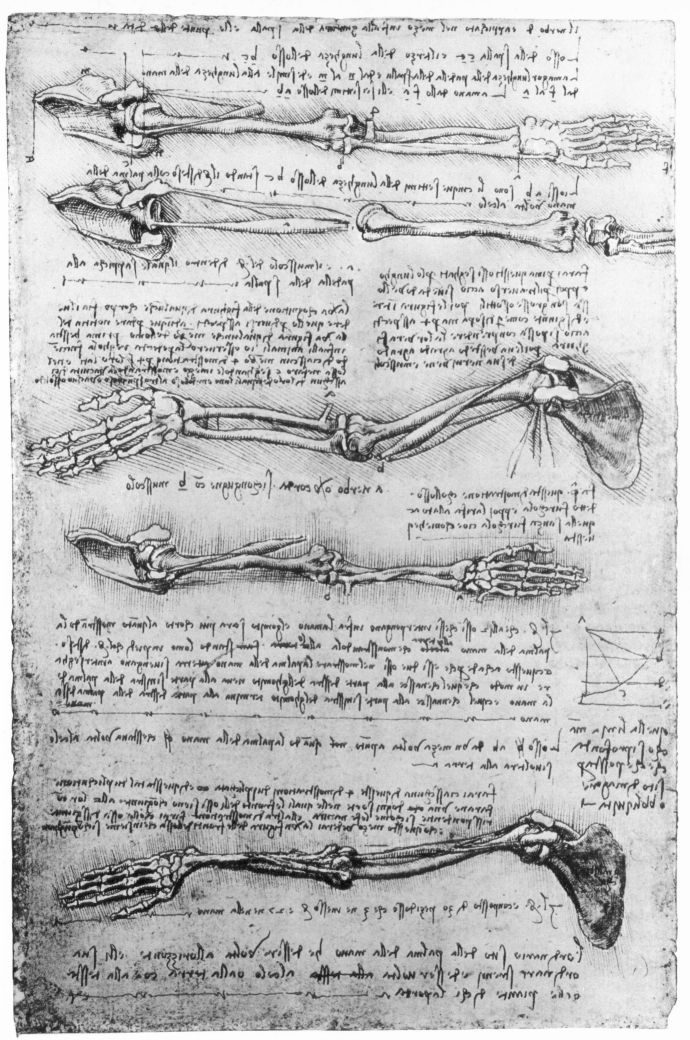

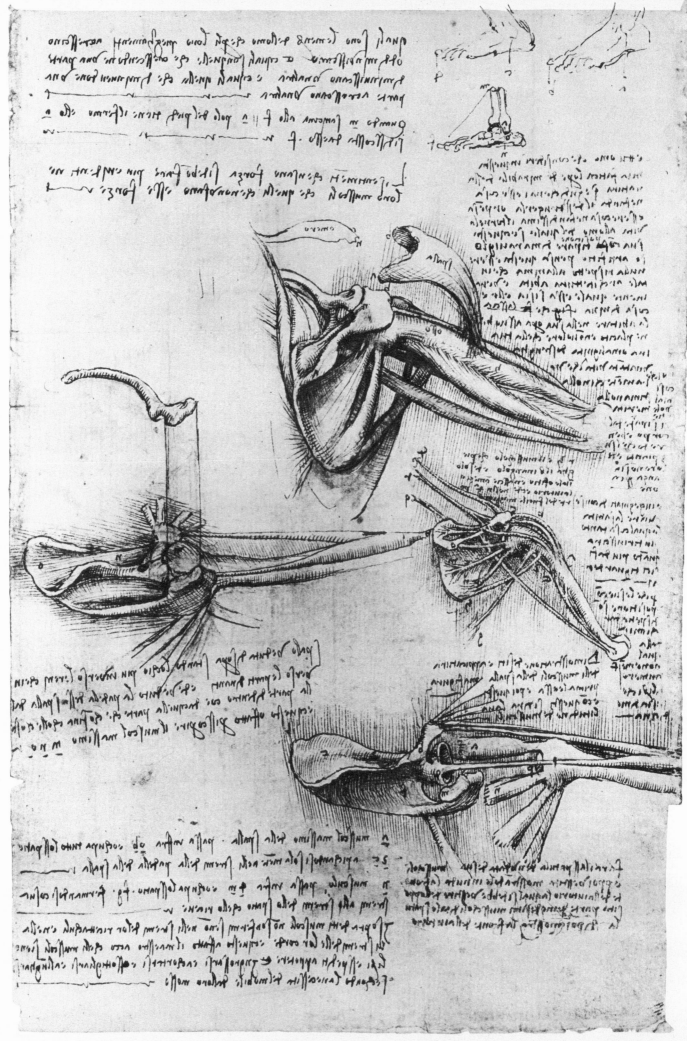

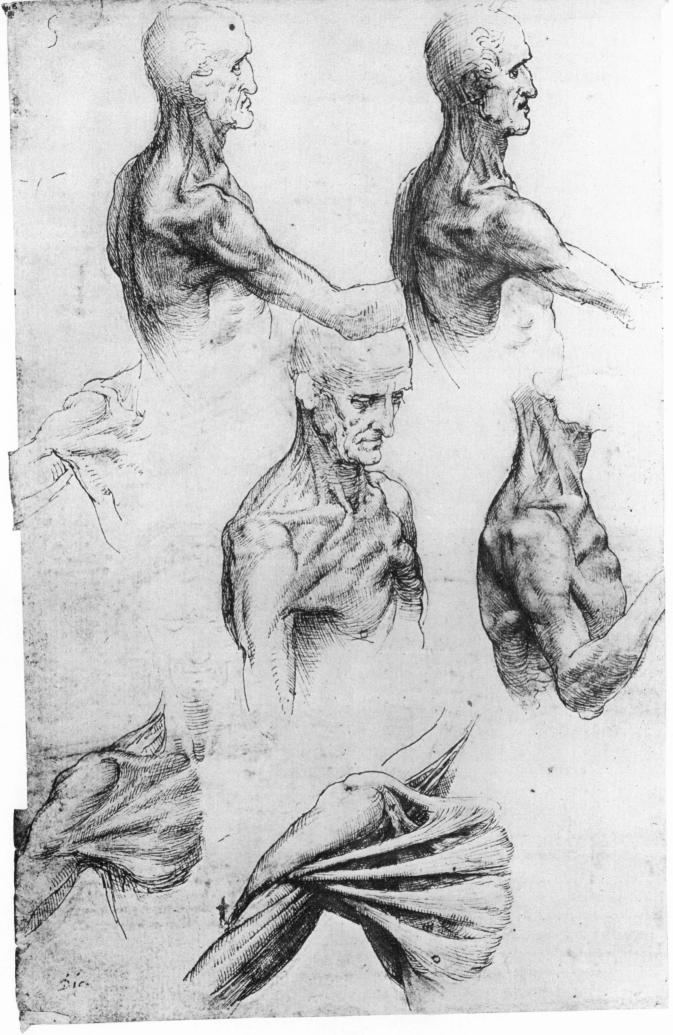

19001 *verso*

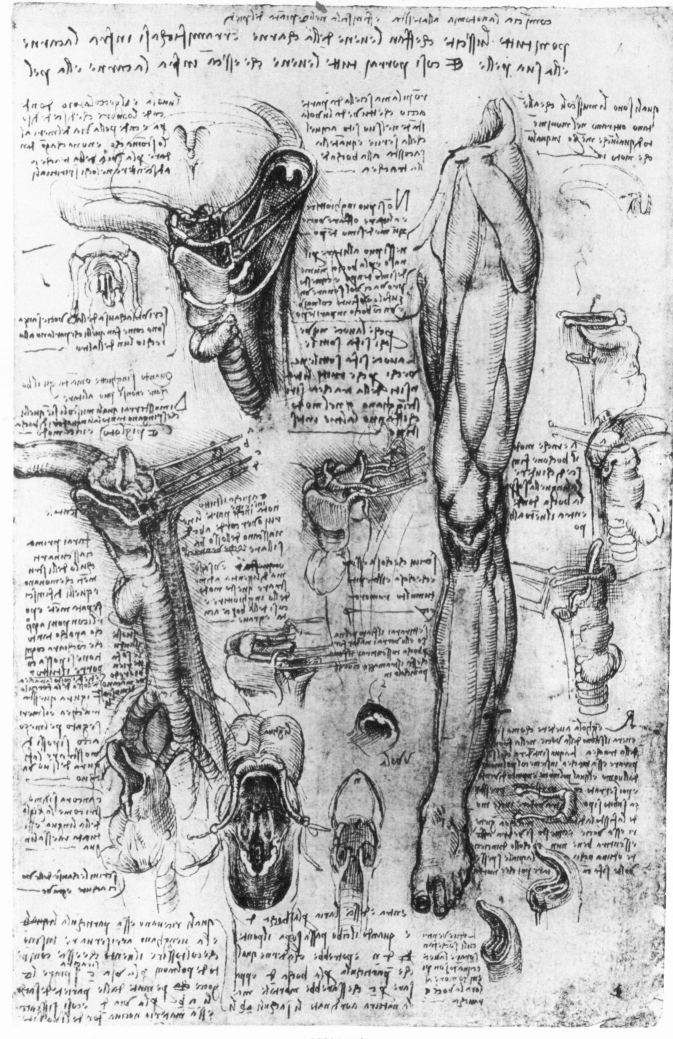

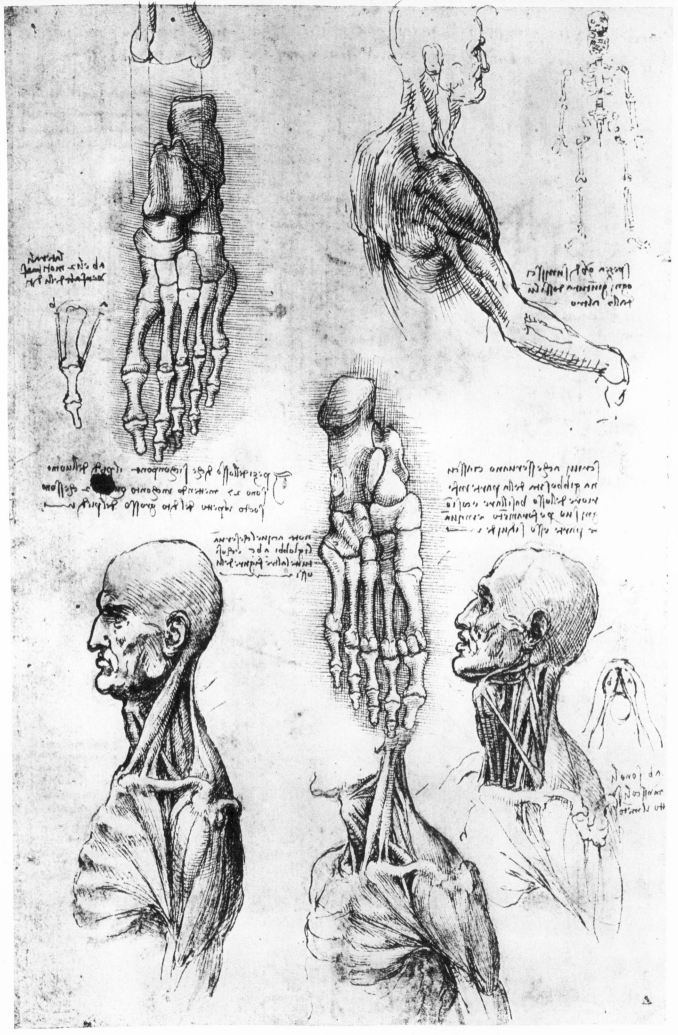

19002 *verso*

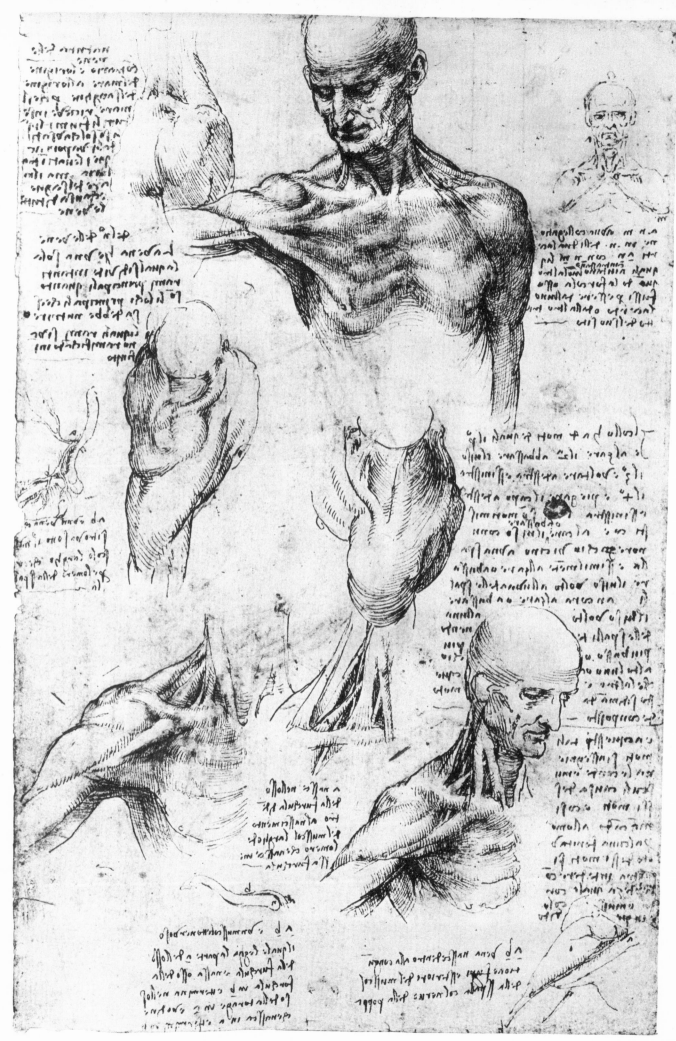

19003 *recto*

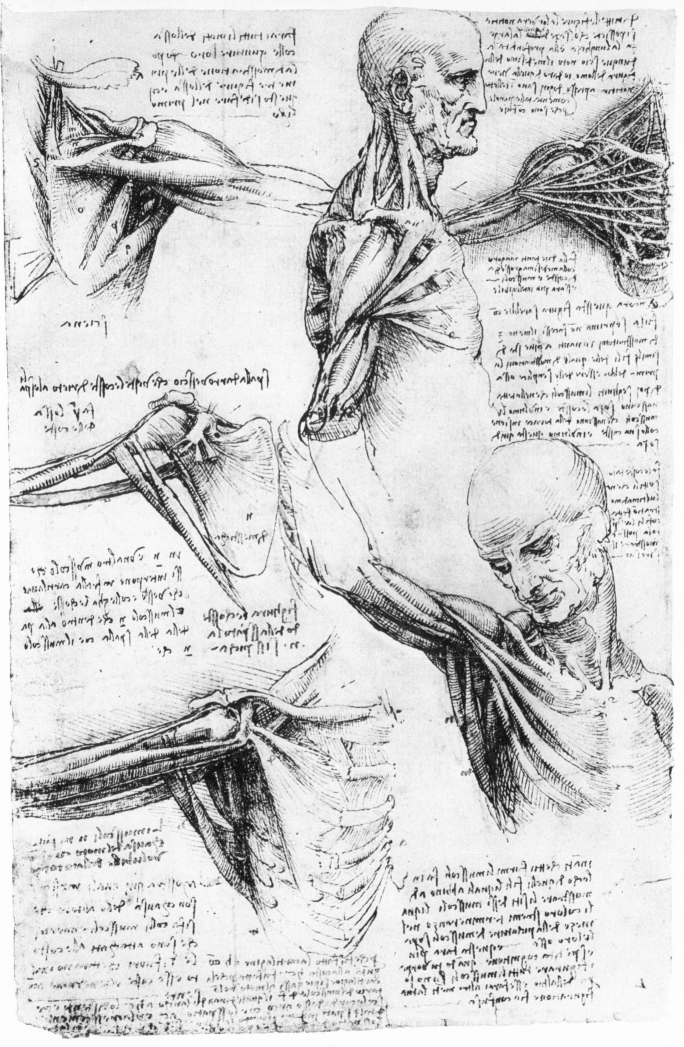

19003 *verso*

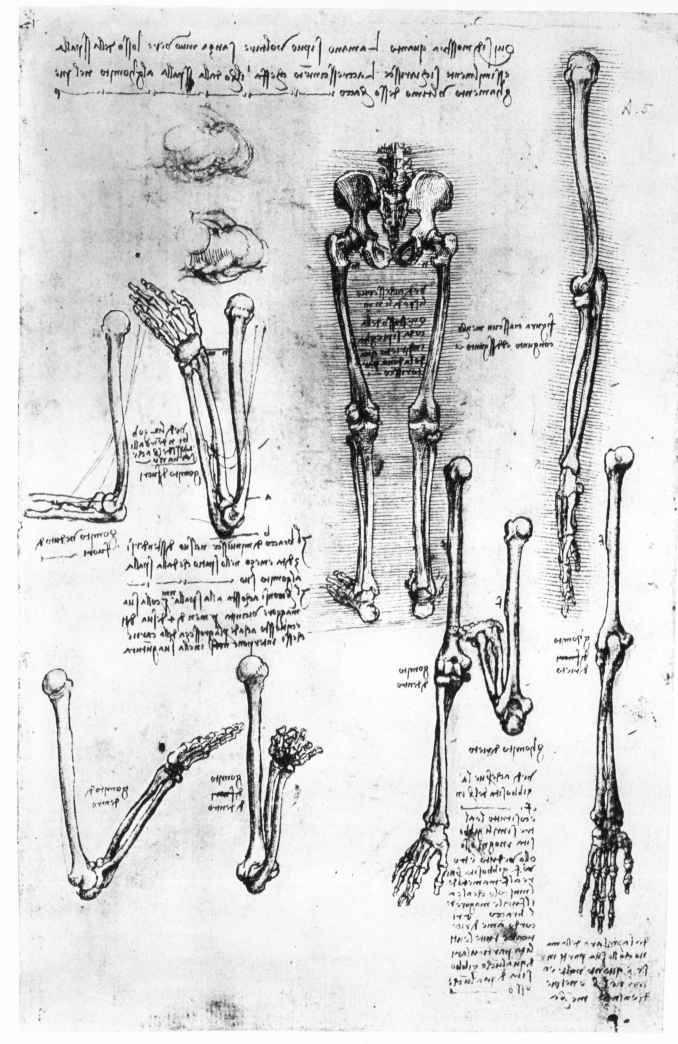

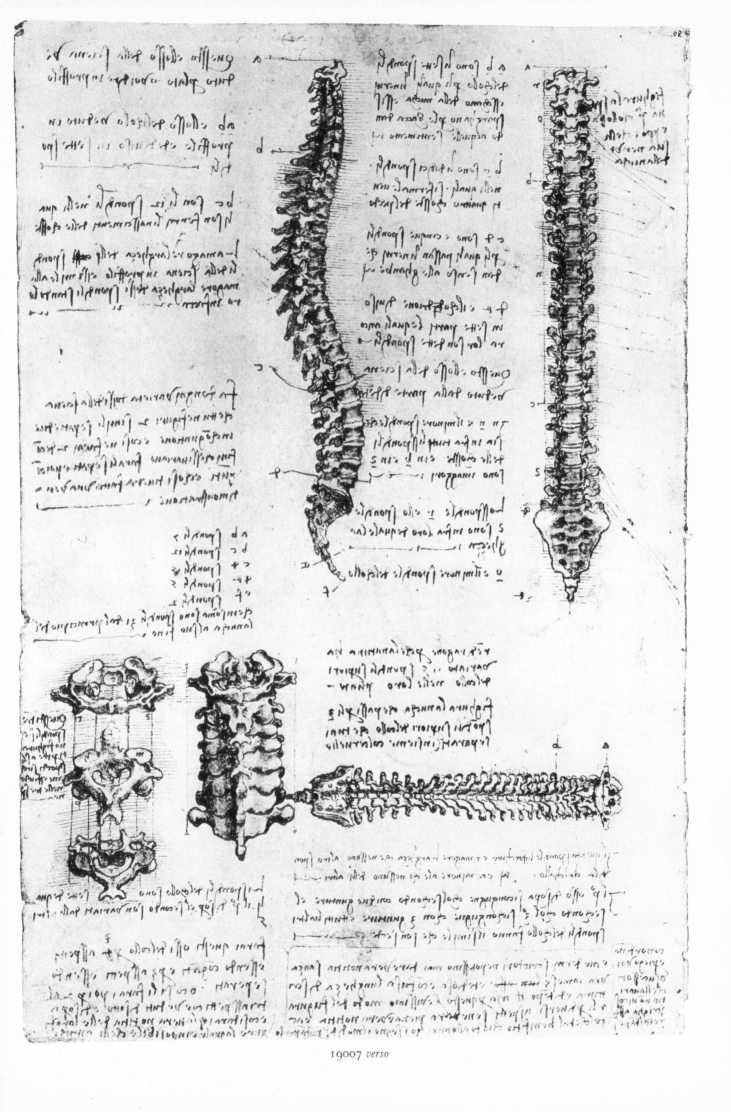

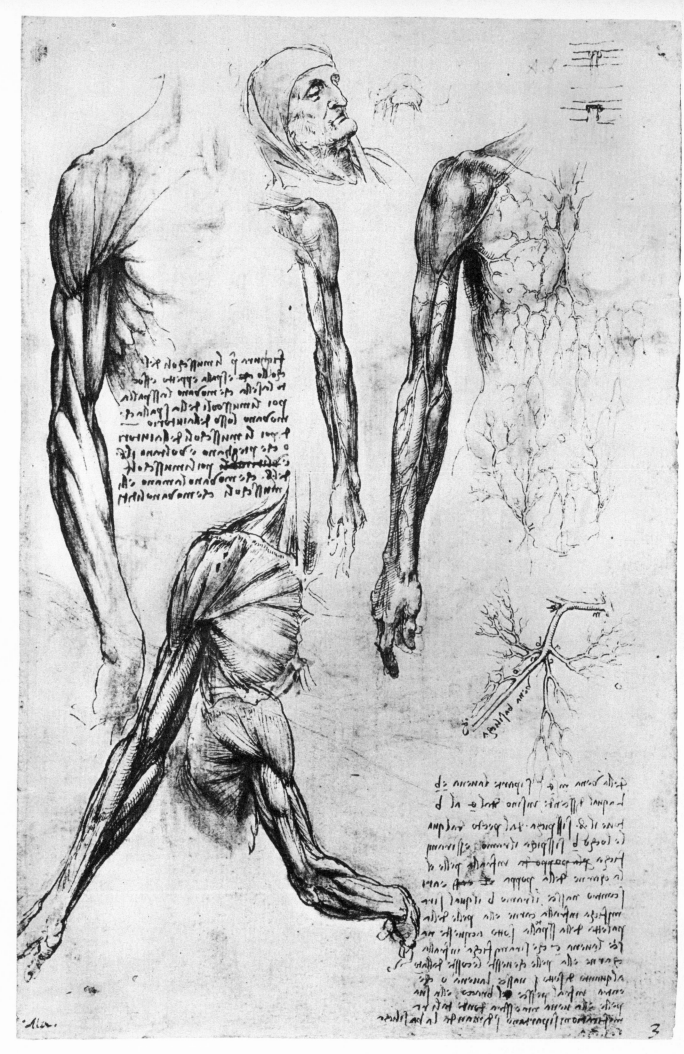

19005 *recto*

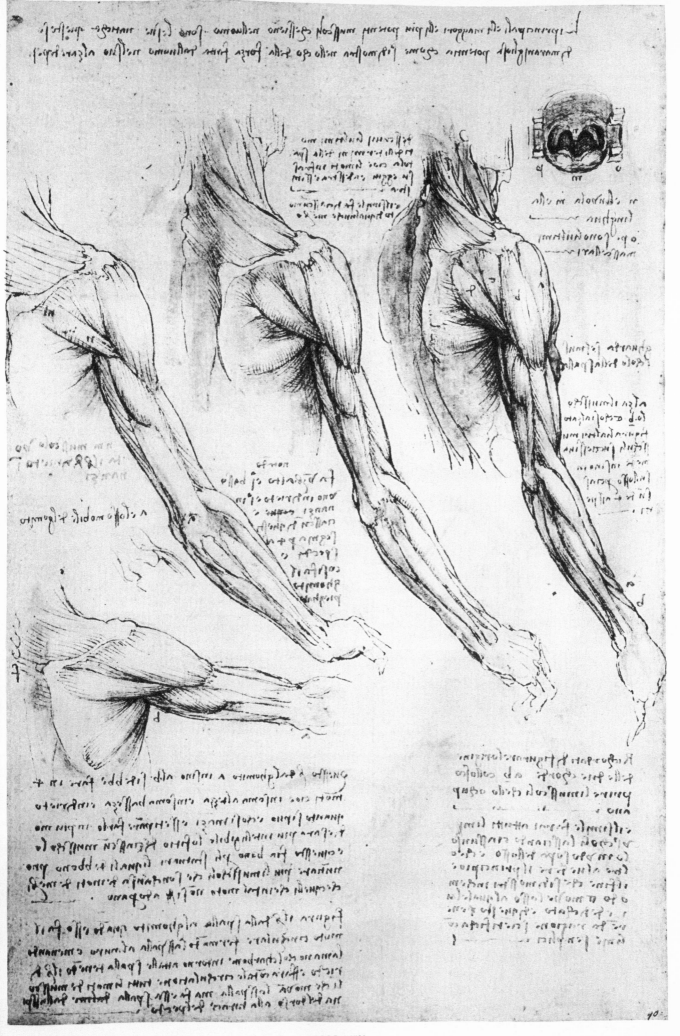

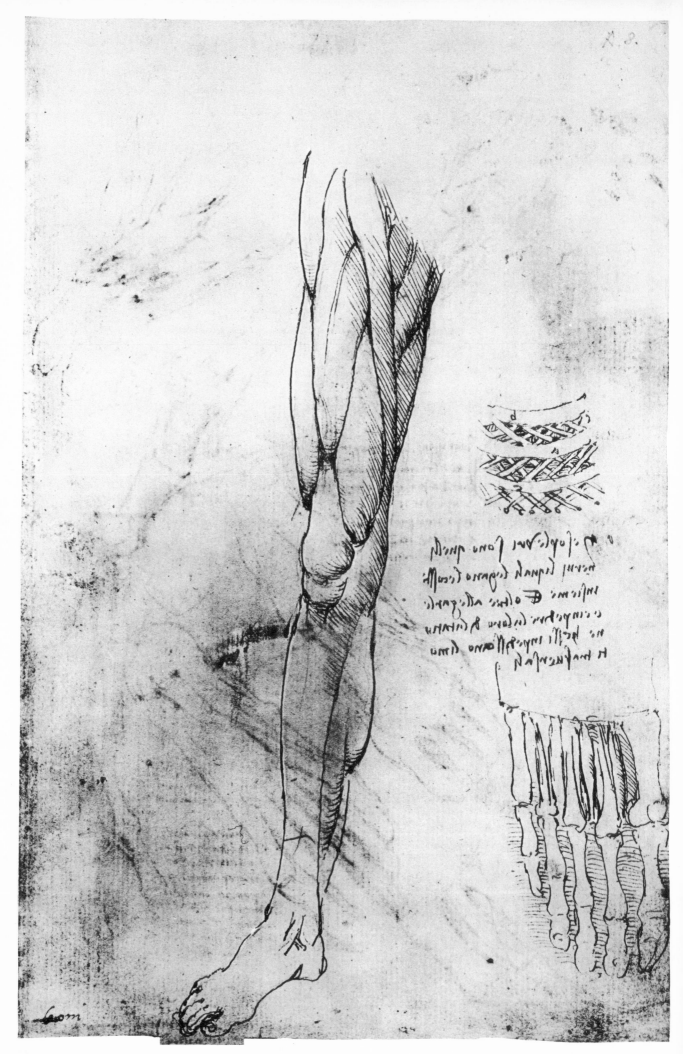

19006 *recto*

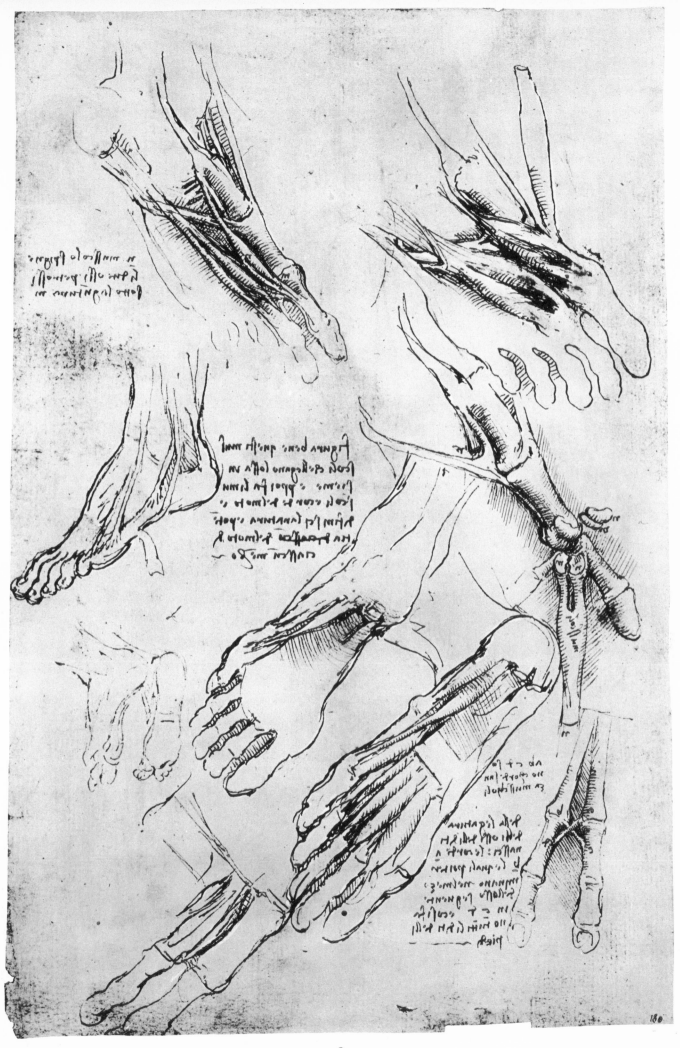

19006 *verso*

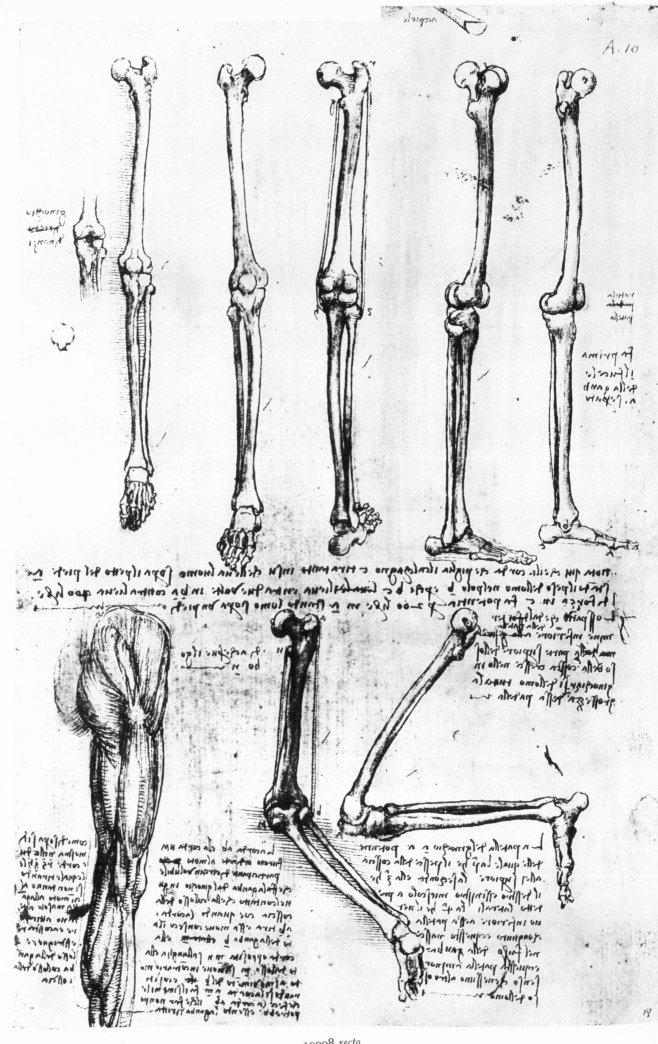

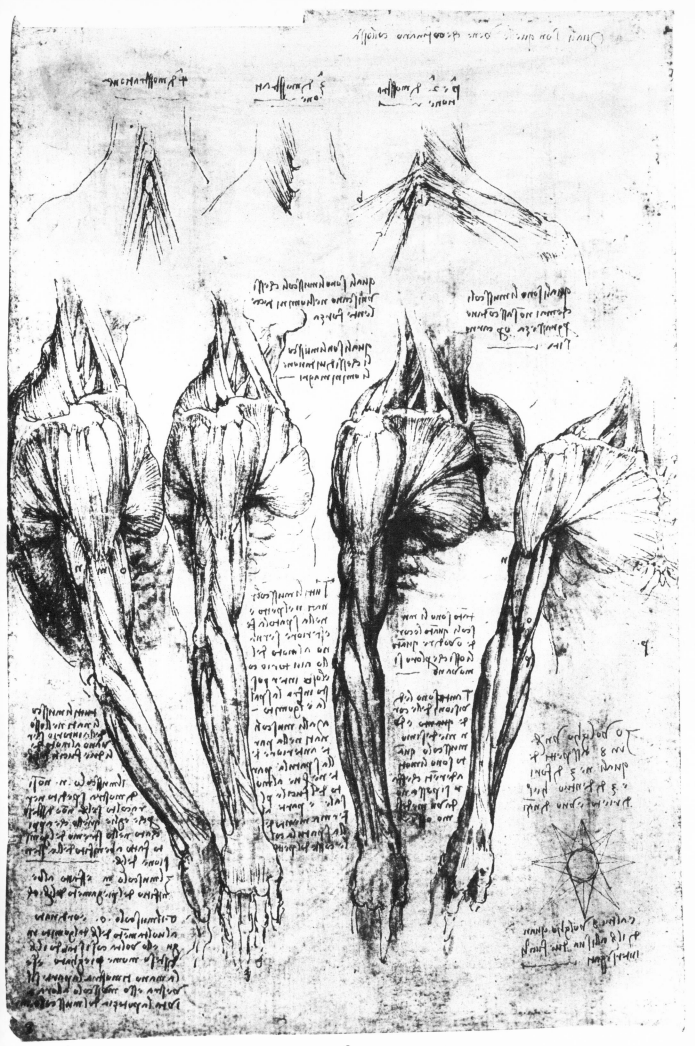

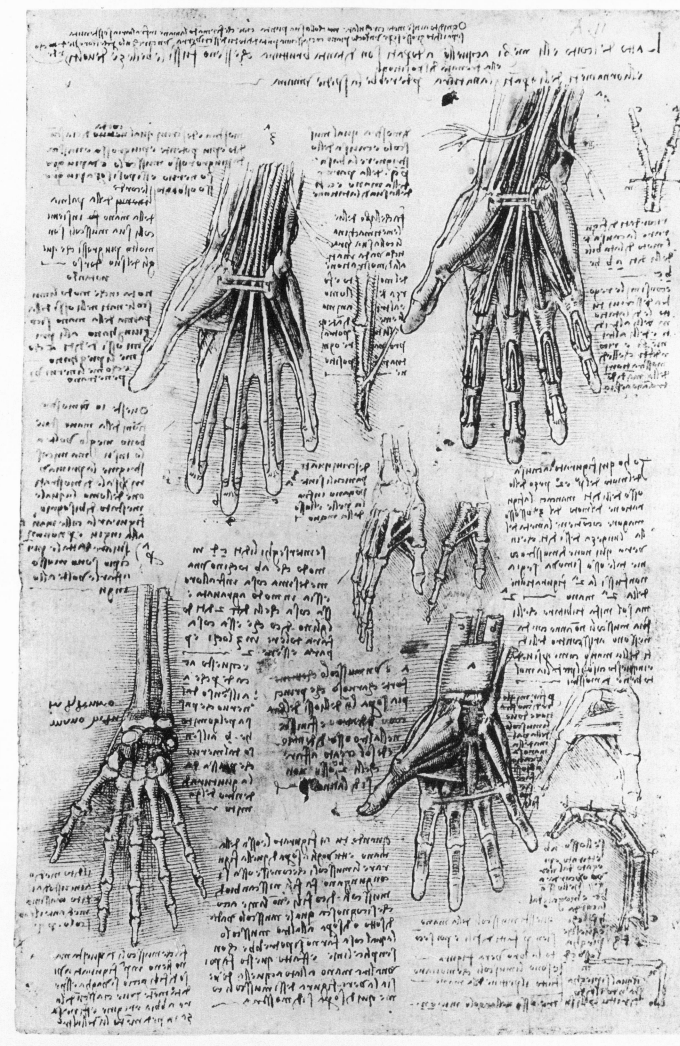

19009 *recto*

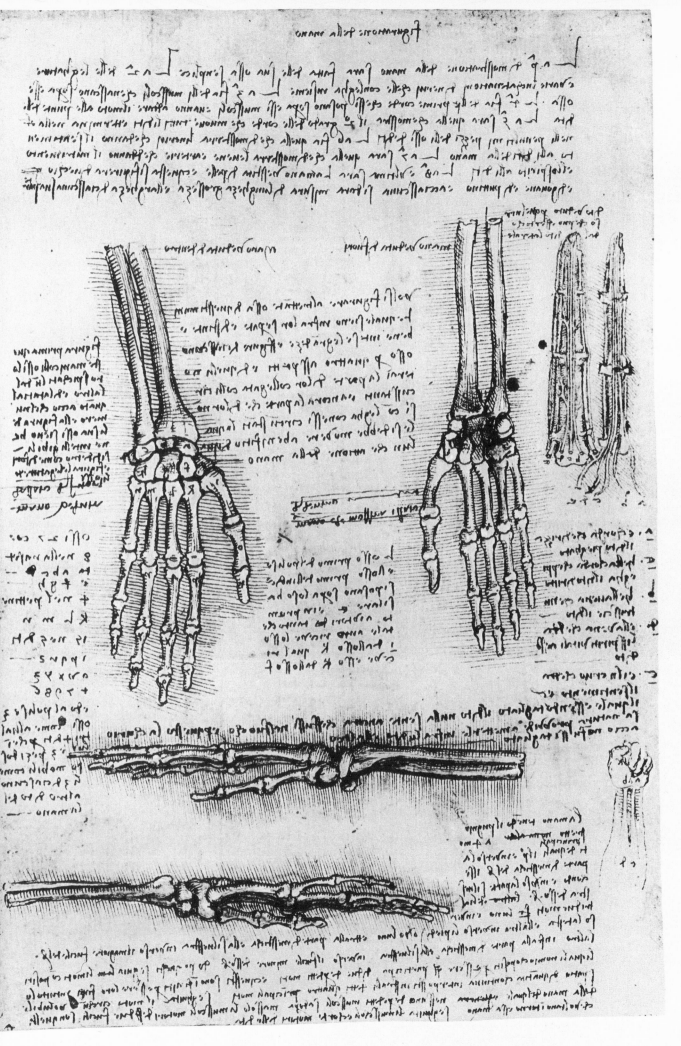

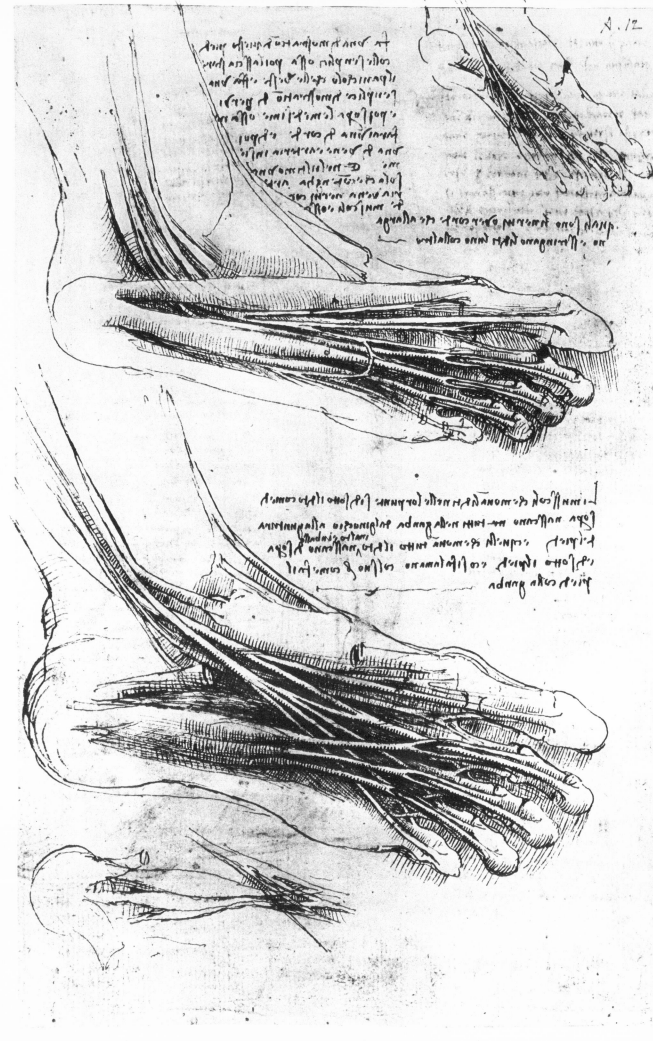

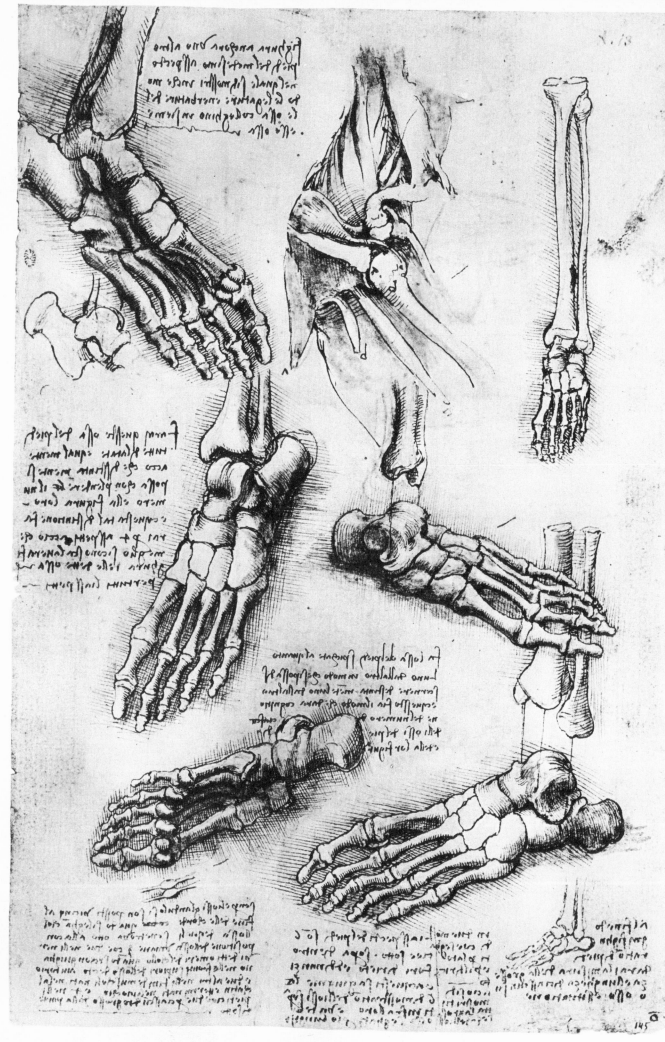

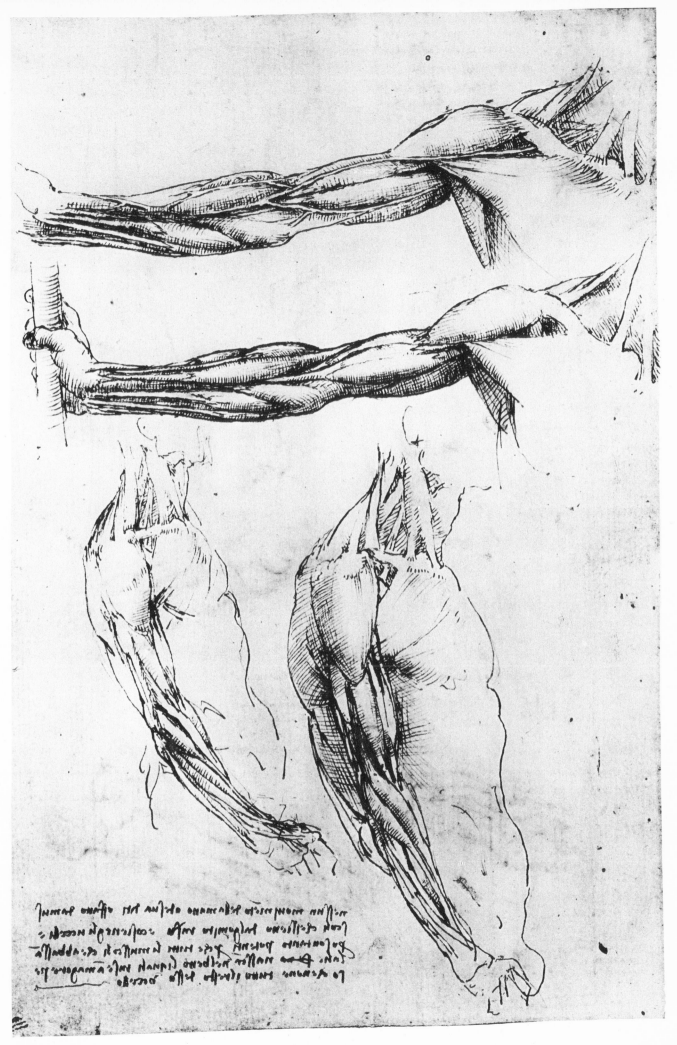

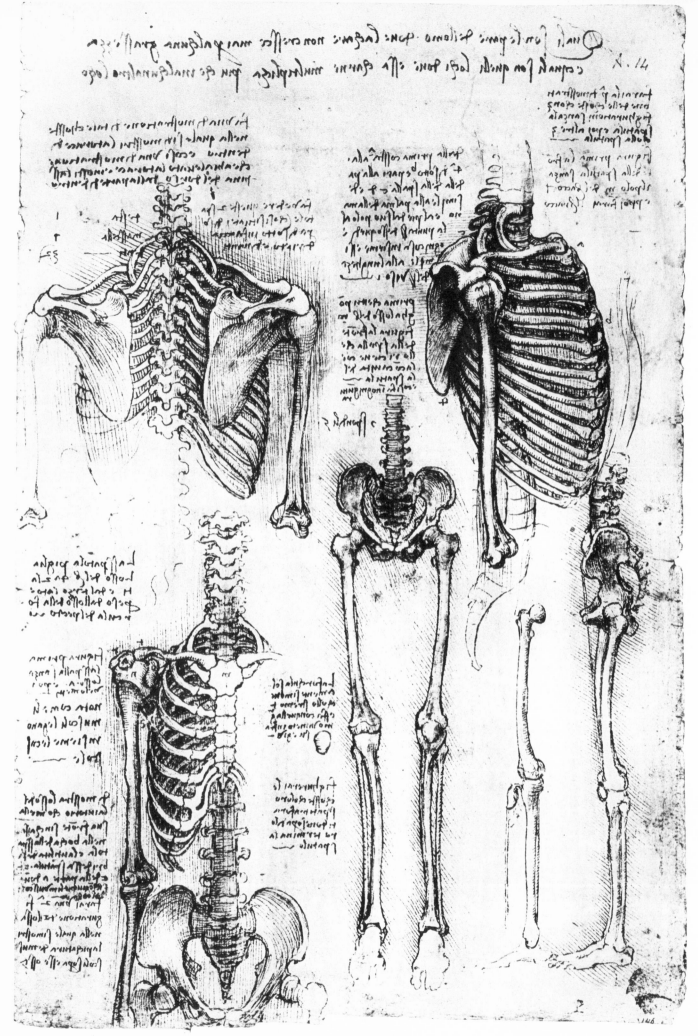

19012 *recto*

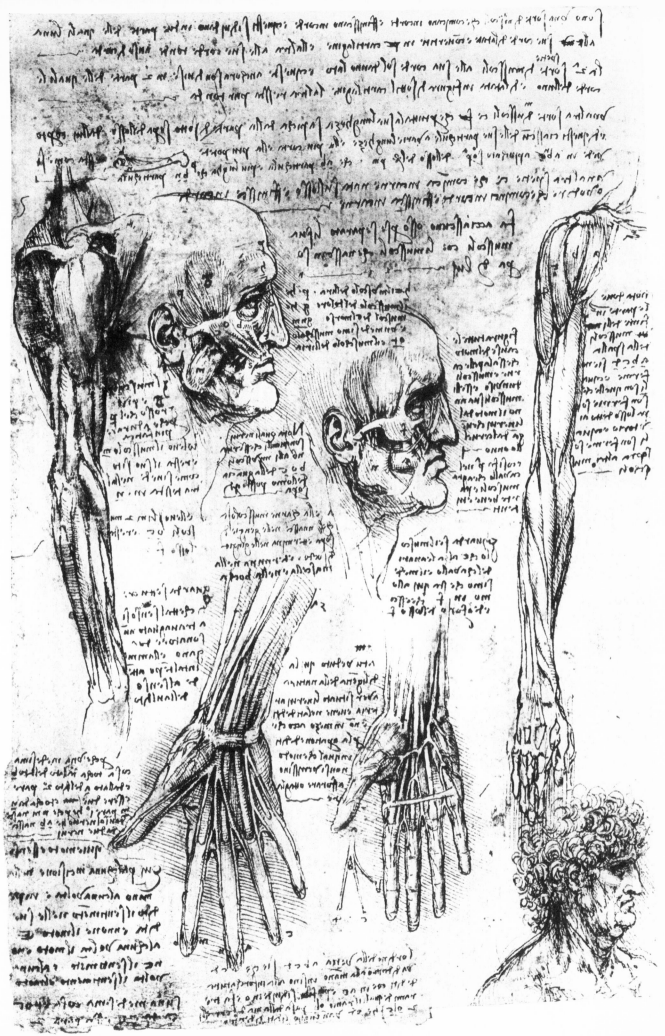

19012 verso

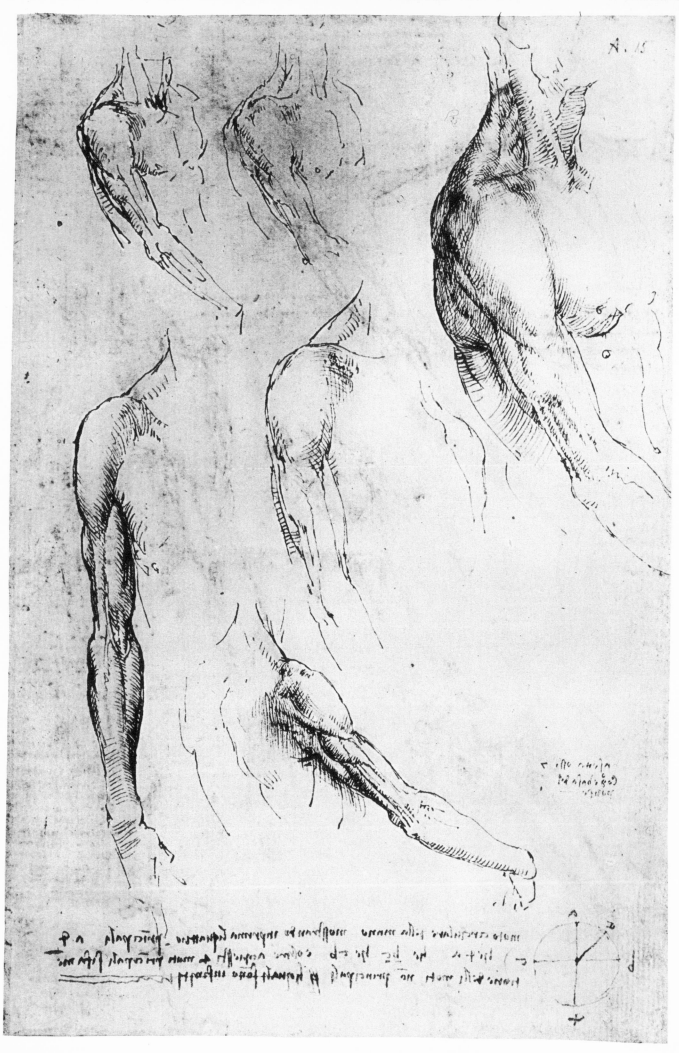

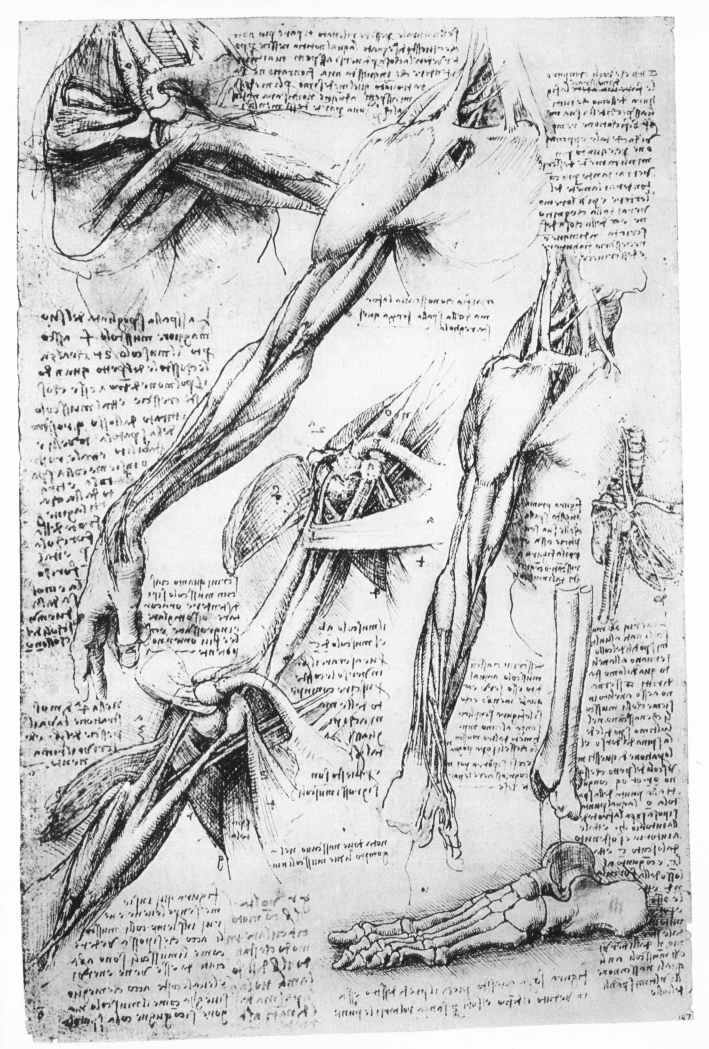

19013 verso

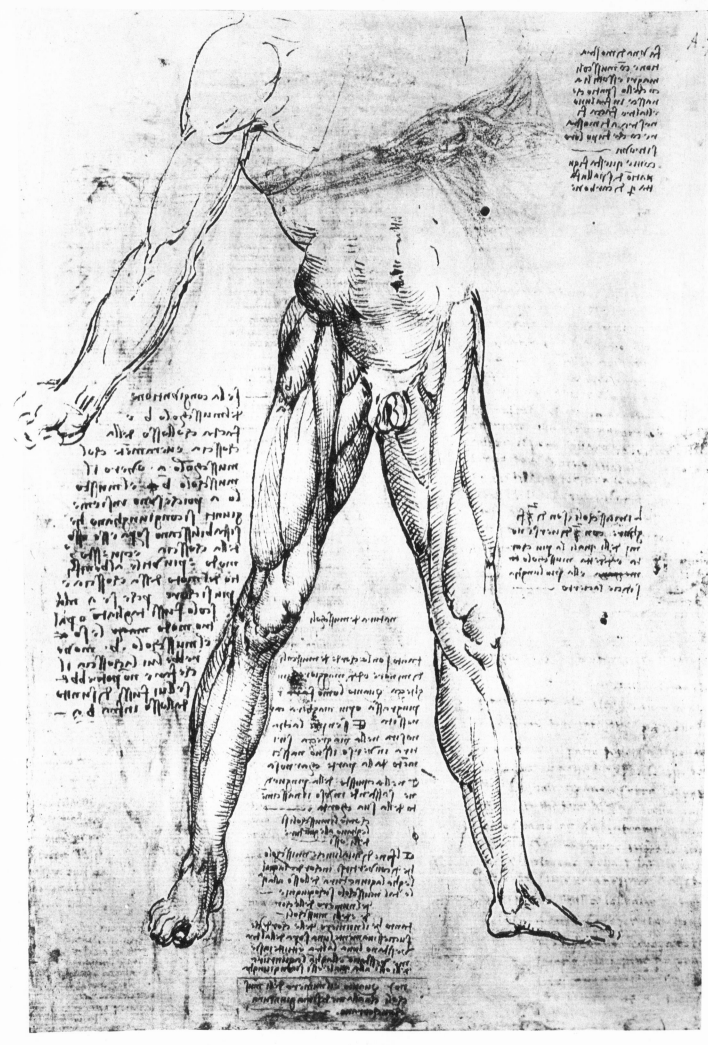

19014 *recto*

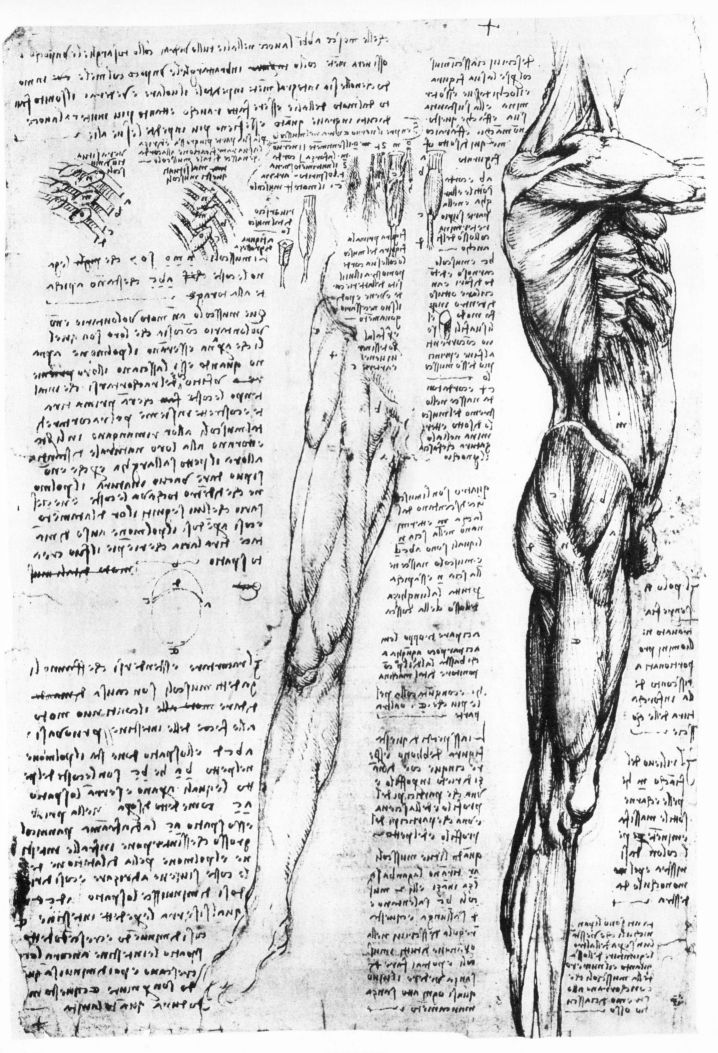

19014 *verso*

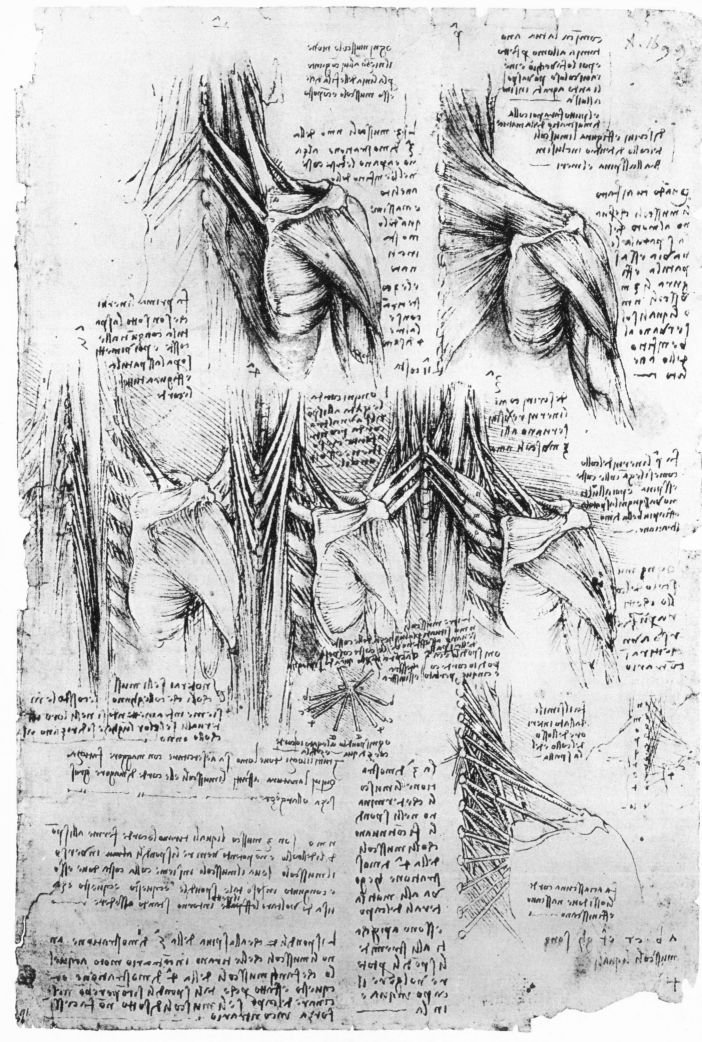

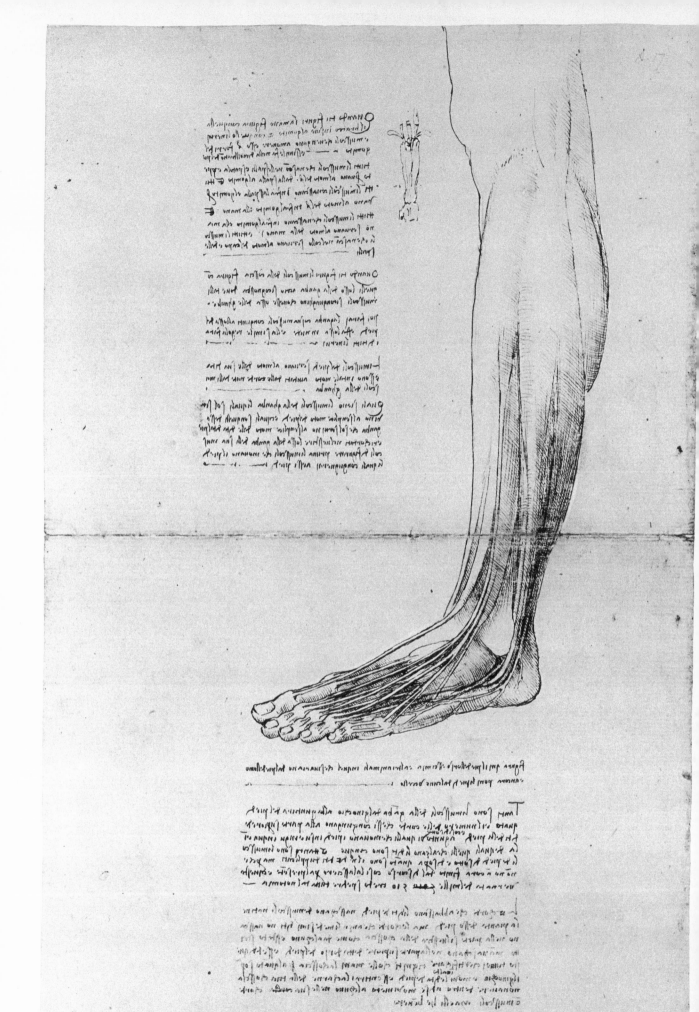

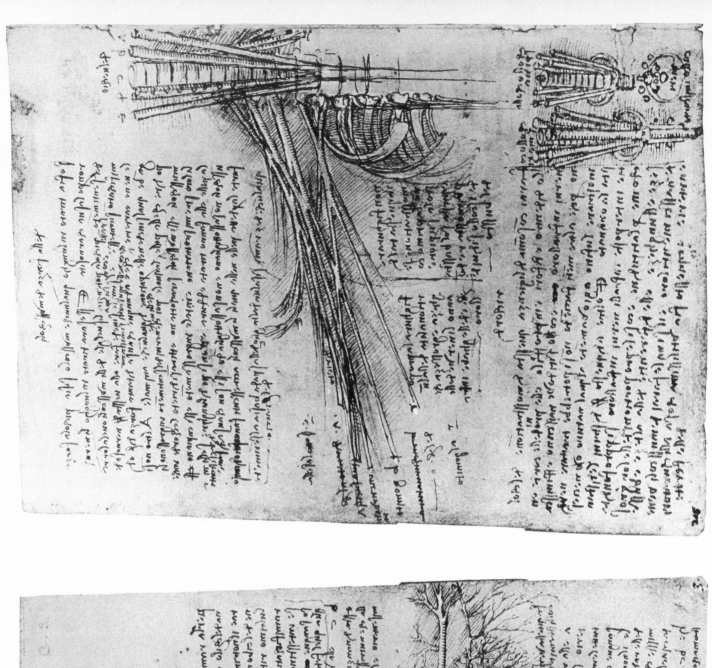

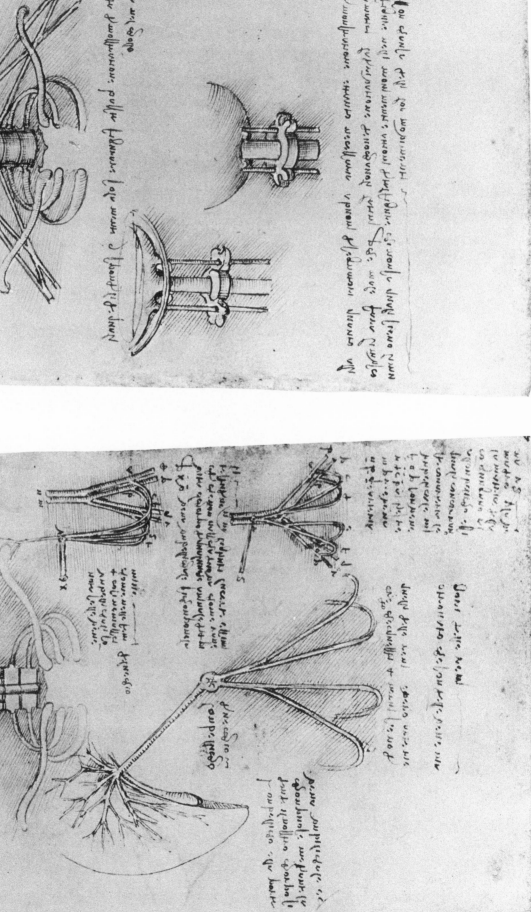

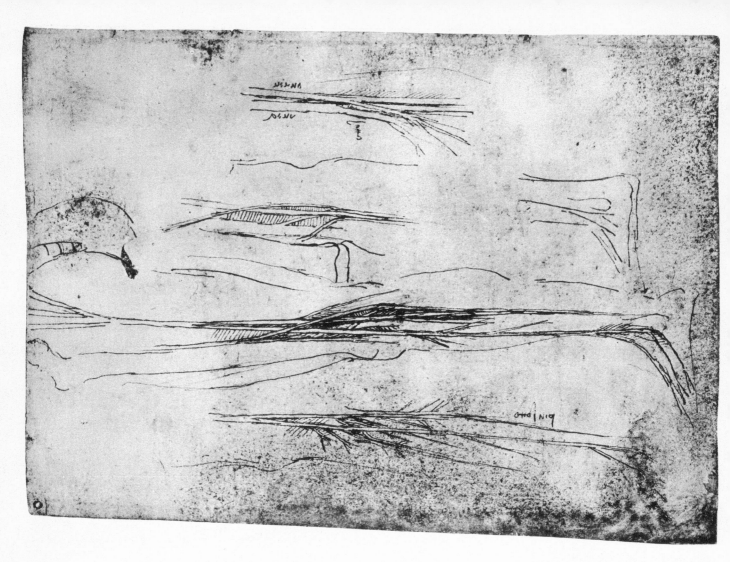

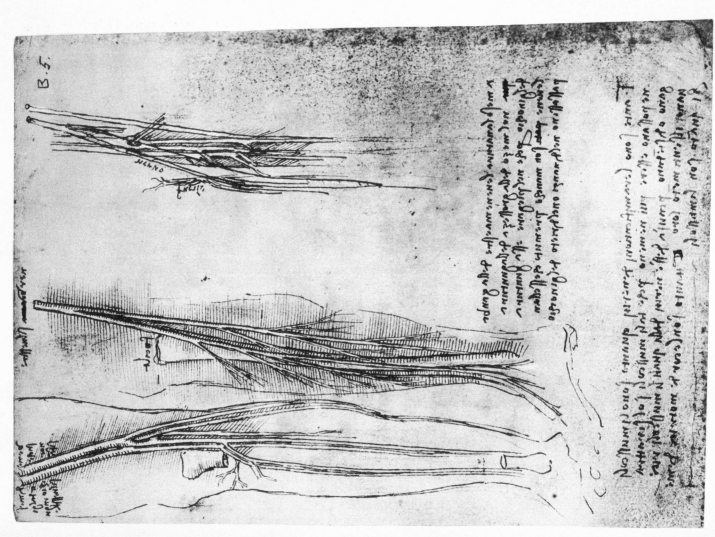

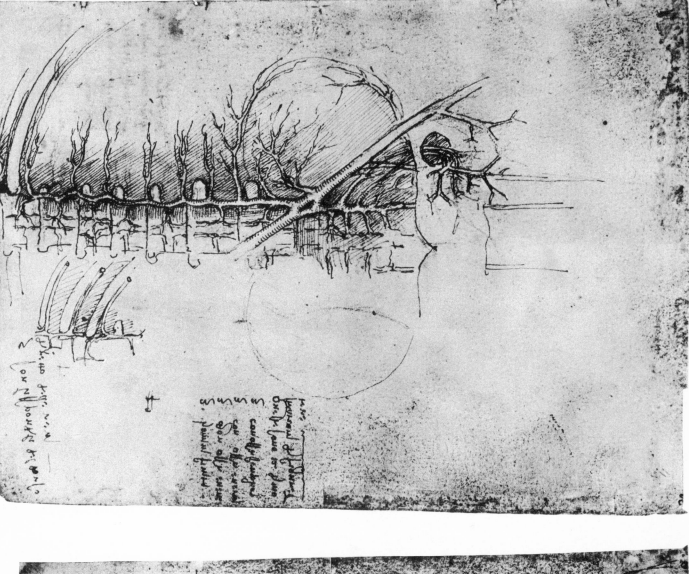

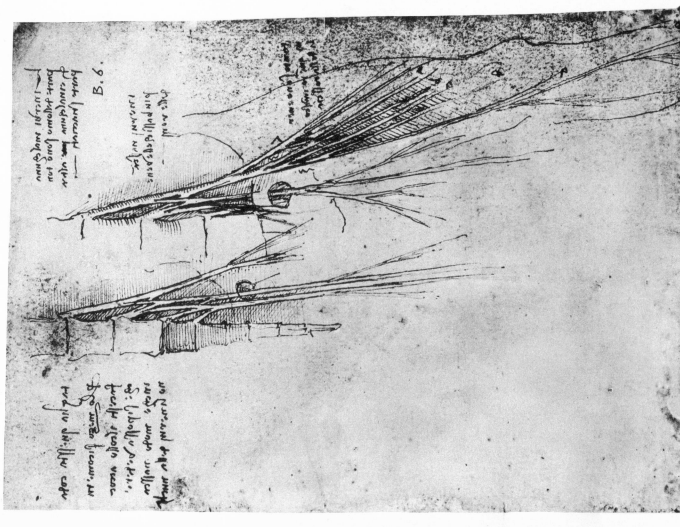

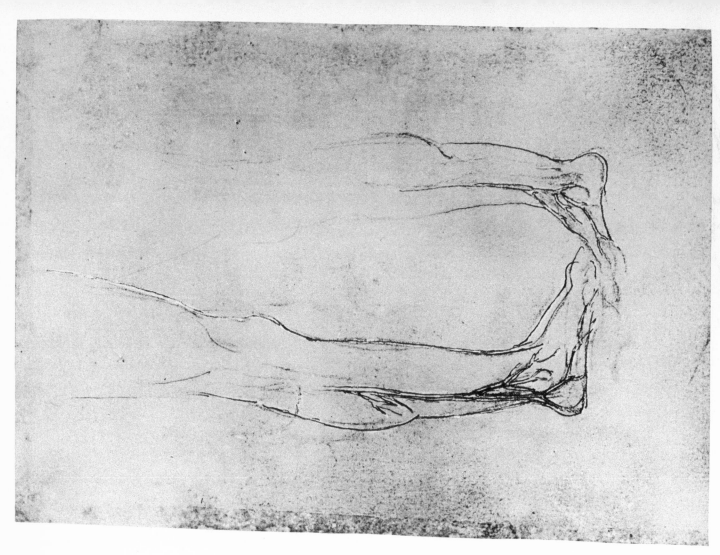

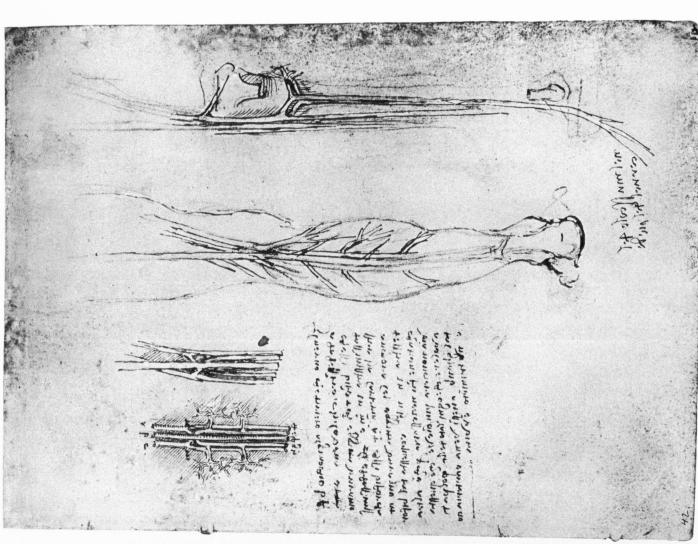

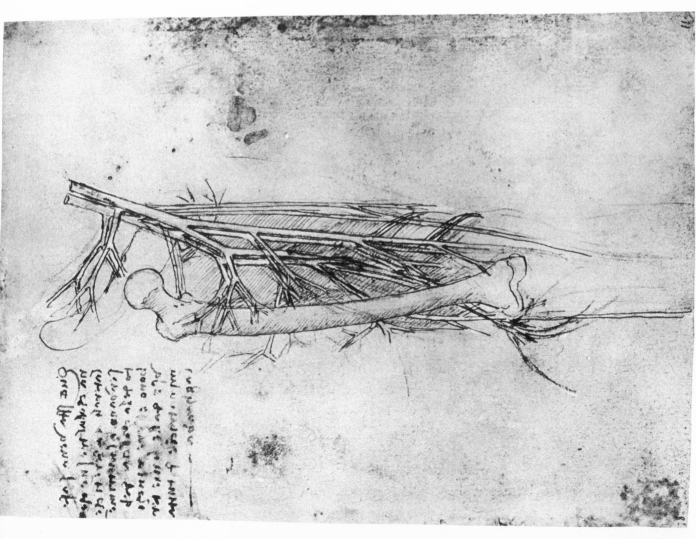

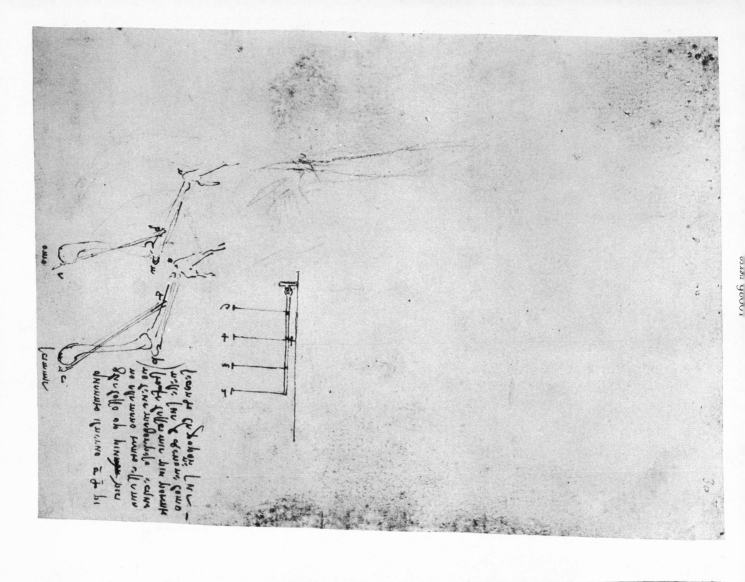

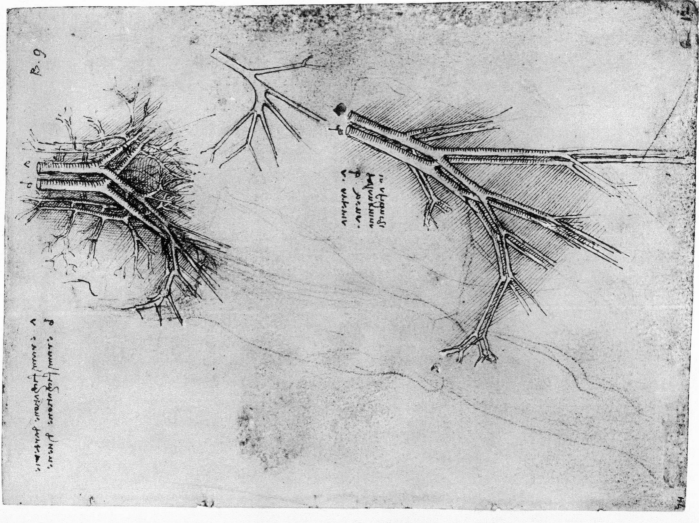

B.10

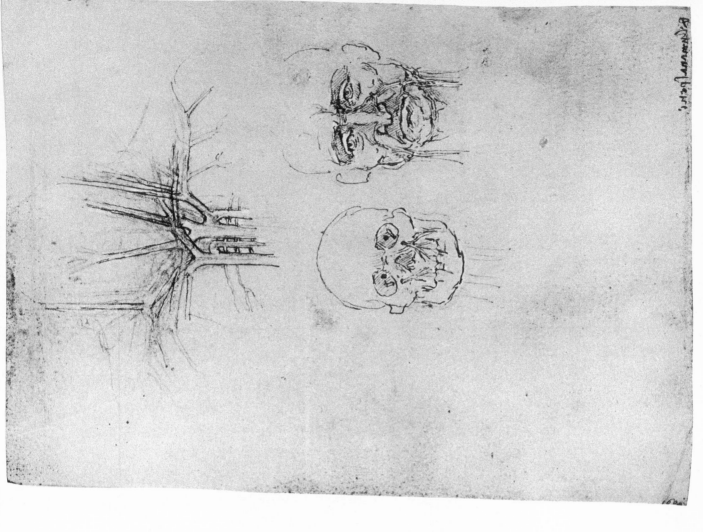

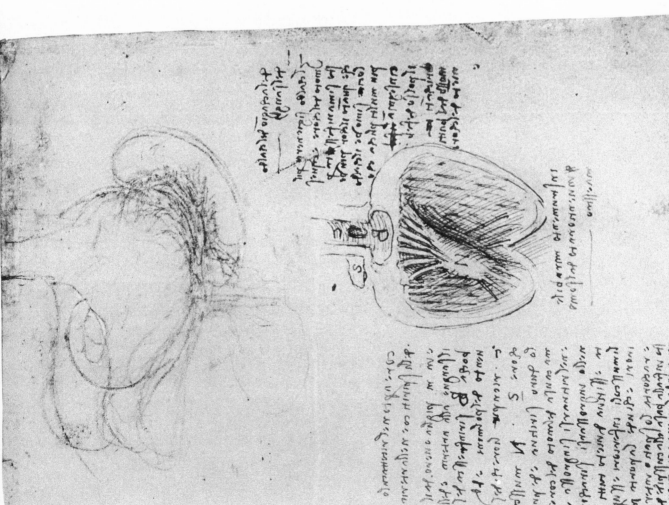

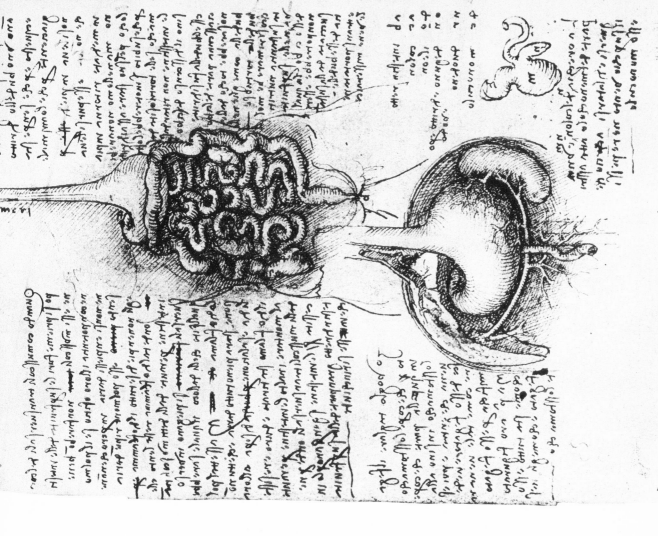

173

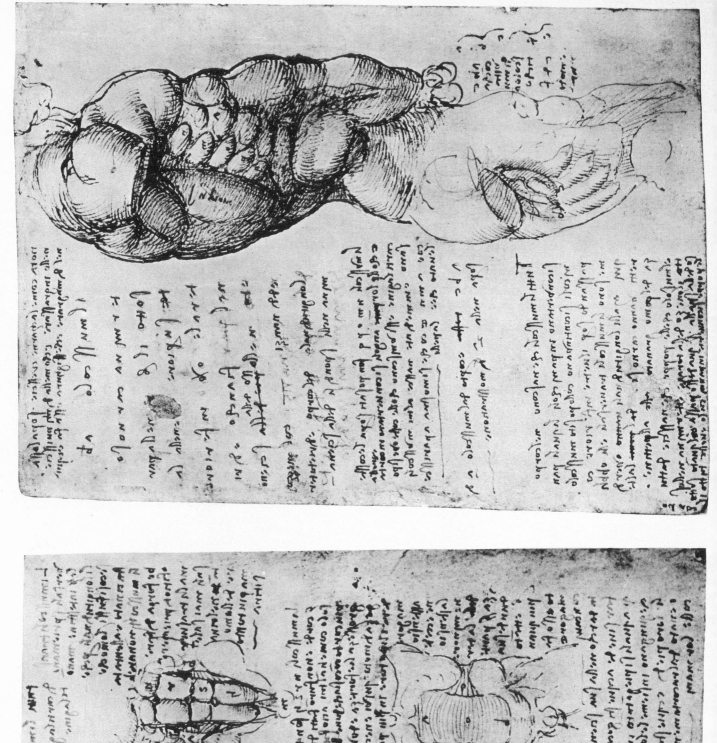

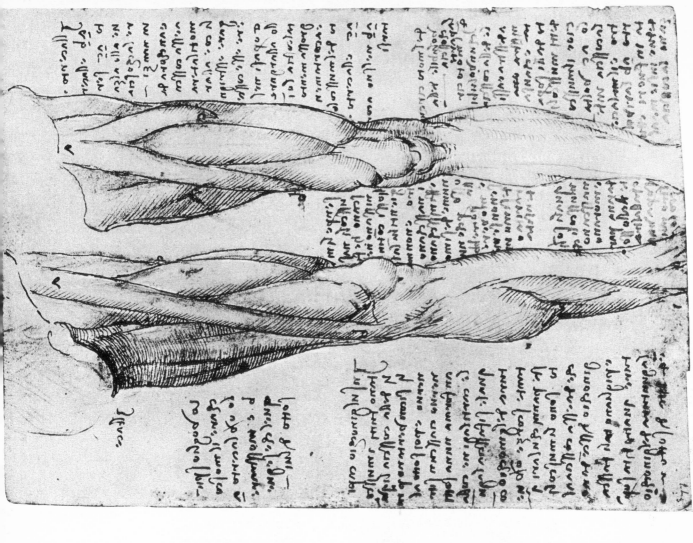

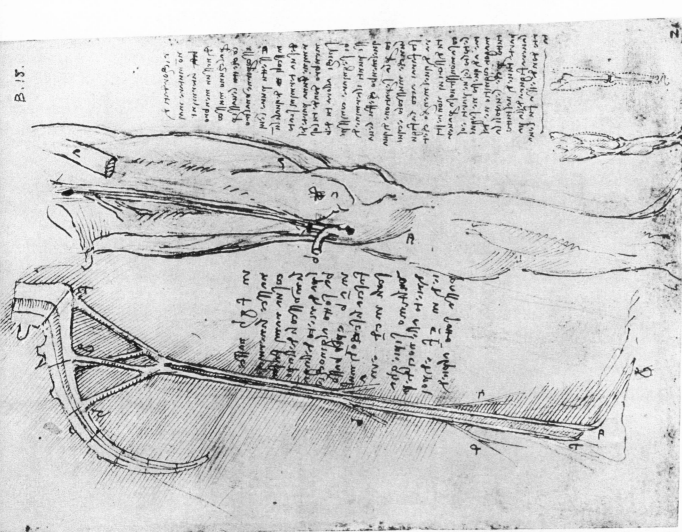

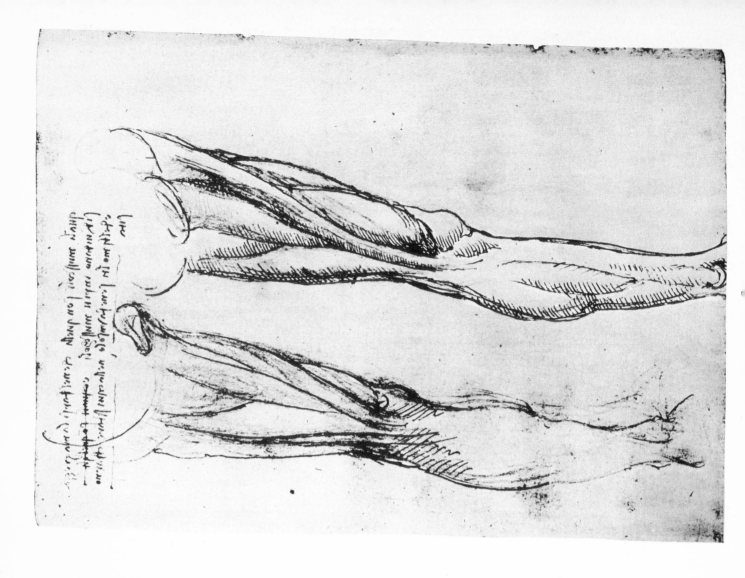

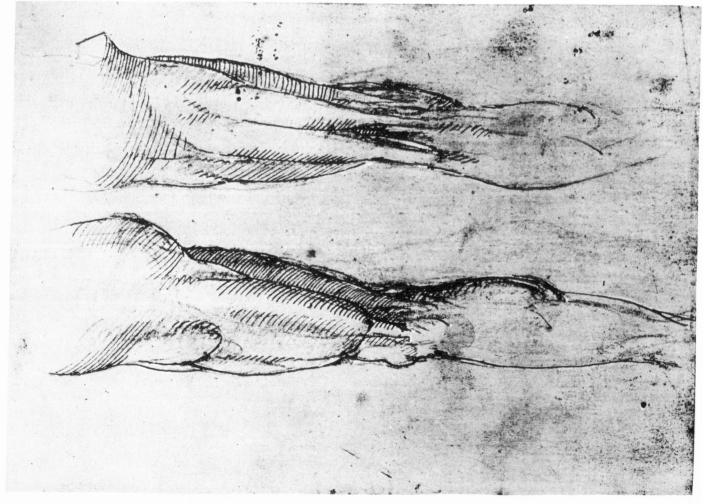

19037 recto

19061 verso

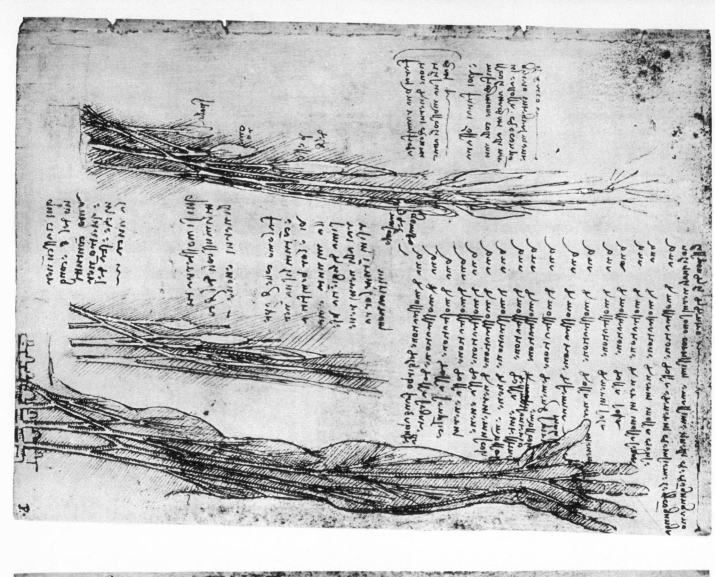

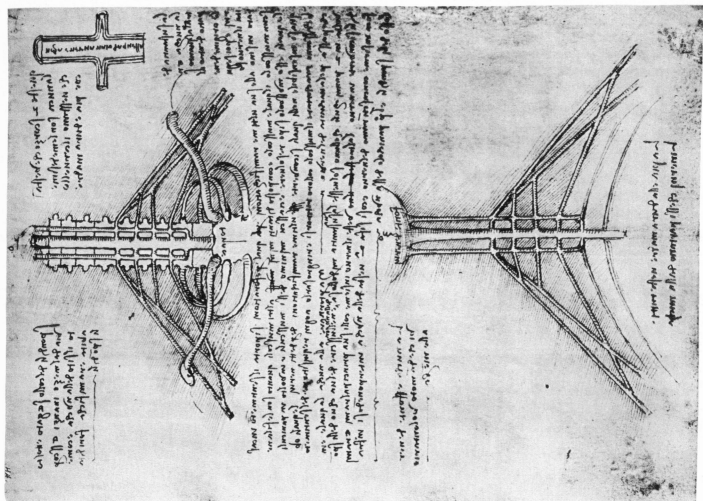

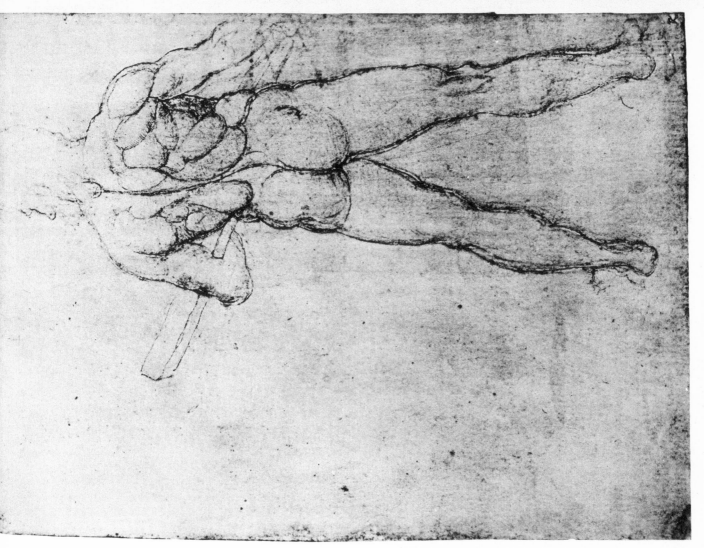

19041 *recto*

19042 *recto*

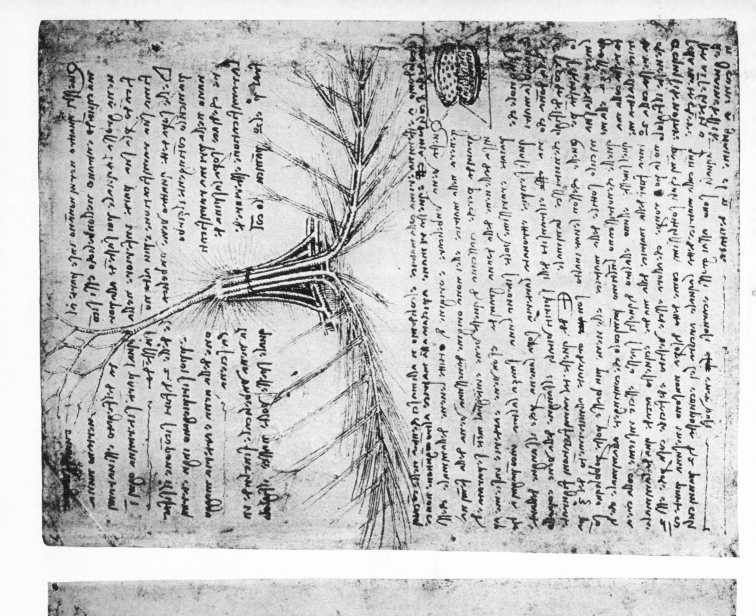

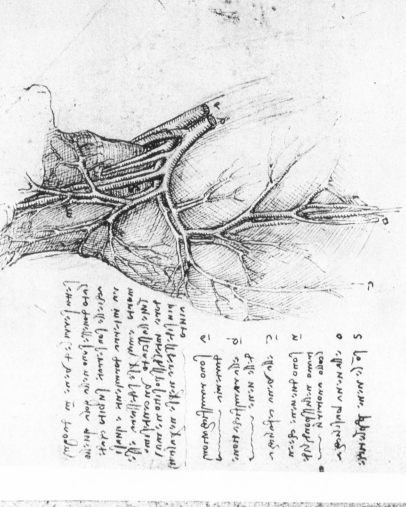
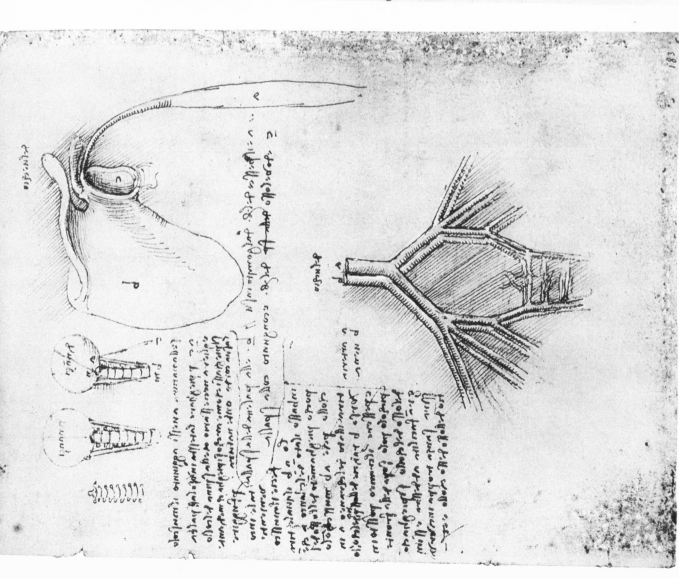

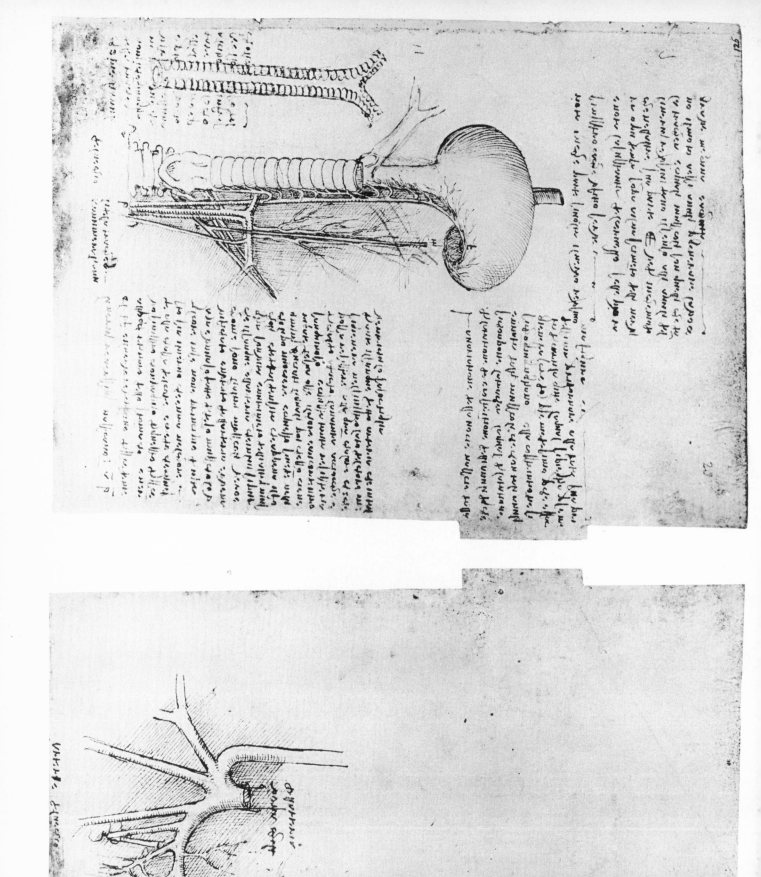

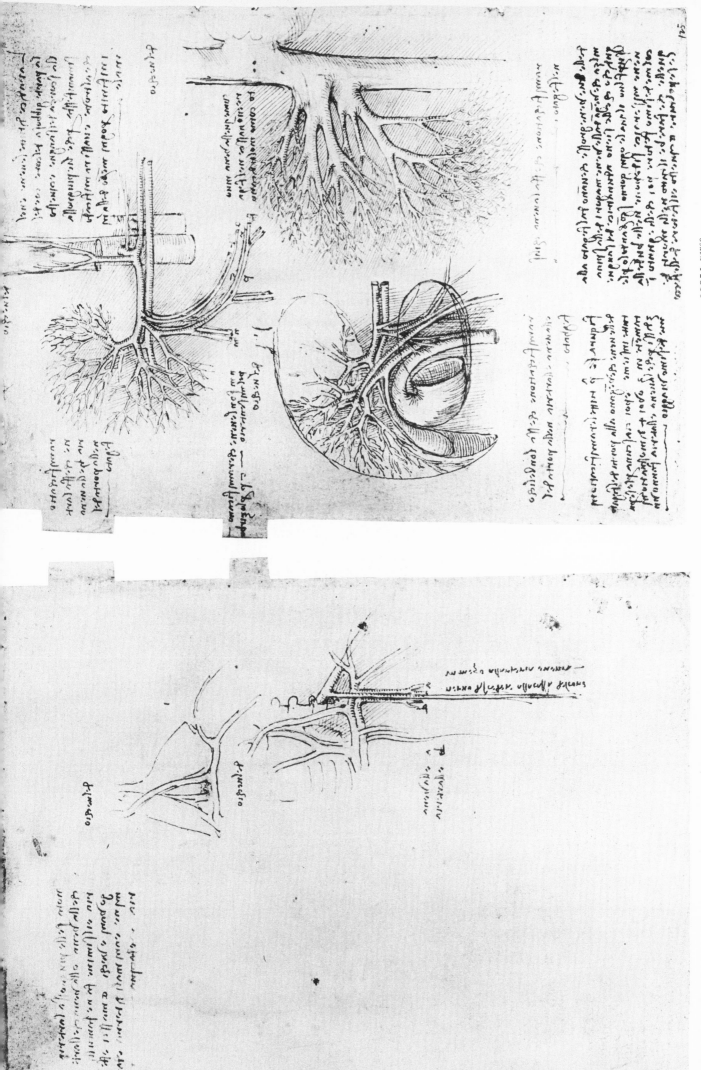

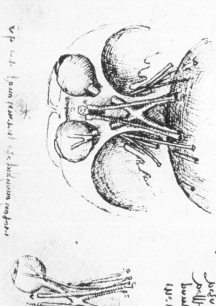

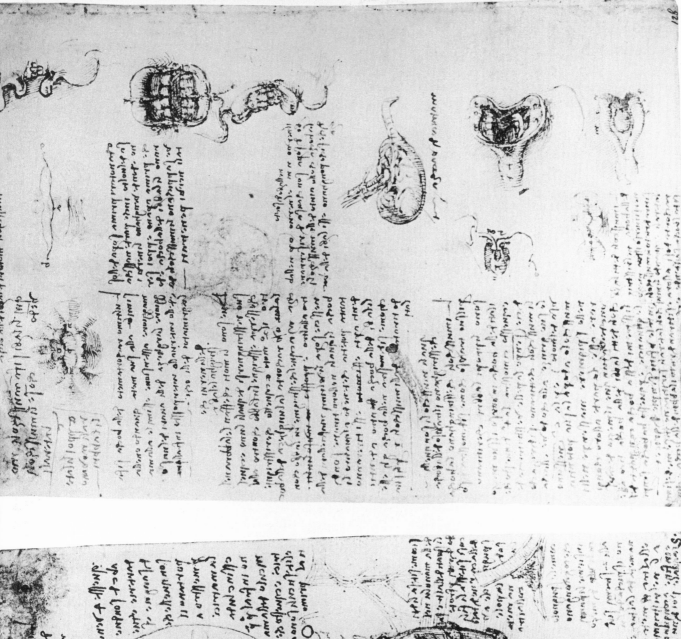

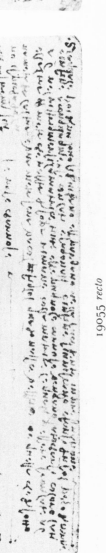

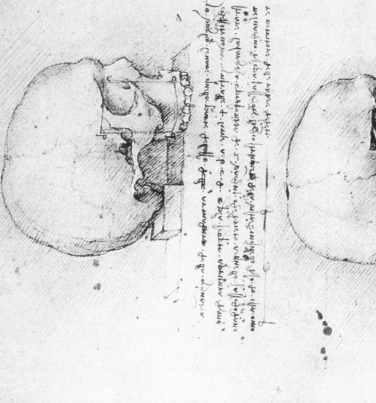

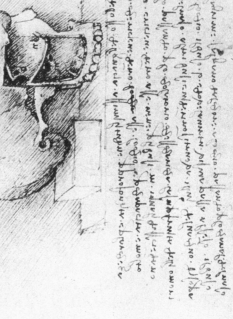

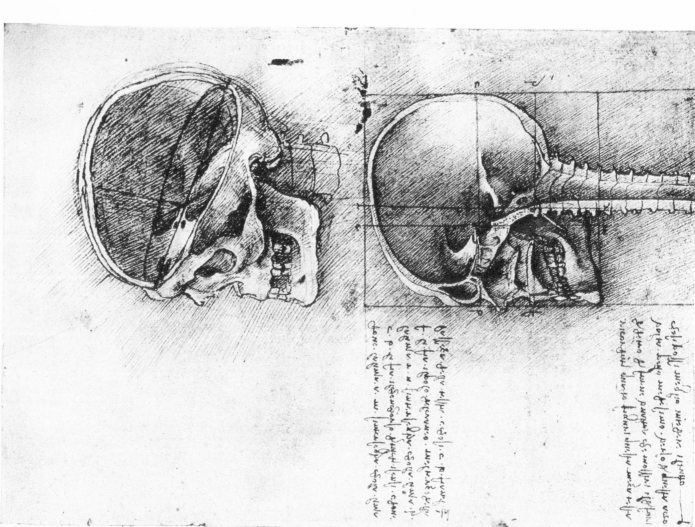

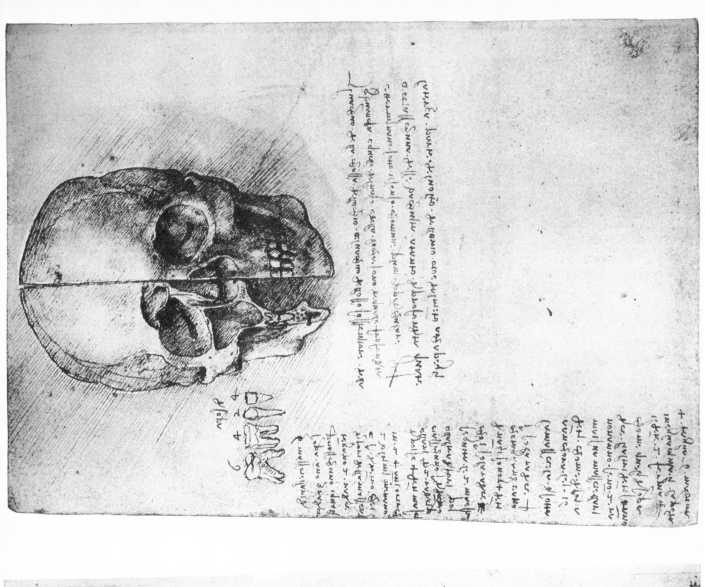

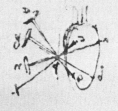

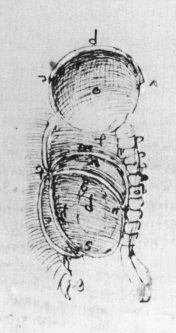

19066 *verso*

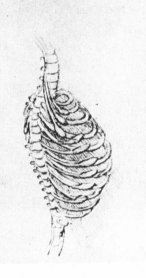

19067 *recto*

19068 *recto*

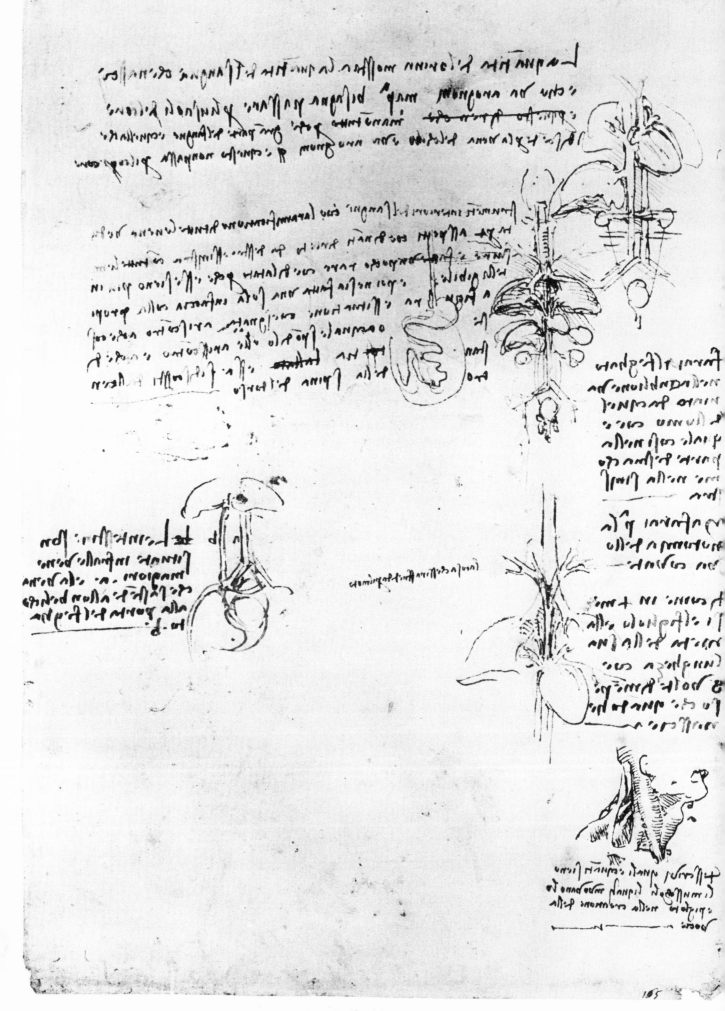

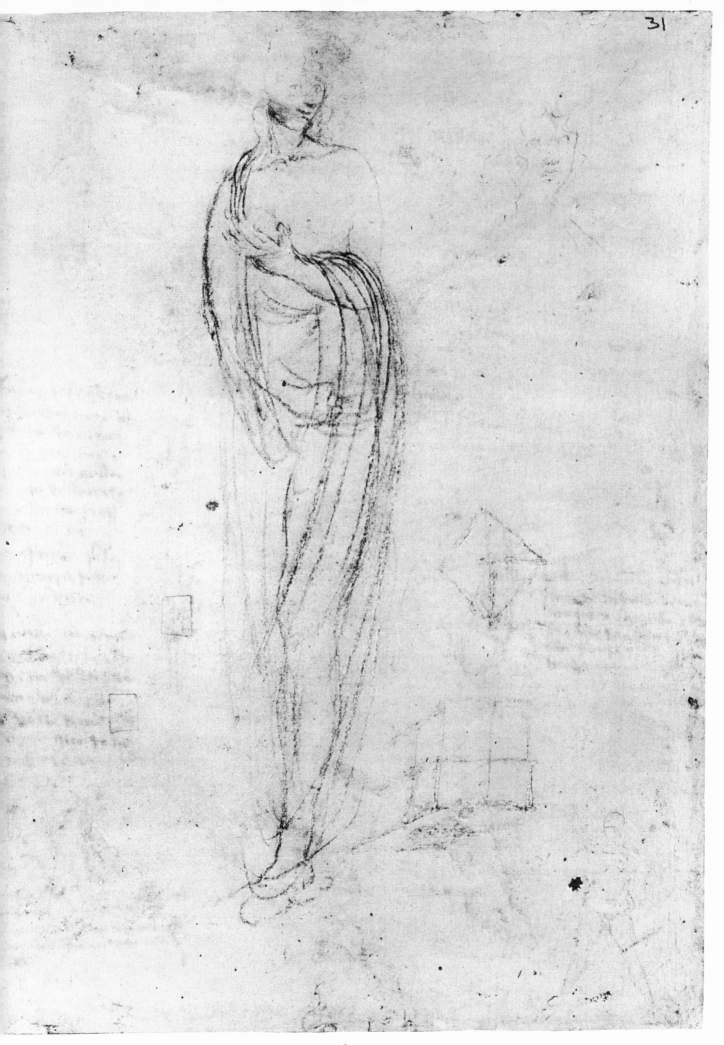

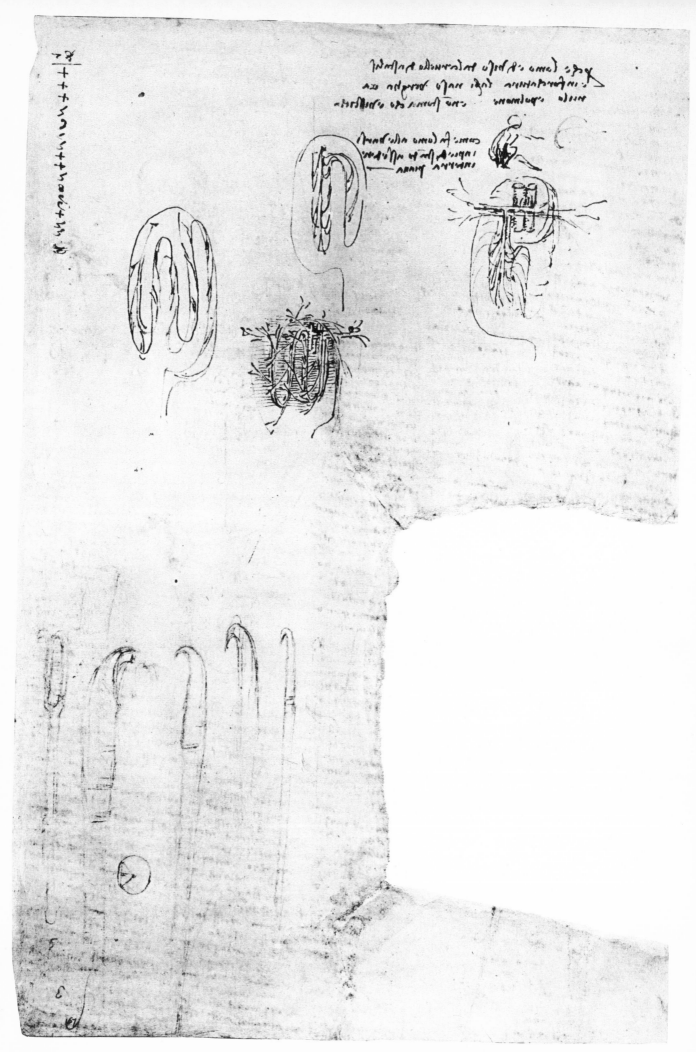

19070 recto

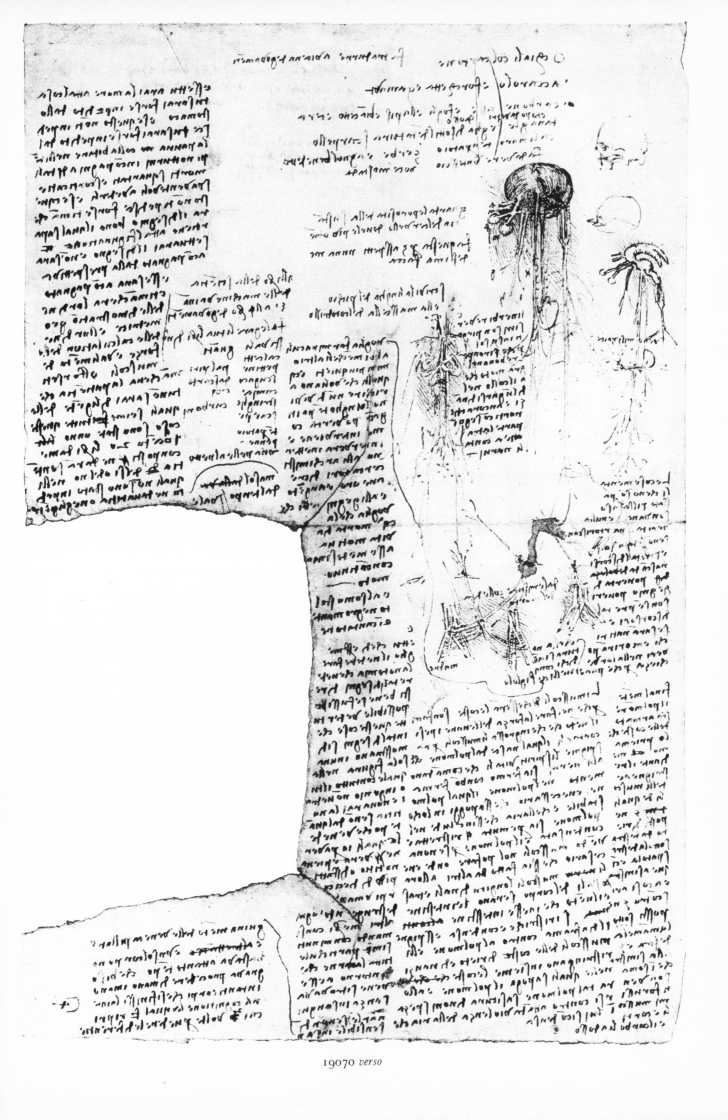

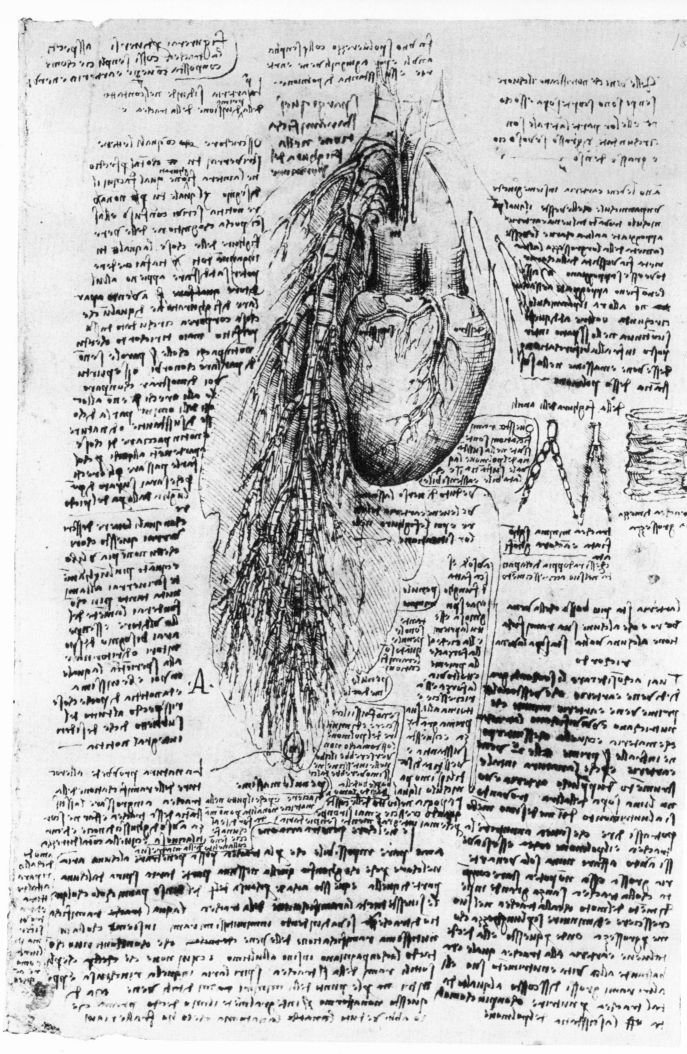

19071 *recto*

229

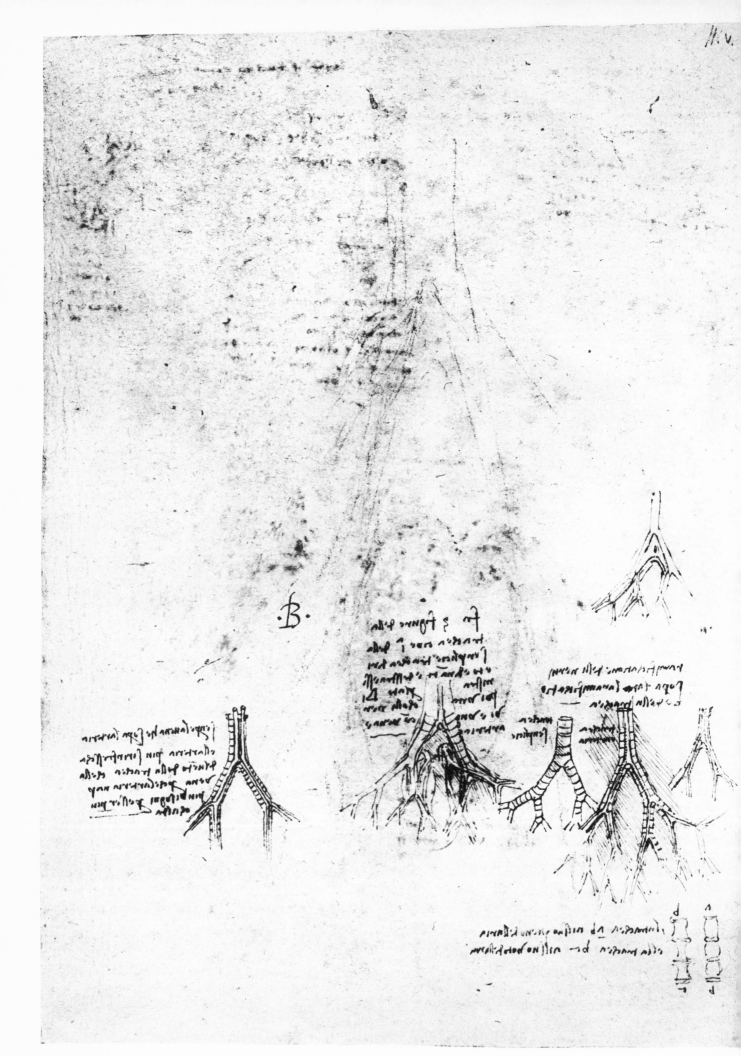

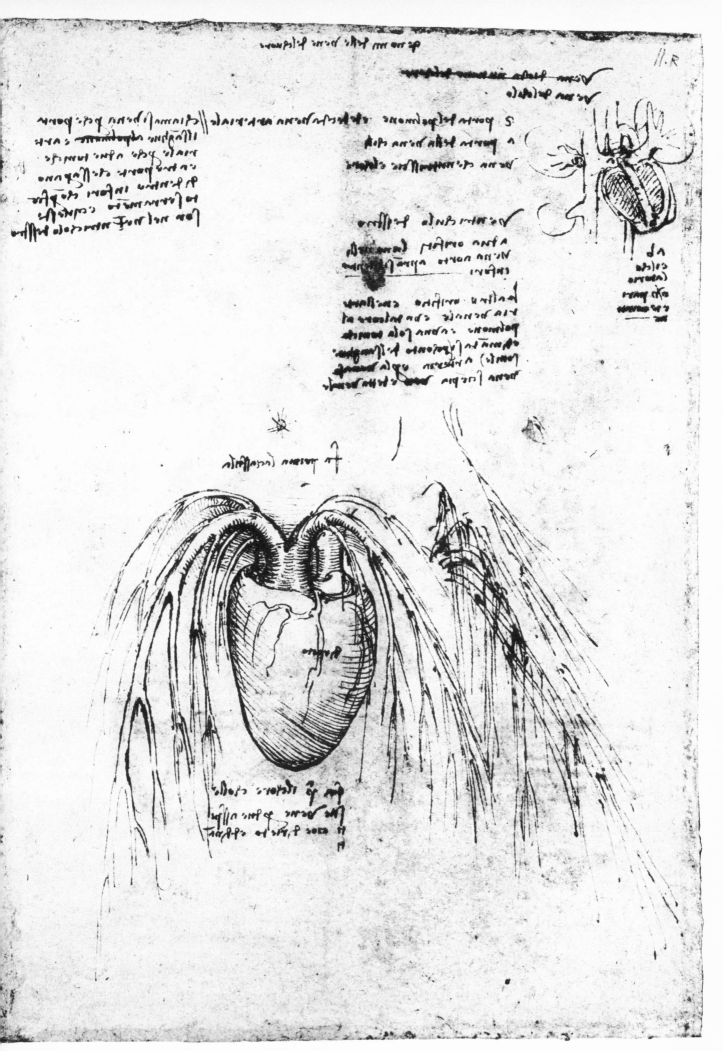

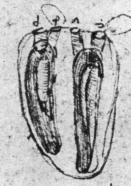

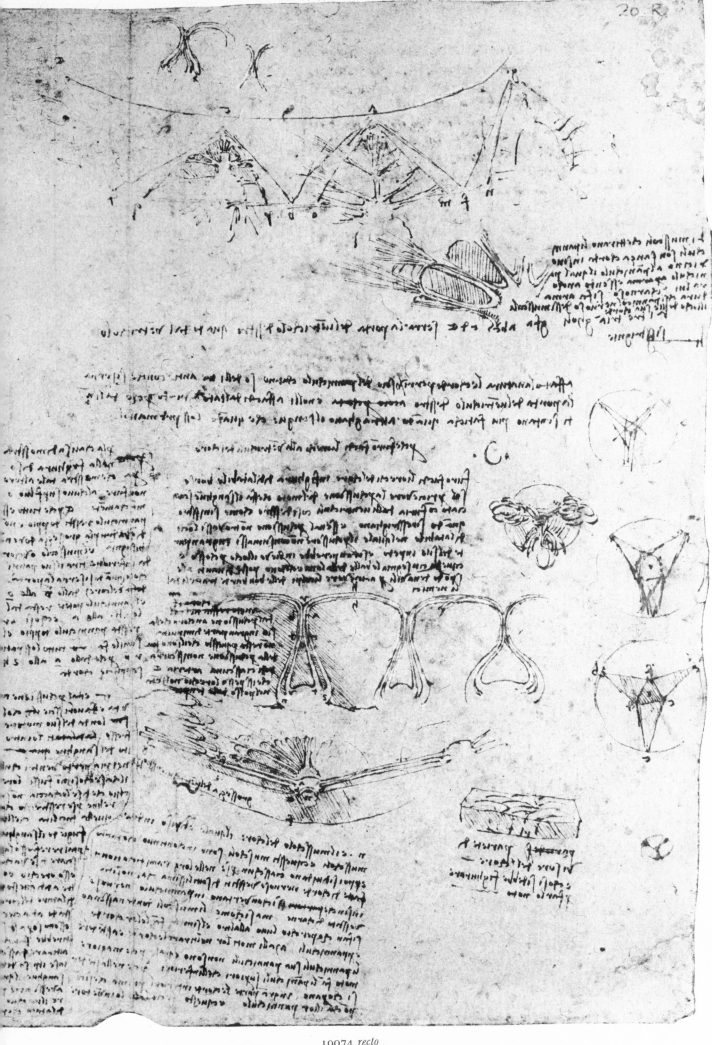

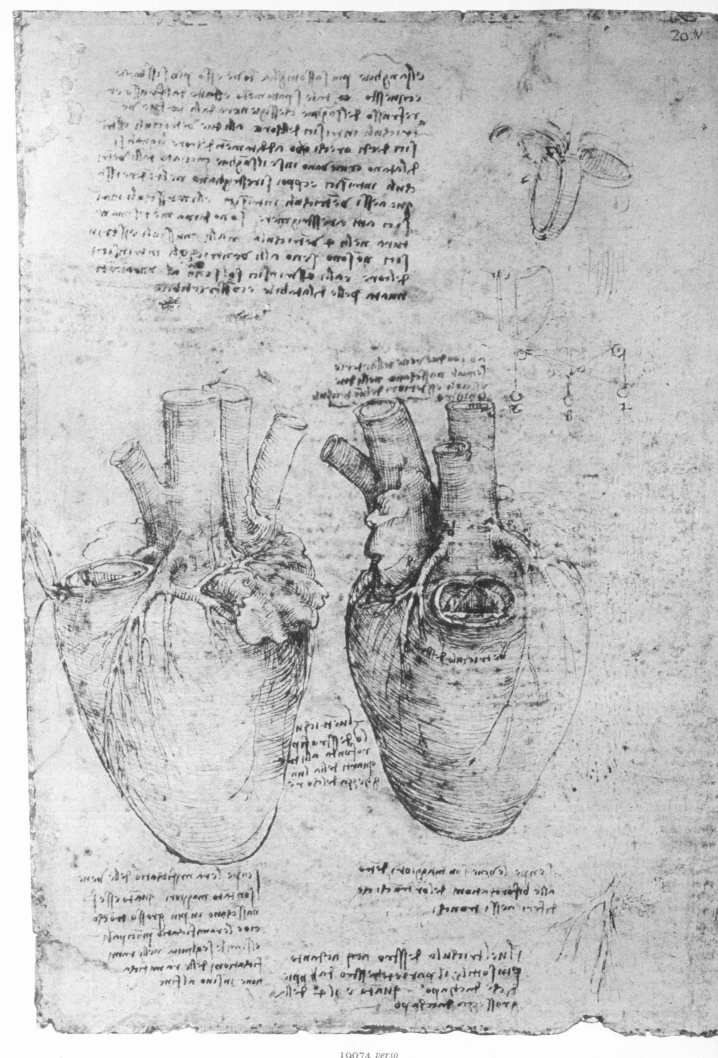

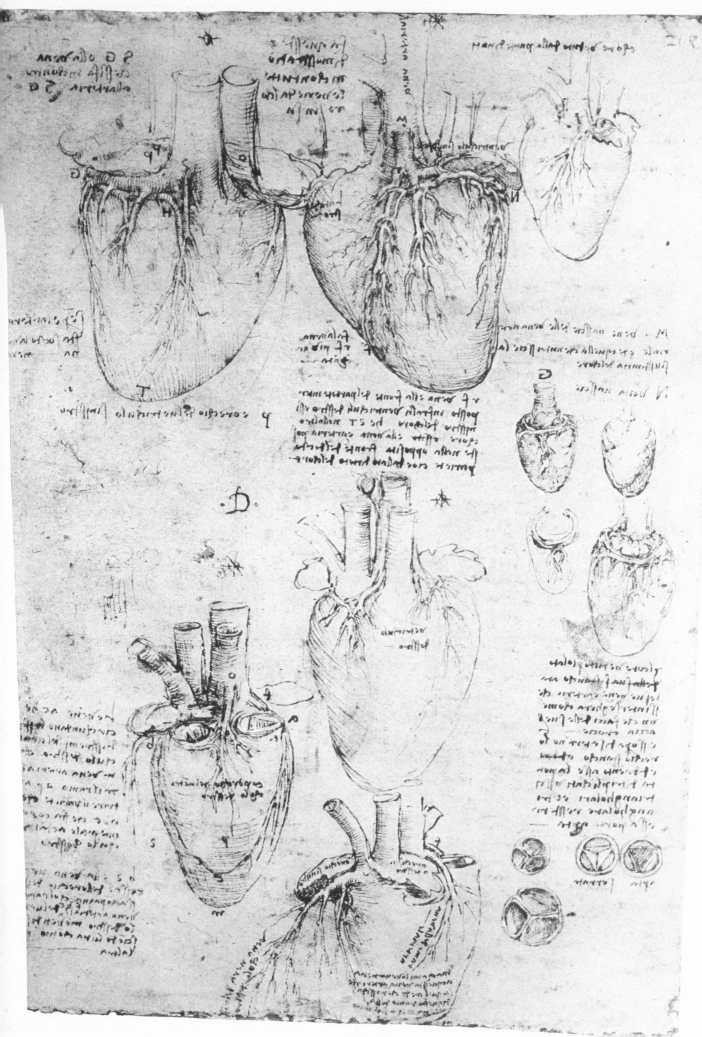

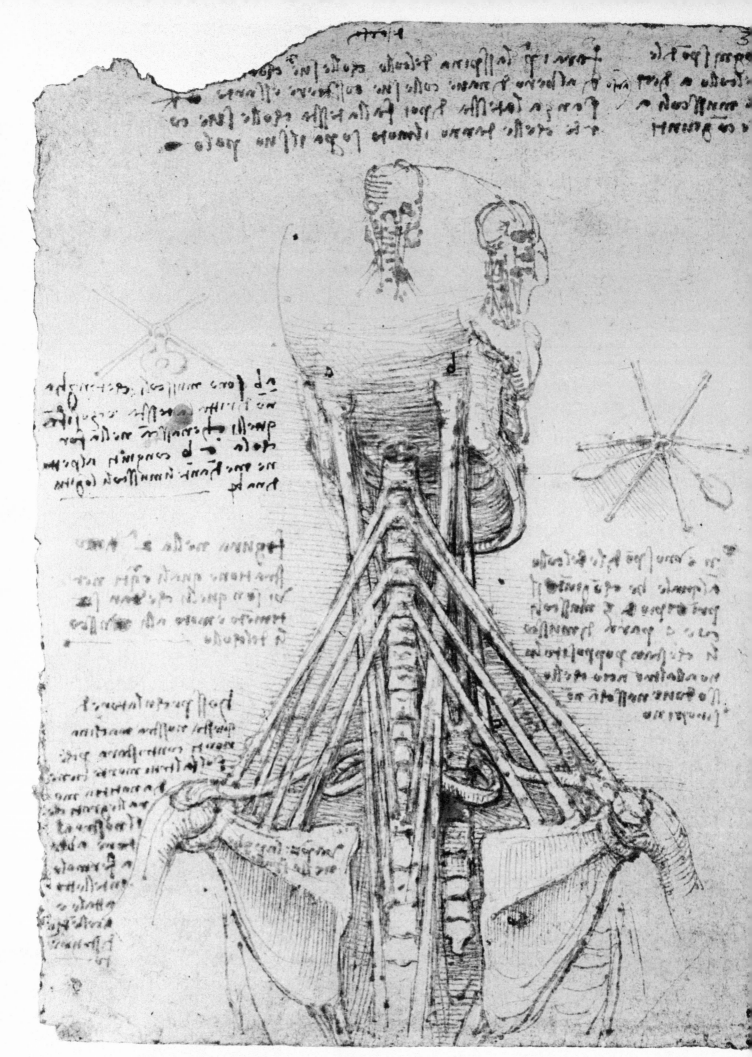

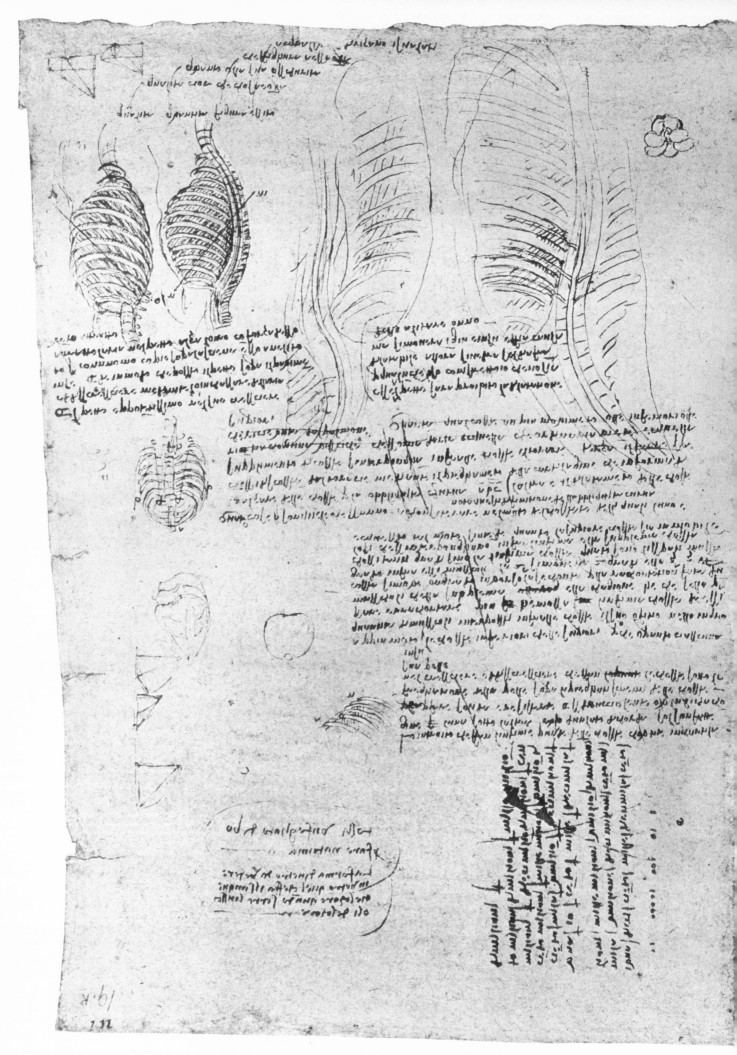

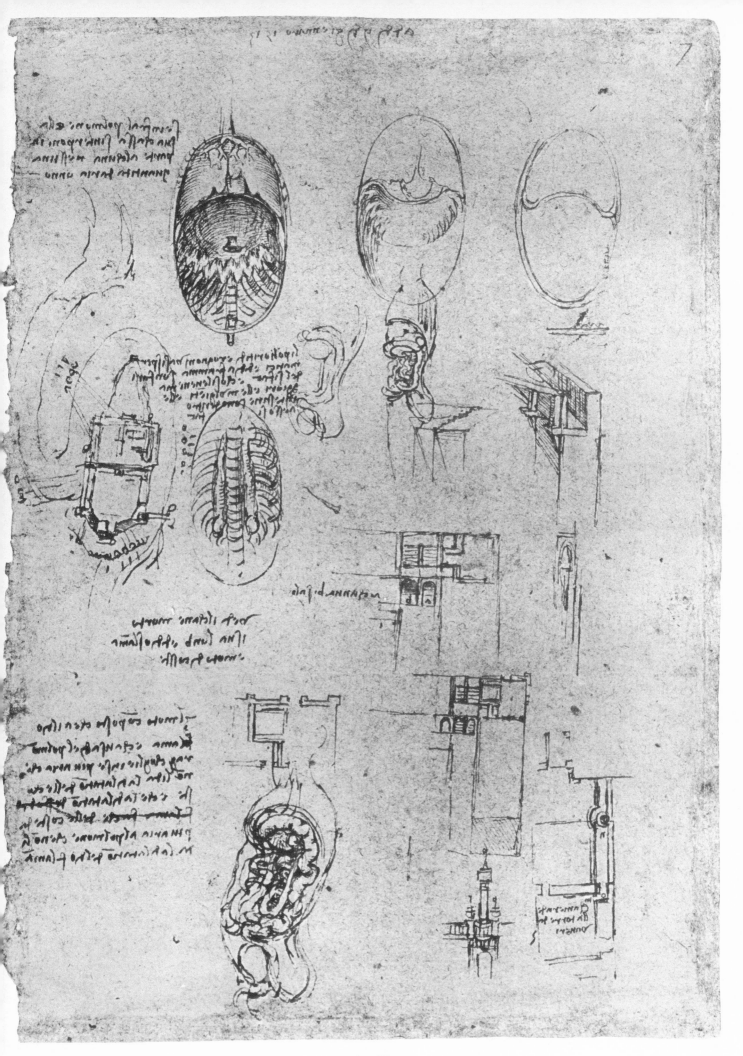

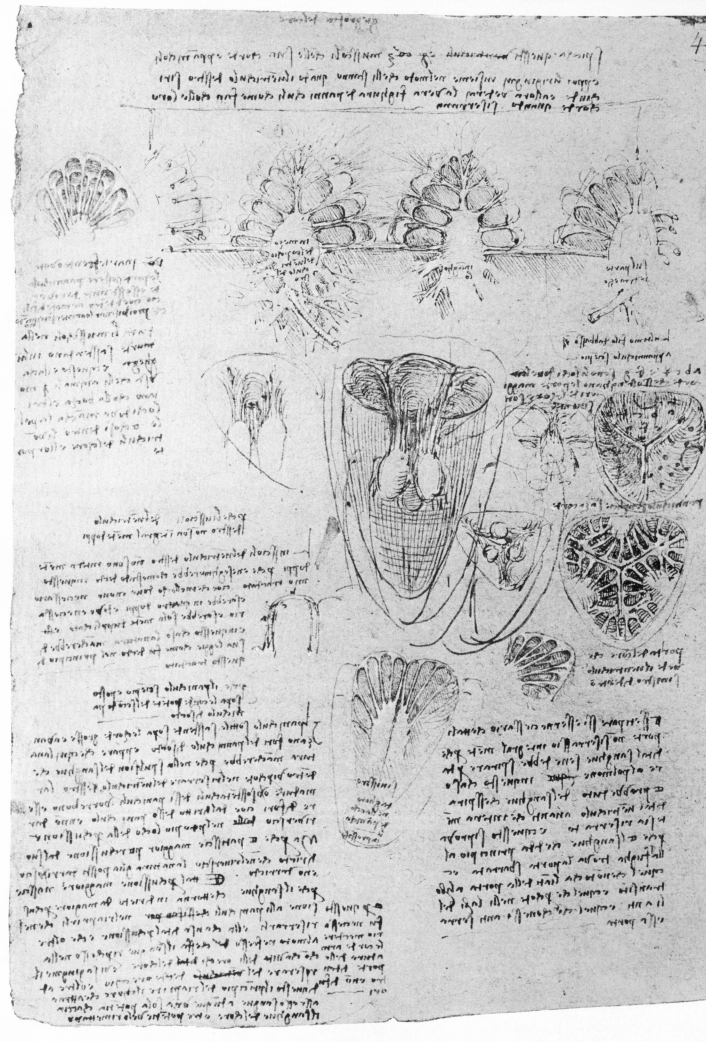

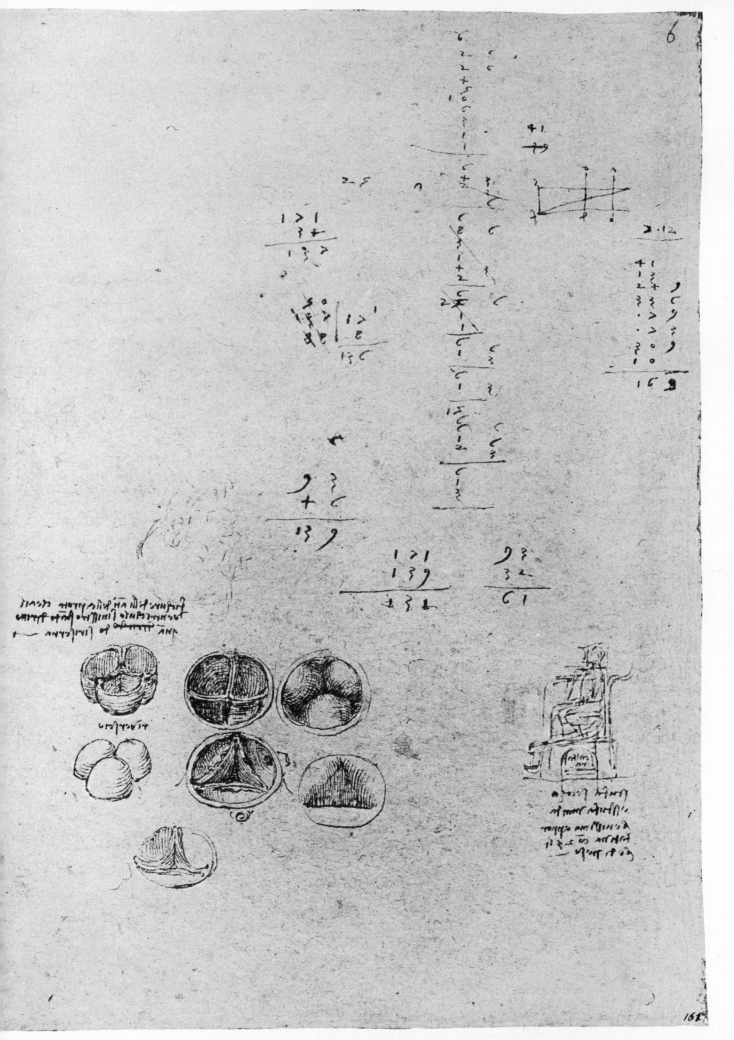

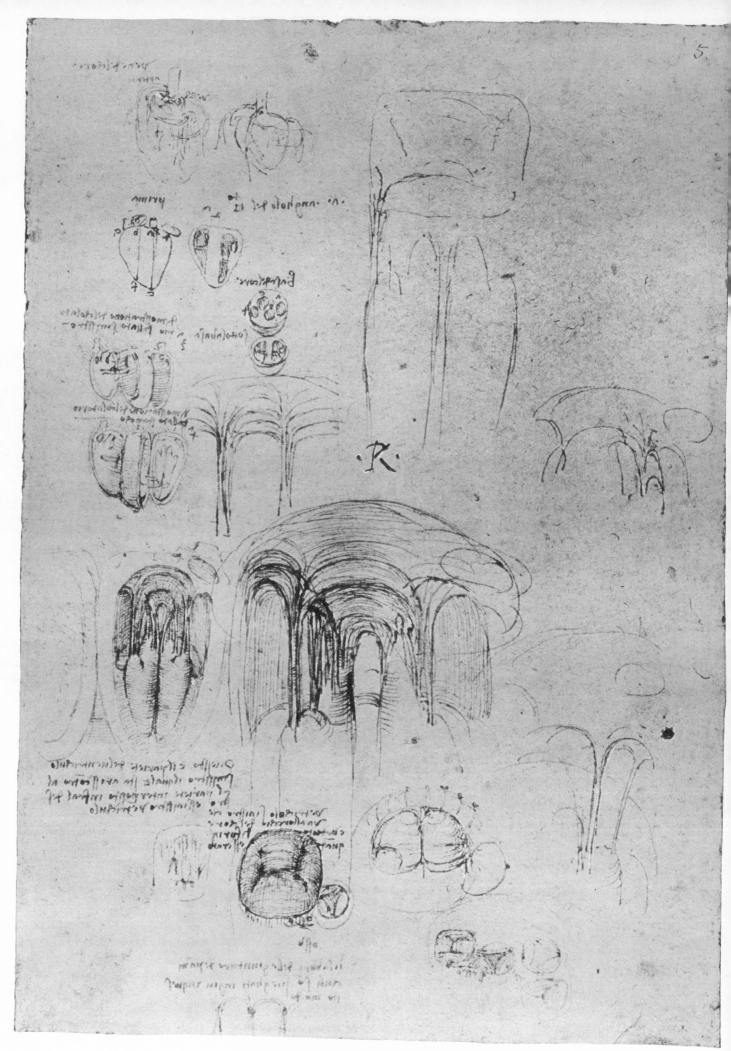

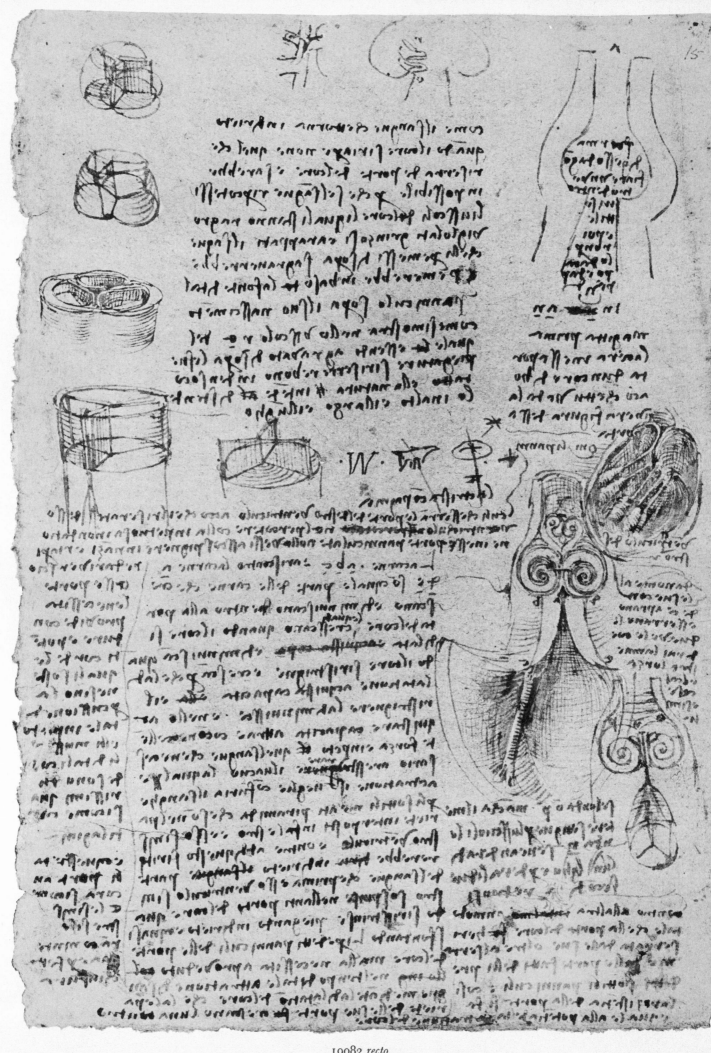

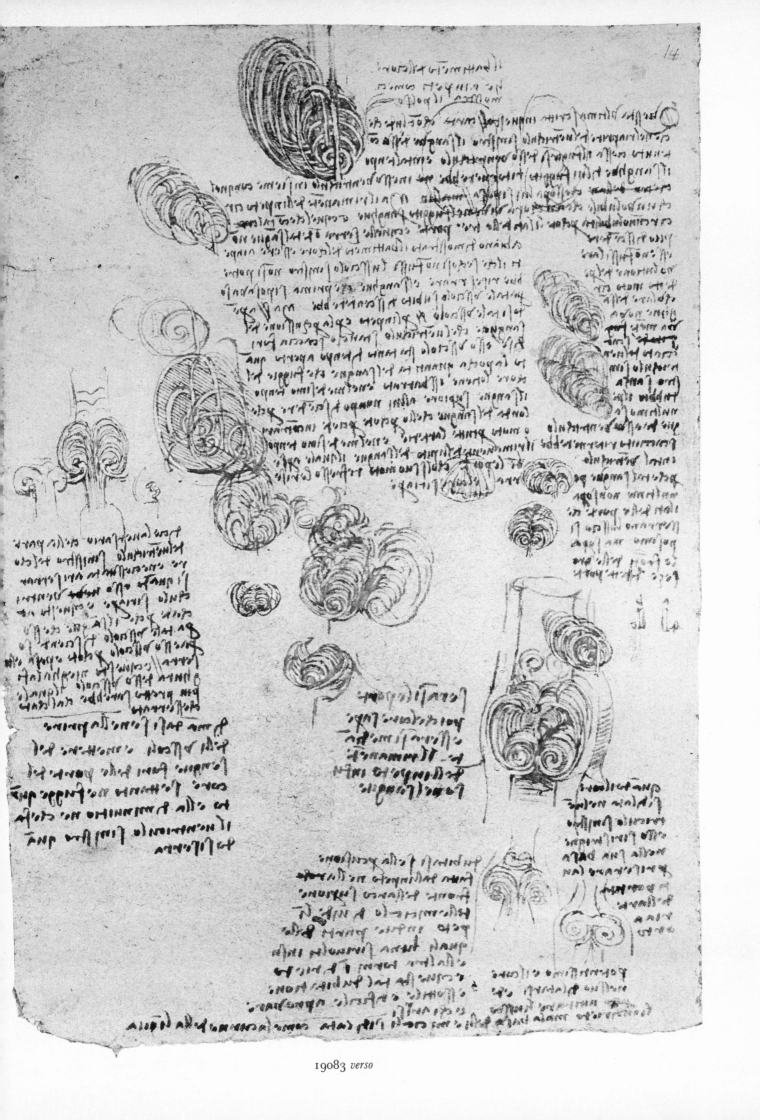

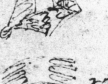

T

fotomane
le lagua fara ps salse p la terra rcarsa dato ch espgourecola
chella terra boluta nella agua farebe salsa vela agua

19090 verso

19091 verso

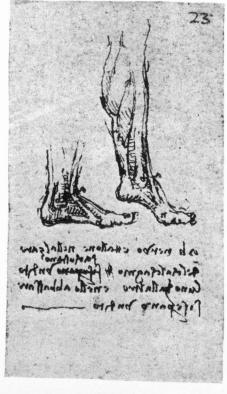

19094 recto

The text on this page is written in mirror-script (reversed) and is largely illegible in this low-resolution image. The page contains Leonardo da Vinci's characteristic mirror-writing in brown ink, along with small technical sketches in the upper right area.

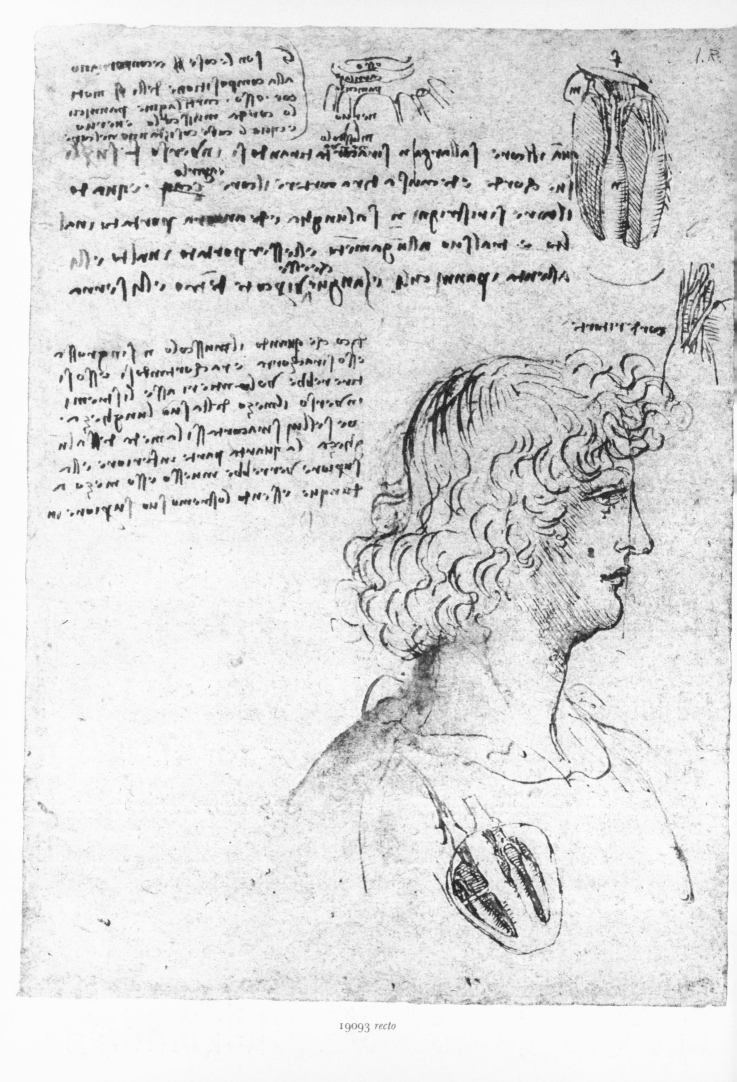

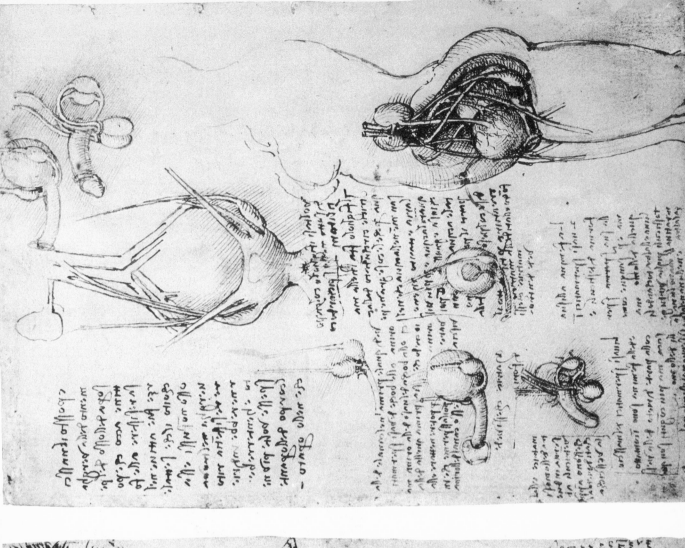

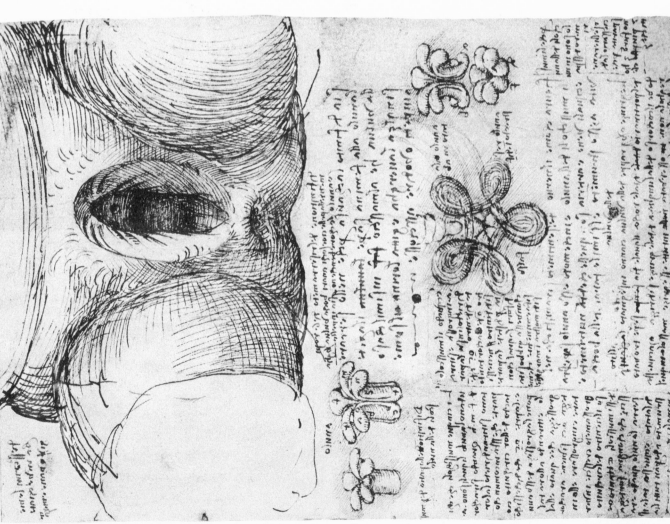

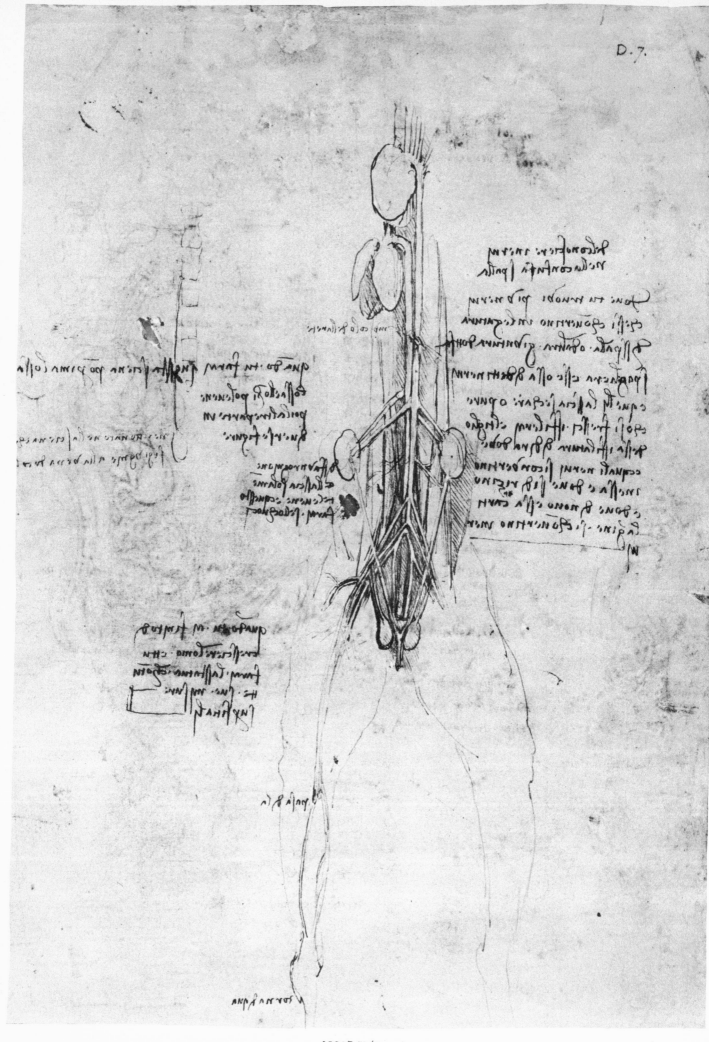

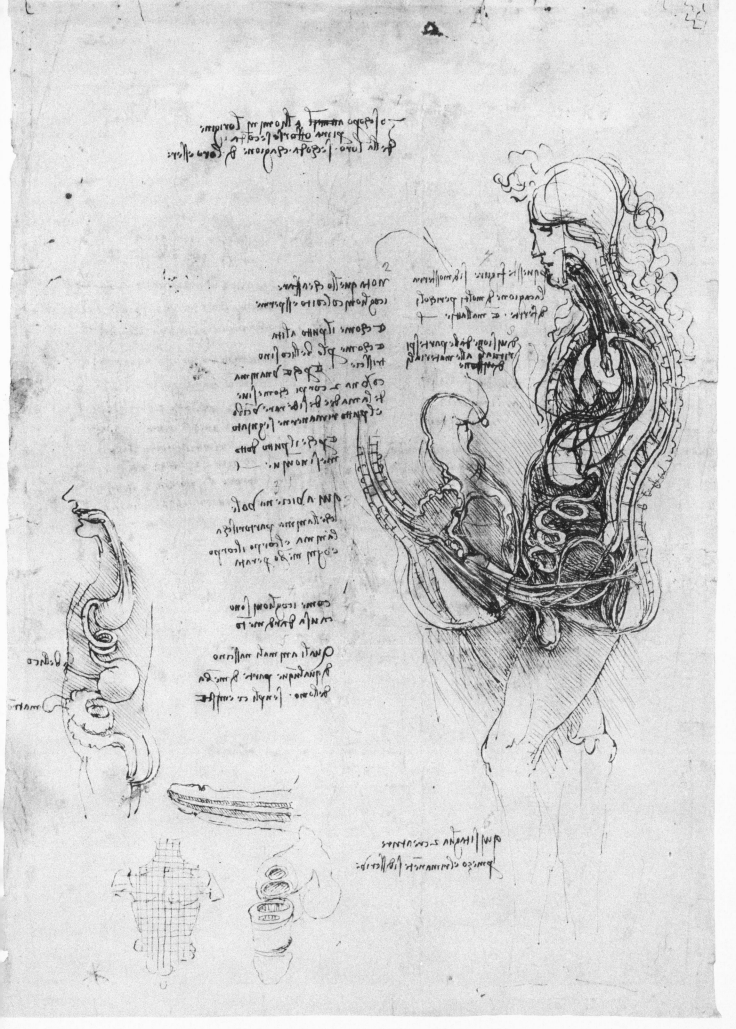

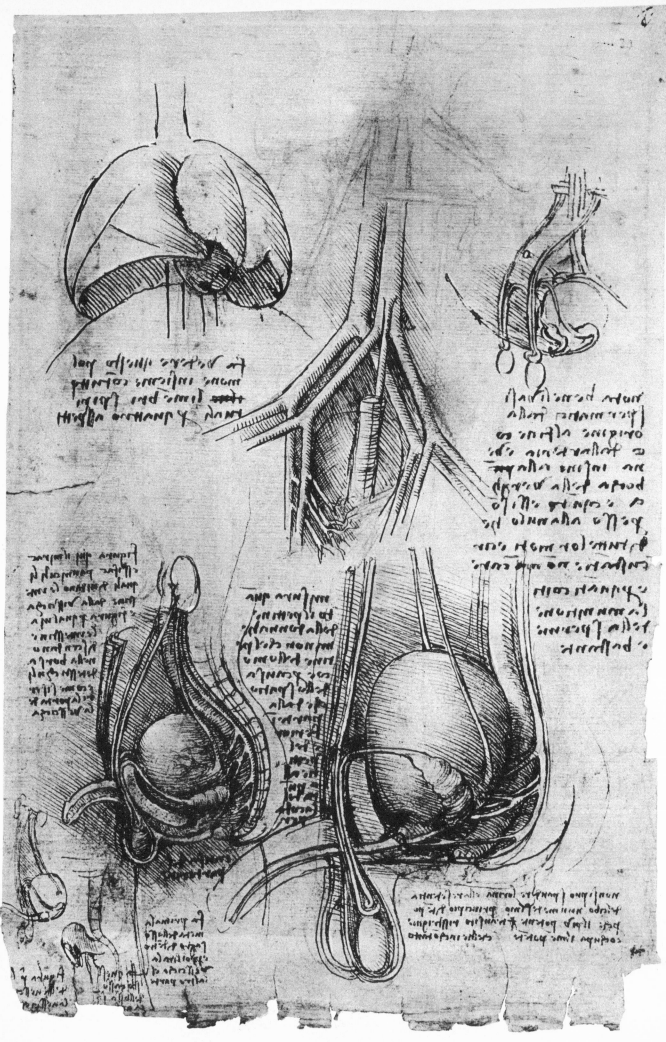

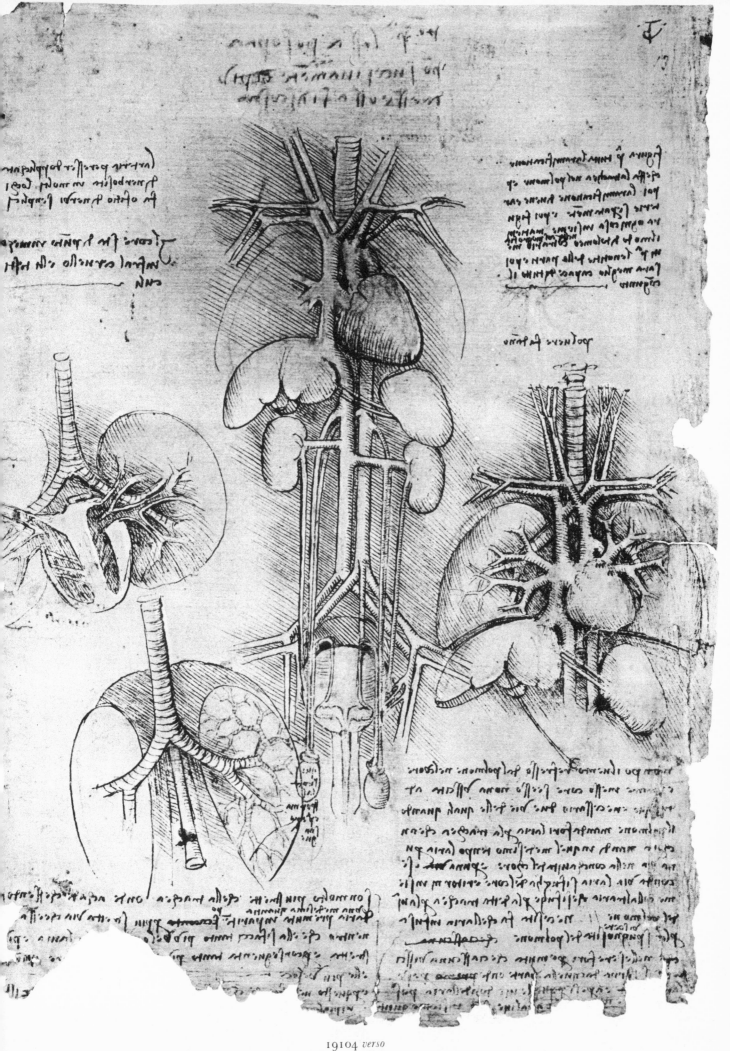

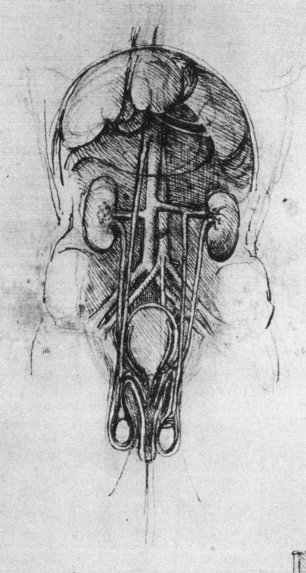

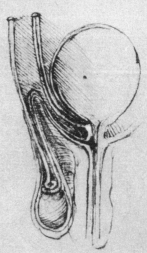

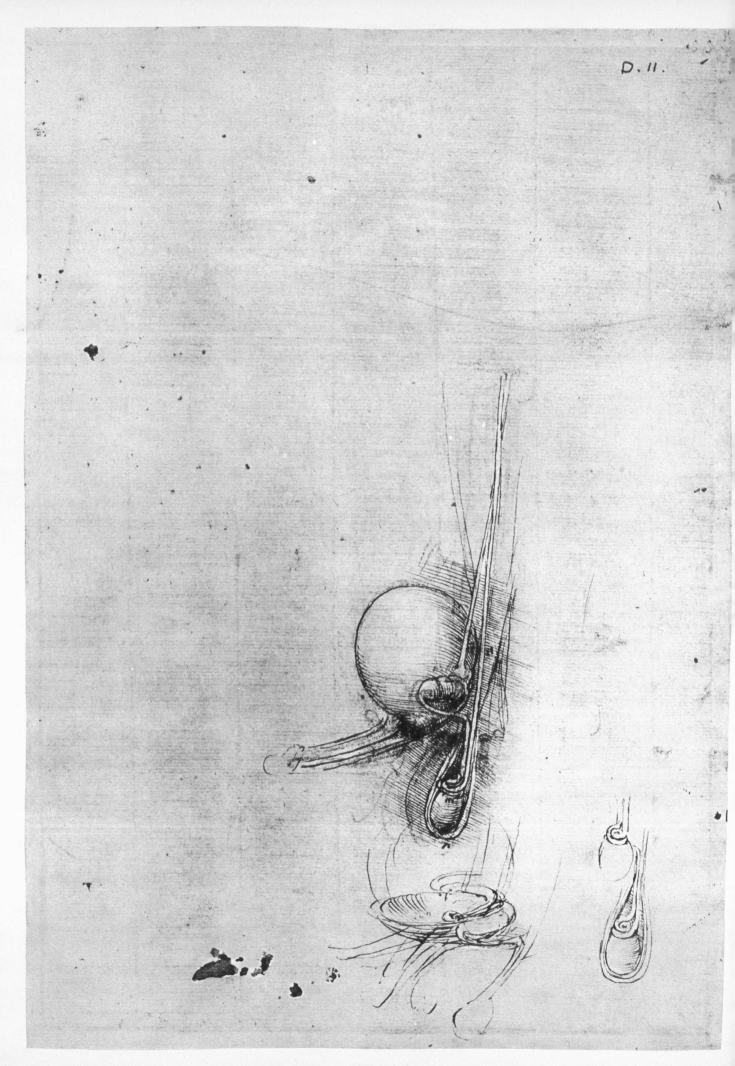

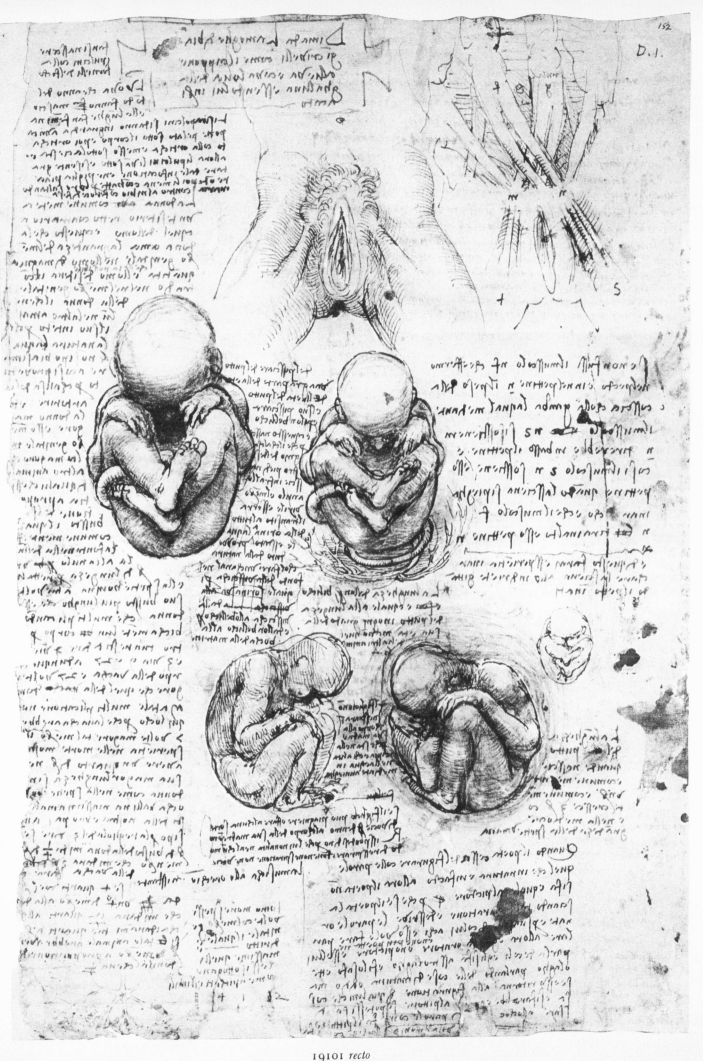

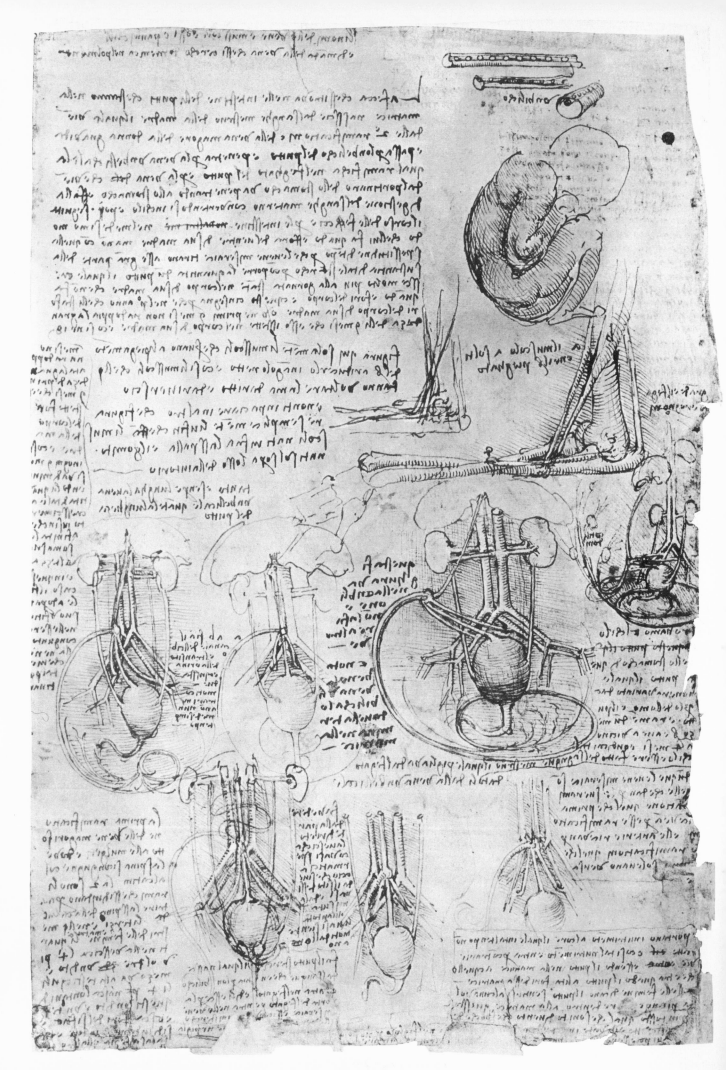

19101 *verso*

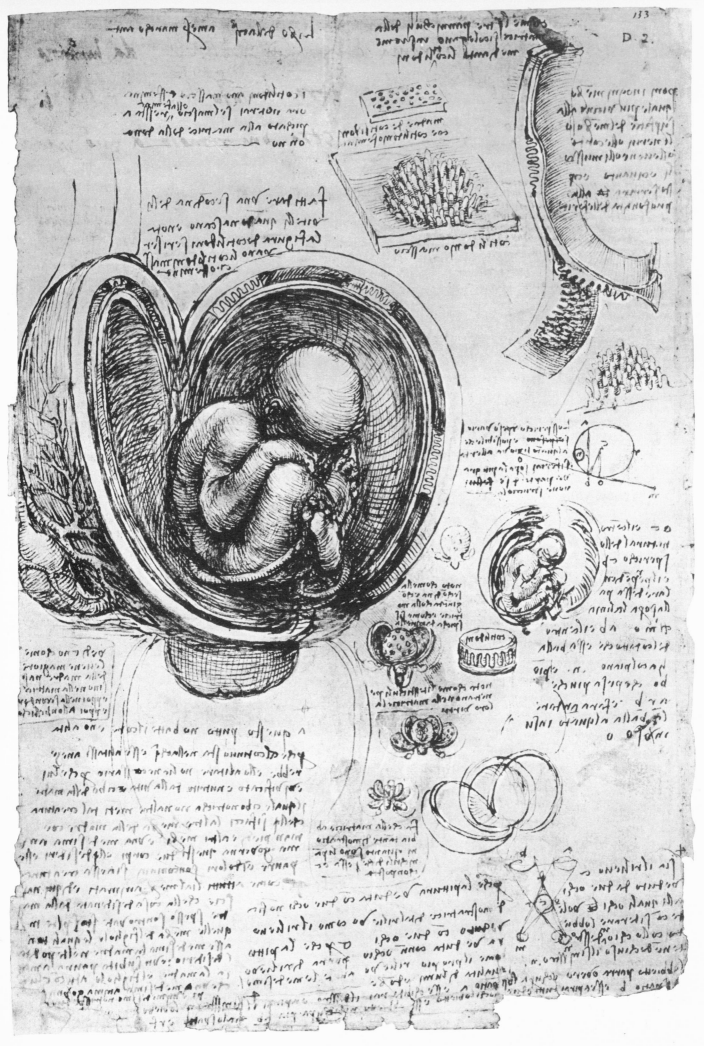

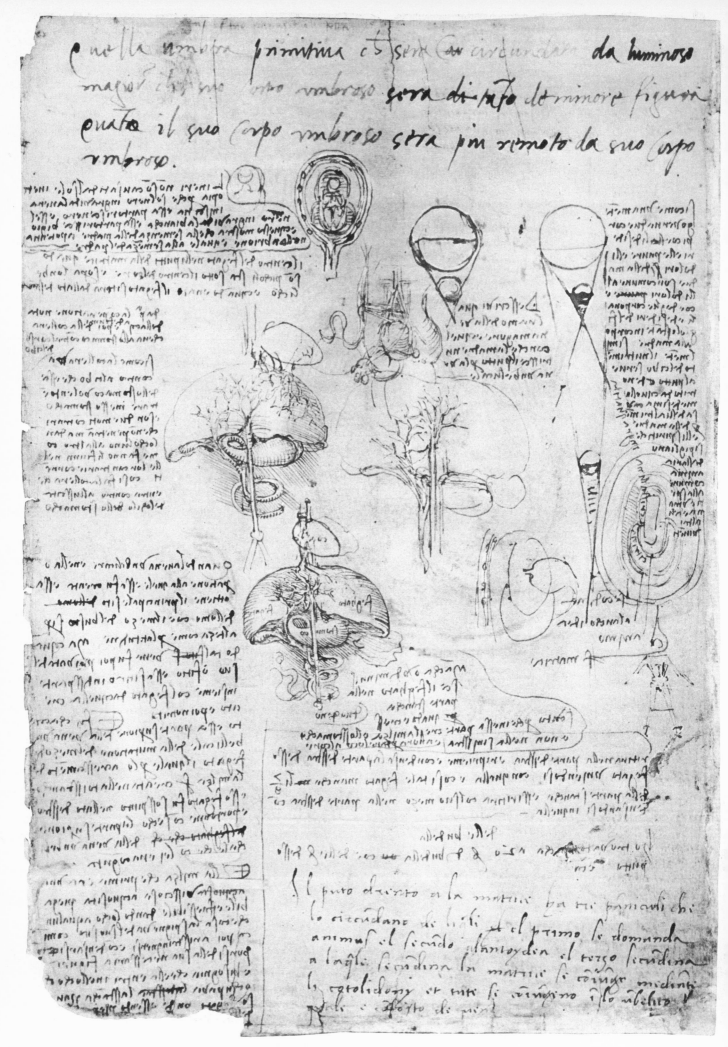

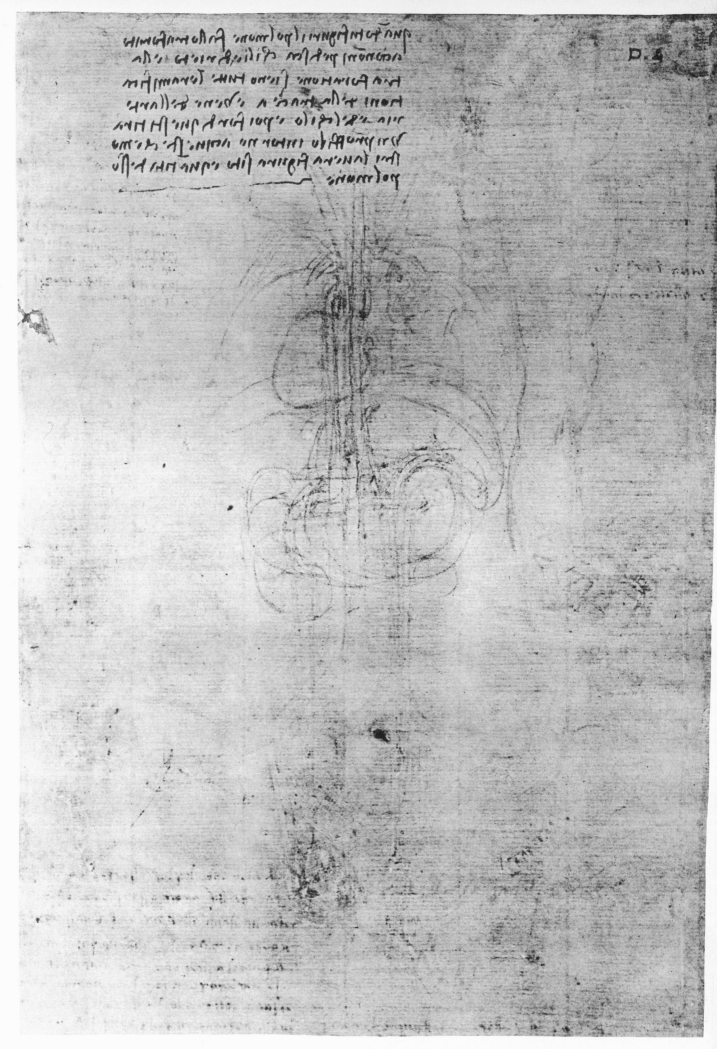

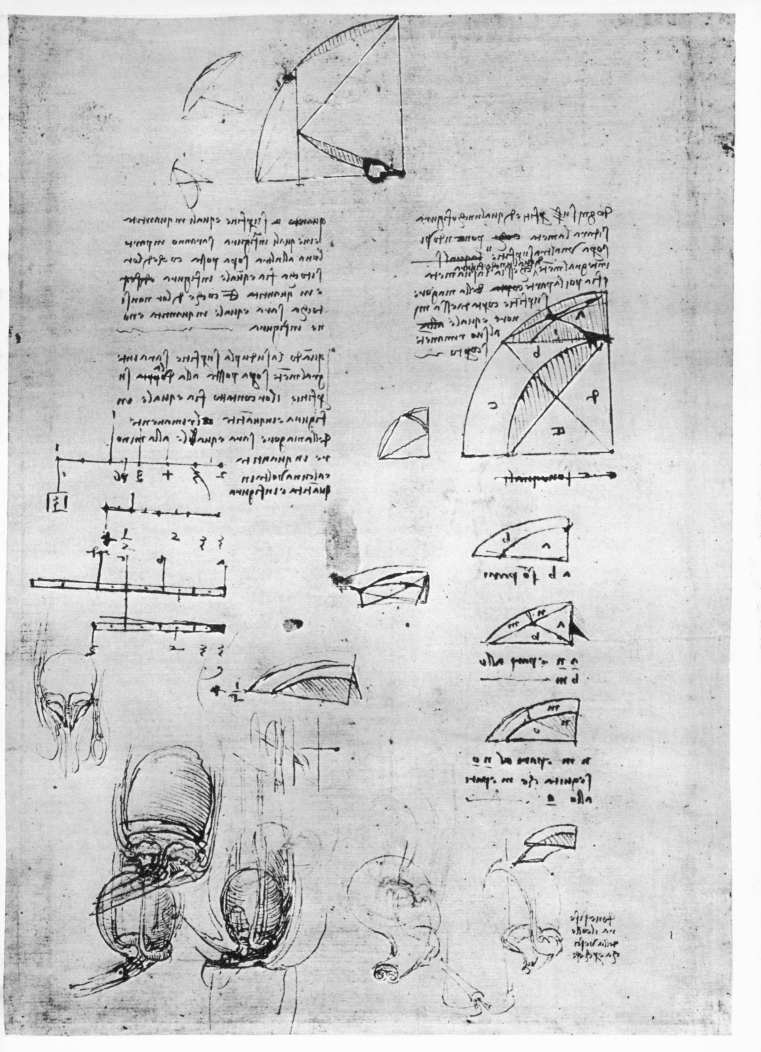

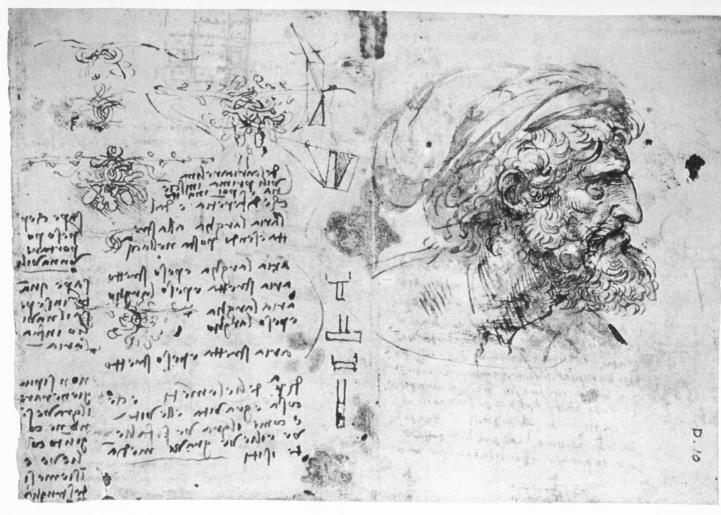

19106 *recto*

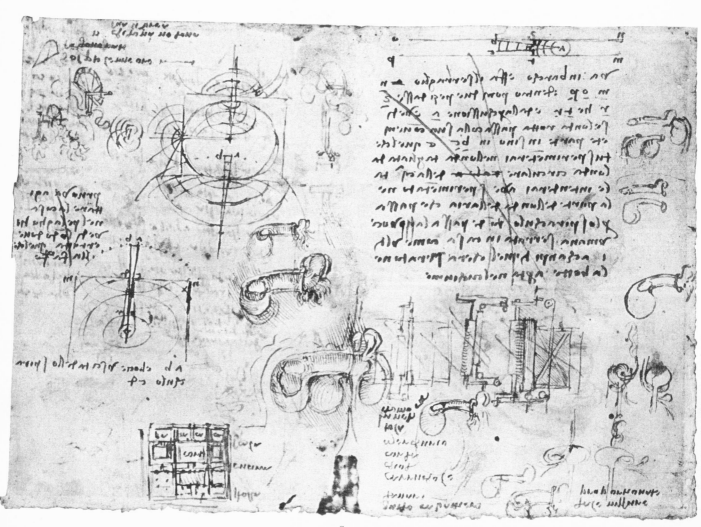

19106 *verso*

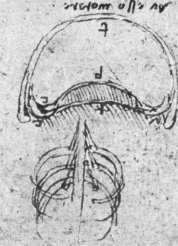

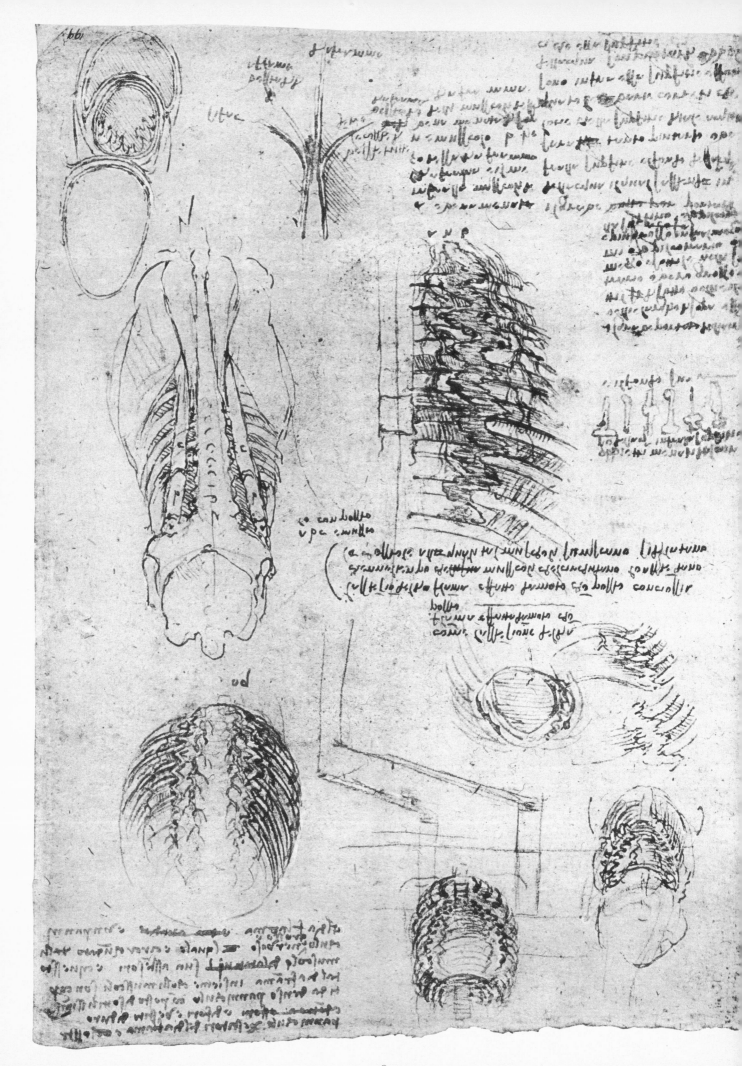

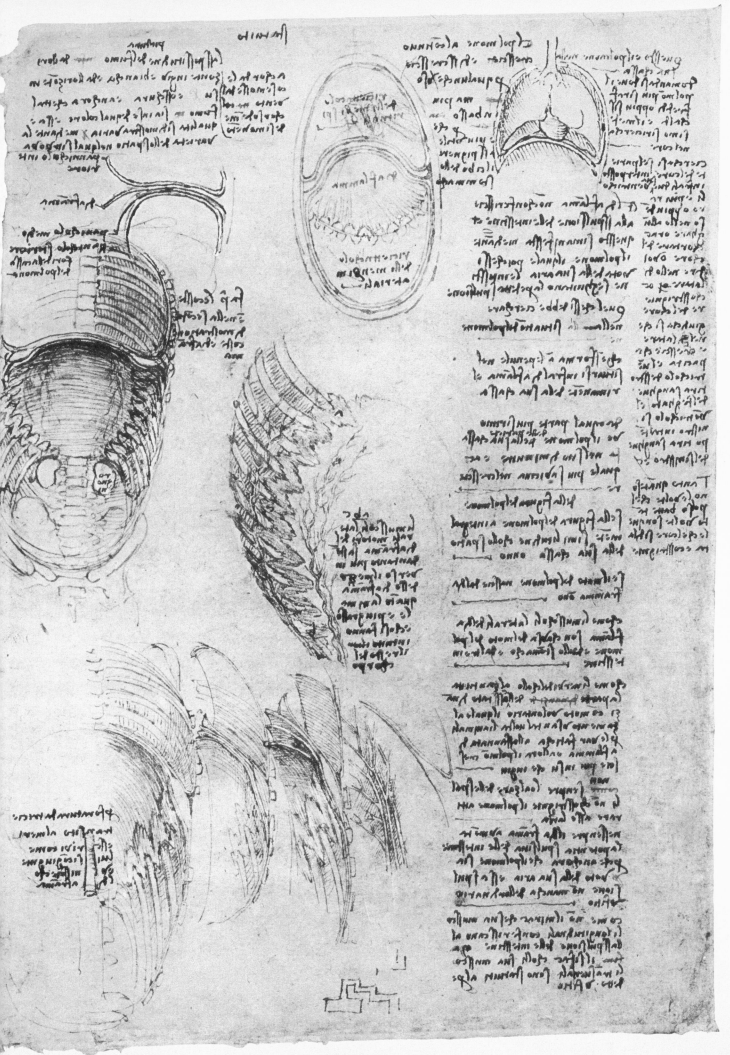

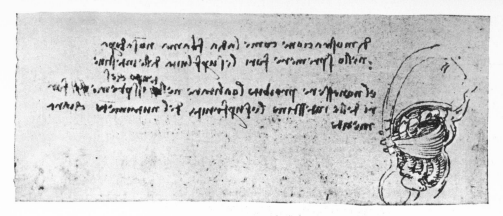

19110 *recto*

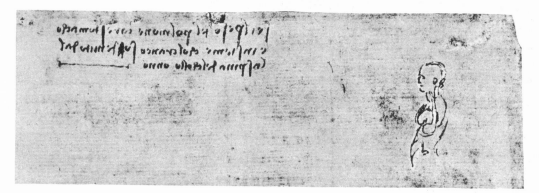

19111 *recto*

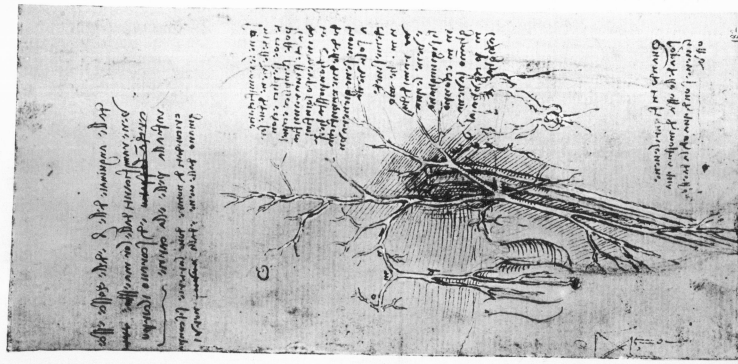

19112 *verso*

19113 *recto*

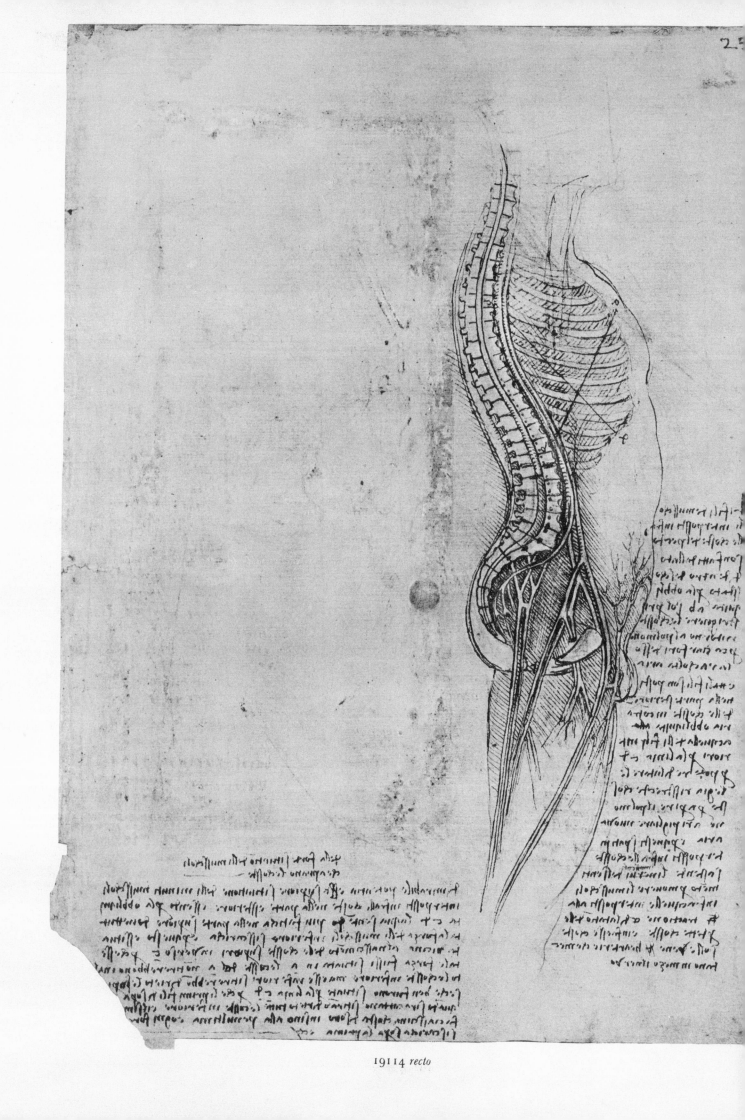

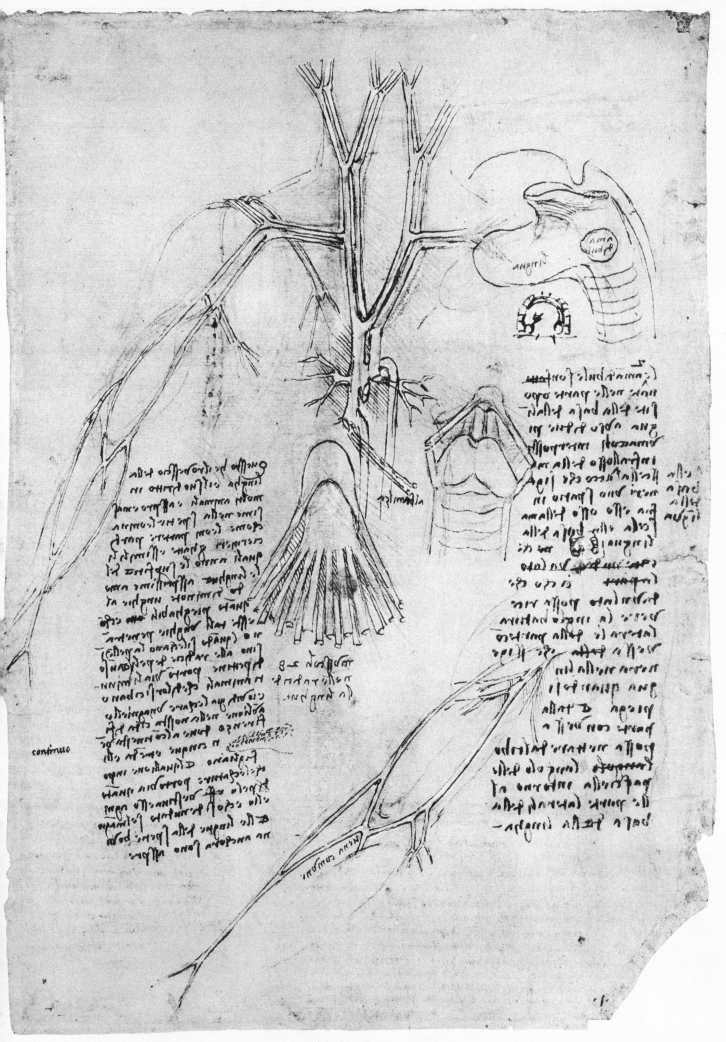

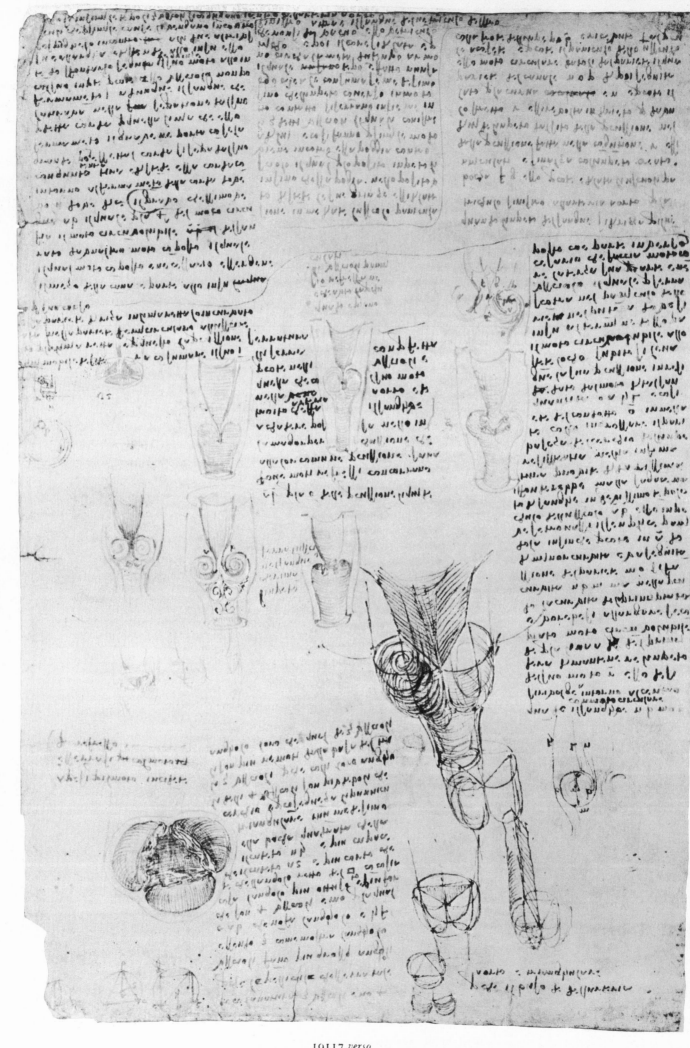

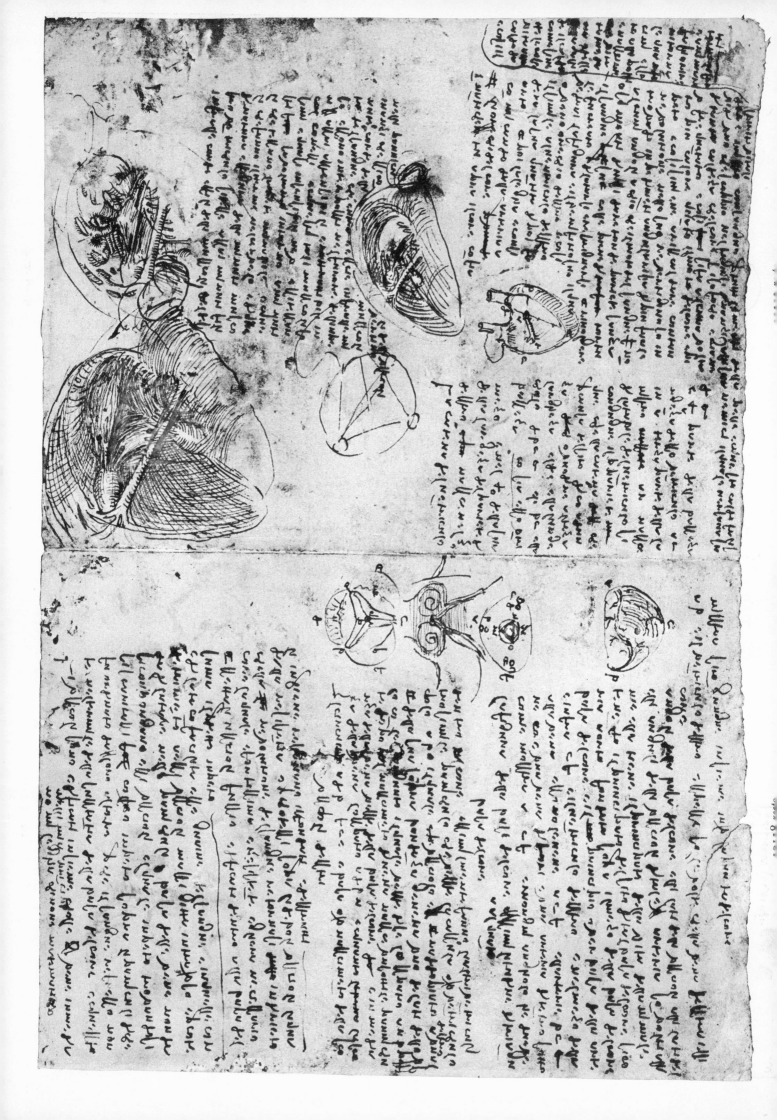

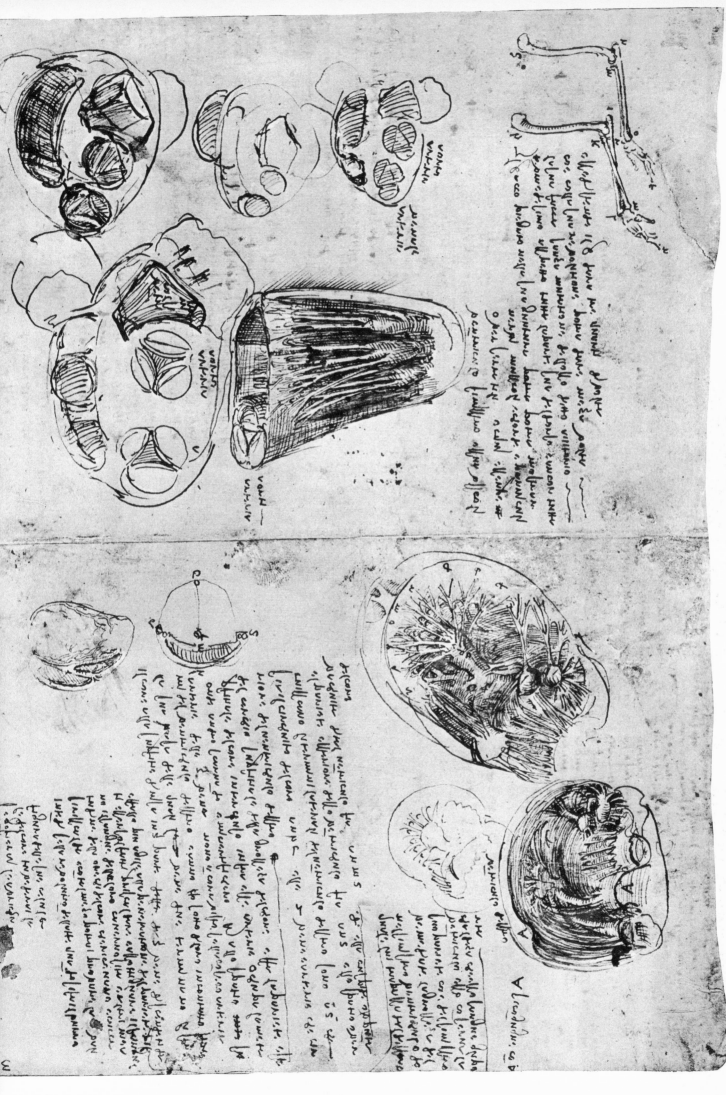

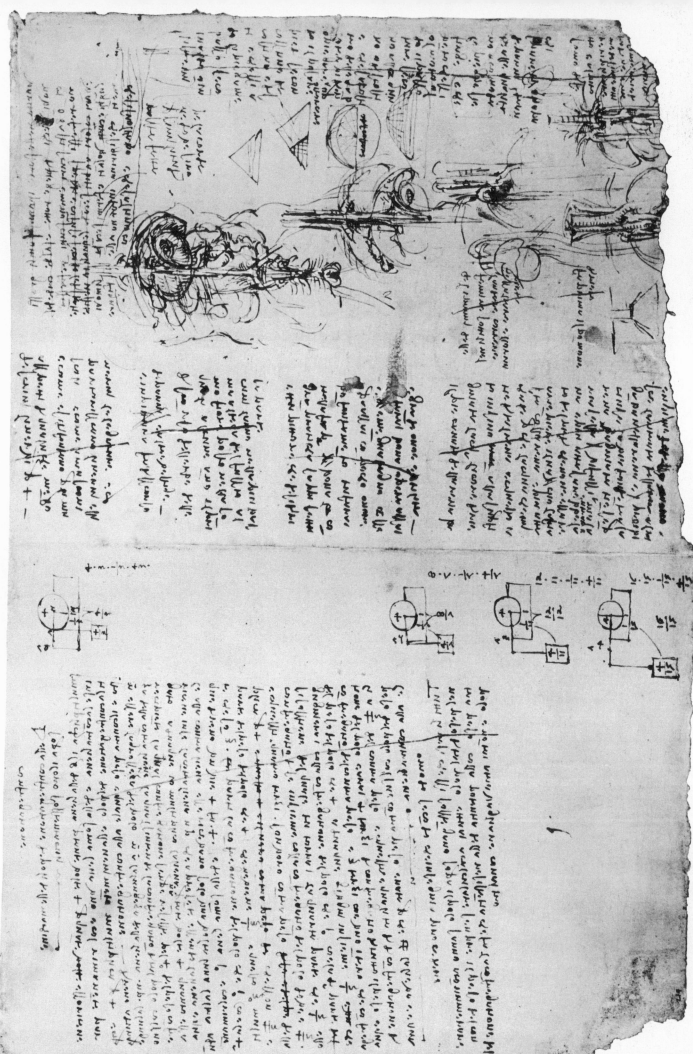

19123 *recto*

19124 *recto*

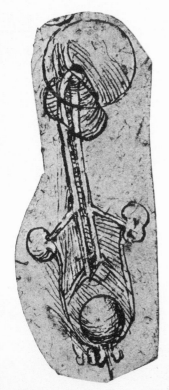

19125 *recto*

19126 *recto*

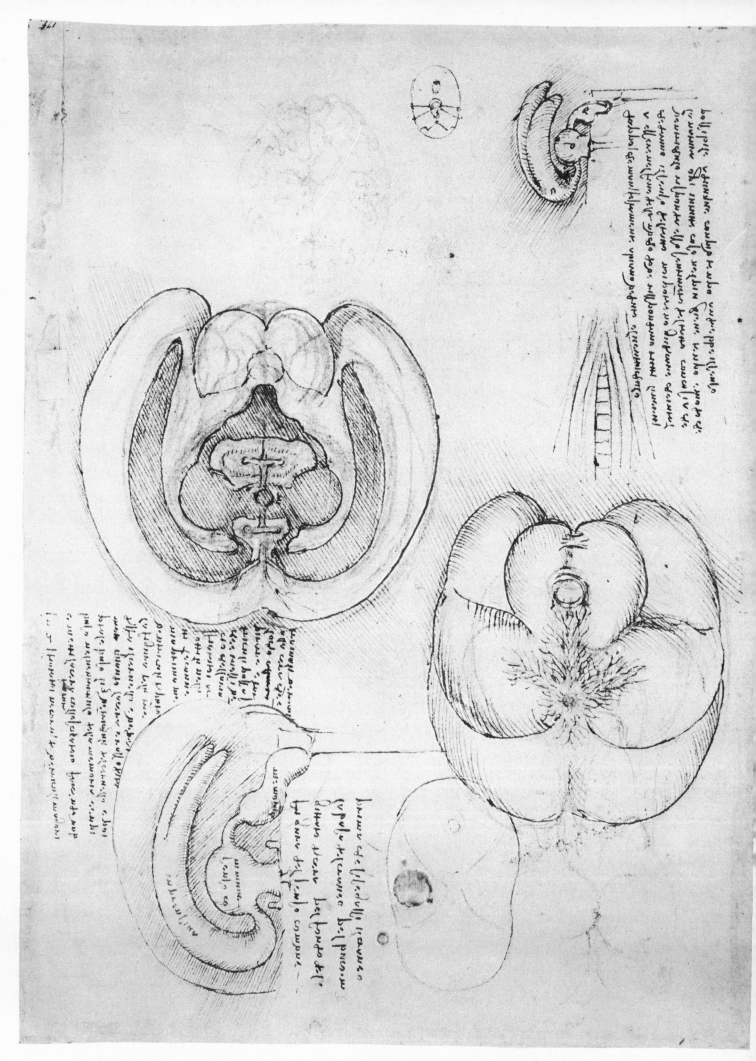

19128 *verso*

19129 *recto*

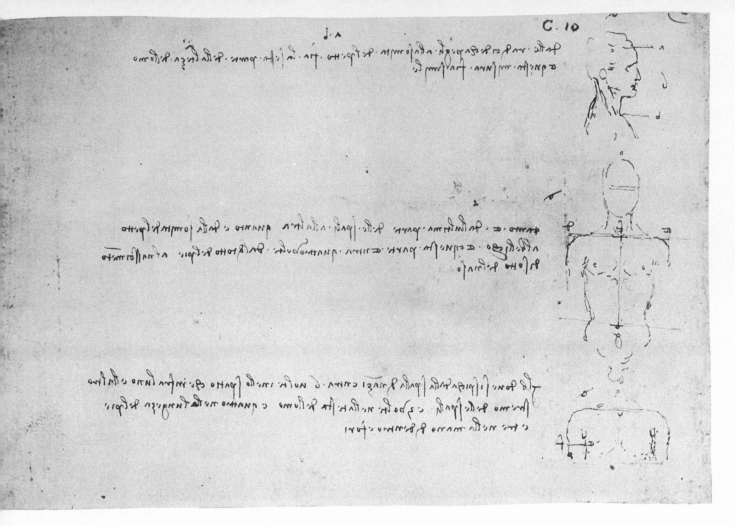

19130 *recto*

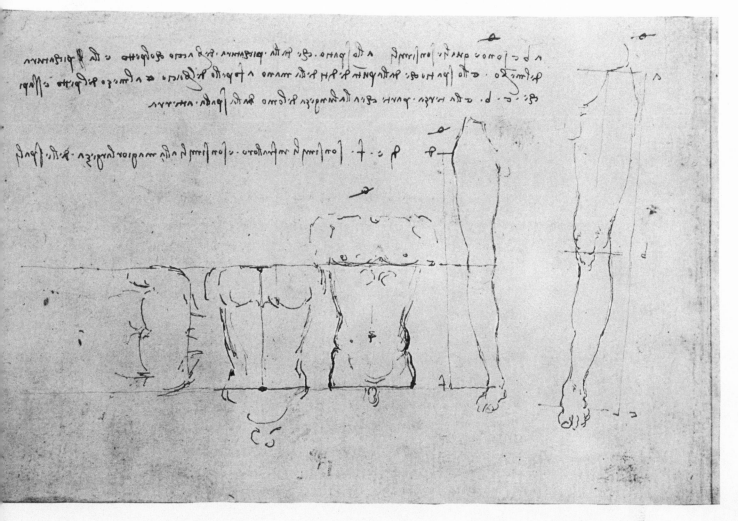

19130 *verso*

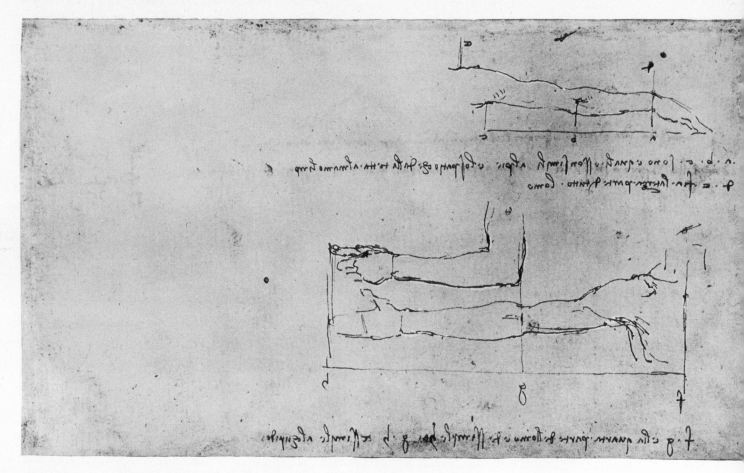

19131 *recto*

19131 *verso*

19132 *recto*

19132 *verso*

19133 *verso*

C. 4

19134 *verso*

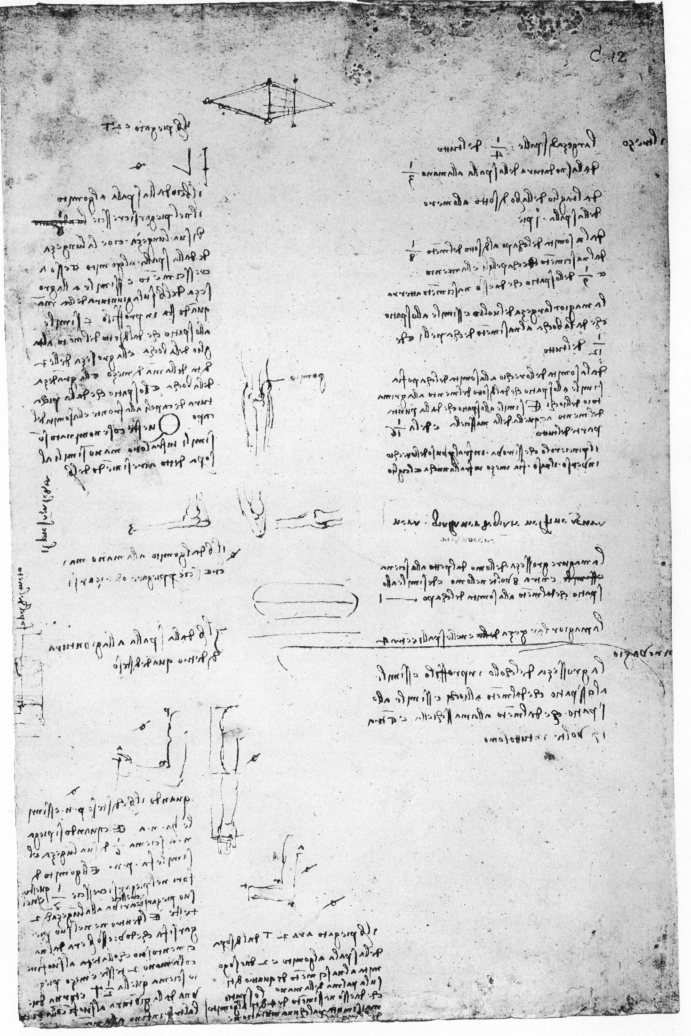

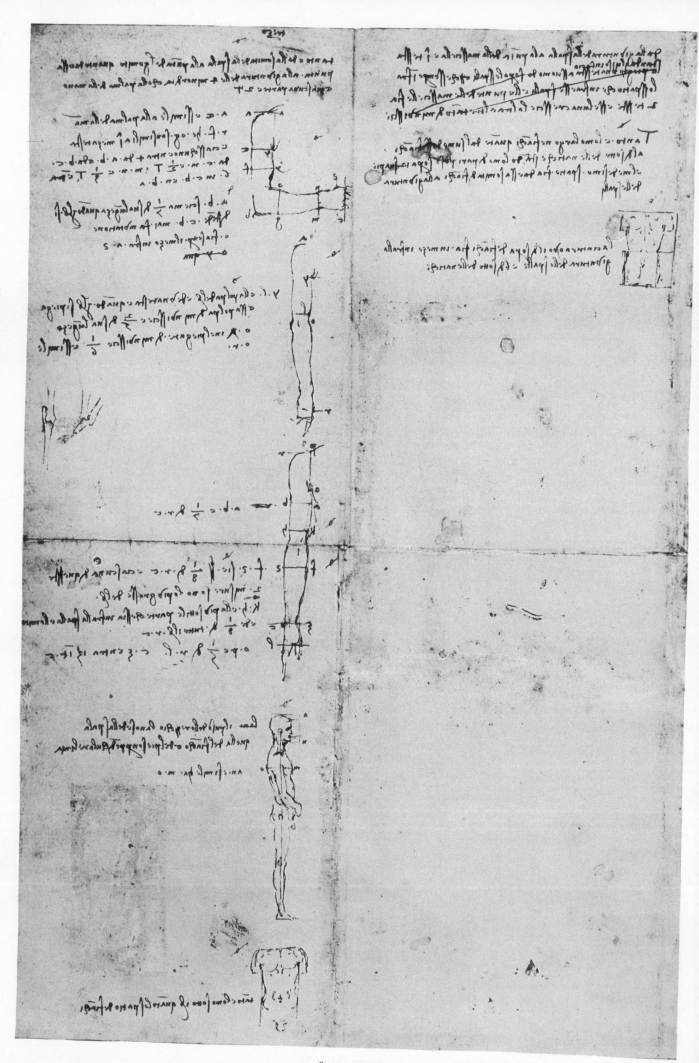

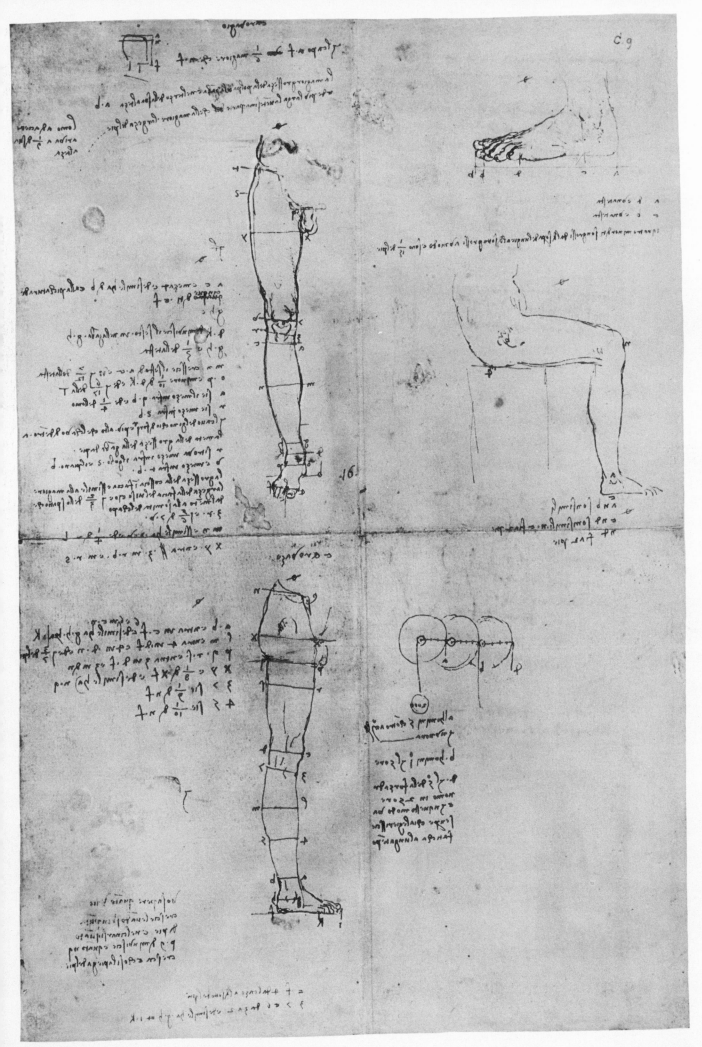

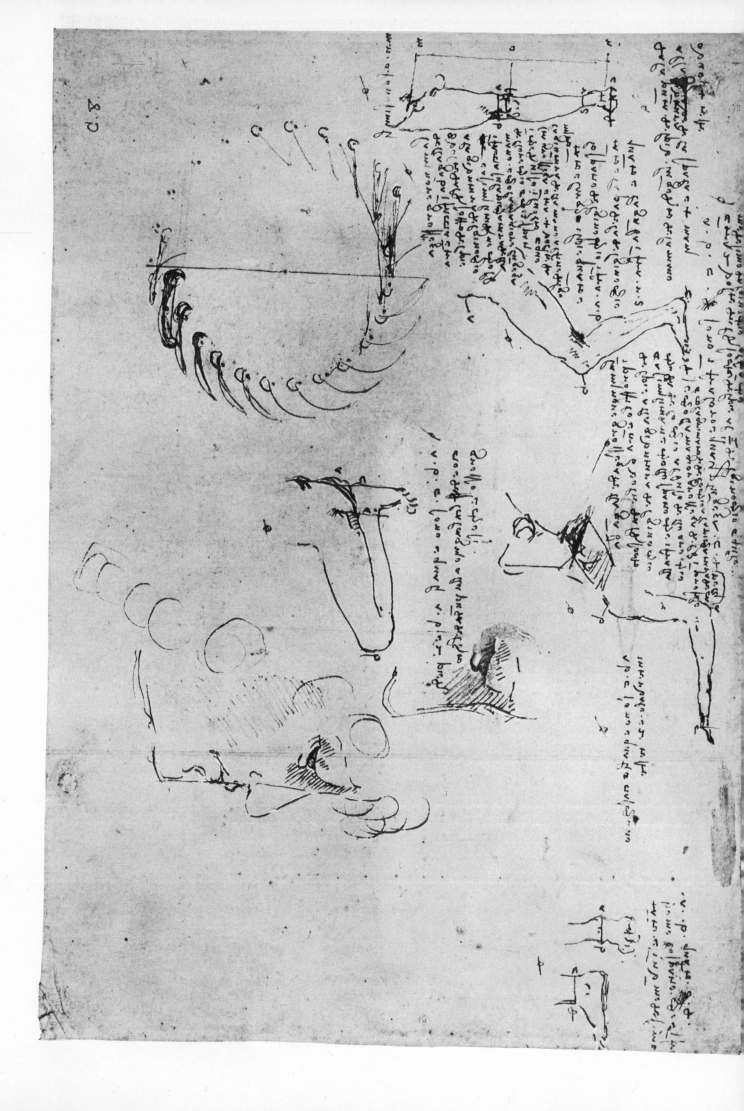

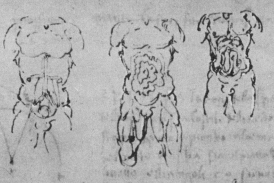

13

14

3

4

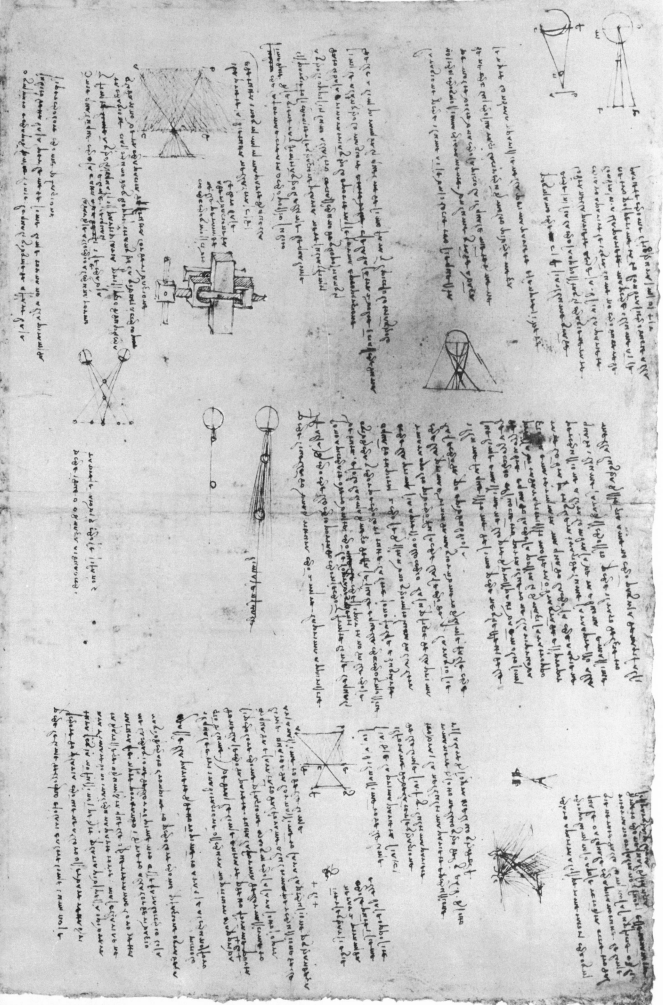

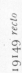

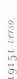

INDEXES

I. INDEX OF NAMES

II. INDEX OF WORKS OF ART

188 *verso*-a, 19121–19120
190 *verso*-a, 19121–19120
190 *recto*-b, *verso*-b, 19044, 19116–19117, 19149–19152
199 *verso*-a, 19113
207 *recto*-a, *verso*-a, 19115, 19121–19120
208 *recto*-a, *verso*-a, *recto*-b, *verso*-b, 19009, 19061
214 *recto*-a, 19023
223 *recto*, 19065
236 *recto*-b, 19079
249 *recto*-c, 19098
260 *recto*-a, 19009, 19061, 19115
269 *verso*-a, 19147–19148
270 *recto*-a, *verso*-a, 19115
288 *verso*-b, 19121–19120
289 *verso*-a, 19006
303 *recto*-b, 19128
305 *recto*-a, *verso*-a, 19115, 19121–19120
324 *recto*, 19147–19148
329 *recto*-b, 19147–19148
335 *recto*-a, 19079
341 *recto*-c, 19021
342 *recto*-c, *verso*-d, 19089, 19115
345 *recto*-b, *verso*-b, 19079, 19116–19117, 19149–19152
353 *recto*-b, *verso*-b, 19147–19148
353 *recto*-c, *verso*-c, 19115
362 *verso*-a, 19124
364 *recto*-c, 19091
371 *recto*-a, *verso*-a, 19091
375 *recto*-c, 19089
378 *verso*-a, *verso*-b, 19092
385 *recto*-a, 19101
385 *verso*-b, 19044
395 *recto*-b, 19107
— Sforza Castle
 Leonardo, The Trivulzian MS., lists of *vocabula*, 19019
 Folio references:
 3 *recto*, 4 *recto*, 19147–19148

NEW YORK, Pierpont Morgan Library
 Anonymous follower of Leonardo, The Codex Huygens
 (M.A.1139), 19102

PARIS, Bibliothèque de l'Institut de France

 Leonardo MSS. A to M

 MS. A and Ashburnham MS. I (or B.N.2038), date
 and handwriting, 19097
 Folio references:
 28 *verso*, 19080

 Ashburnham MS. I, folio 6 *verso*, 19008

 MS. B, handwriting, 19034; architectural studies,
 19134–19135; drawing of standing Leda (after 1506),
 19140

Folio references:
56 *recto*, 19147–19148

MS. D, notes on optics, 19034, 19042, 19044, 19102,
 19141–19142, 19149–19152
Folio references:
5 *recto-verso*, 19030, 19063
6 *recto-verso*, 19030, 19063
8 *verso*, 19116–19117
10 *verso*, 19121–19120

MS. E., geometry and stereometry, 19128; notes on
 light and shade, 19076; notes on painting, water and
 flight of birds, 19086
Folio references:
1 *recto*, 19094
4 *recto*, 19121–19120
16 *verso*, 19121–19120
17 *recto*, 19009, 19013
24 *recto-verso*, 19121–19120
25 *recto-verso*, 19121–19120
30 *recto*, 19121–19120
31 *verso*, 19121–19120
35–63, 19107
50 *recto*, 19121–19120
59 *verso*, 19107

MS. F, studies on optics, 19121–19120; studies on water,
 19116–19117; no notes on flame, 19115; notes on its
 cover, 19025, 19034, 19064, 19070
Folio references:
1 *recto*, 19027
5 *verso*, 19044
69 *recto-verso*, 19141–19142
82 *recto-verso*, 19141–19142
95 *verso*, 19009, 19025, 19061

MS. G, no notes on flame, 19115; notes on plants,
 19121–19120
Folio references:
1 *verso*, 19119–19118
26 *recto*, 19032
42 *recto-verso*, 19121–19120

MS. H (three note-books bound in one), dates 19097

MS. K (three note-books bound in one), handwriting
 and mediums in vol. III, 19032; notes on optics in
 vol. III, 19116–19117
Folio references:
79 *et sqq.*, 19141–19142

MS. L
Folio references:
22 *recto*, 19122, 19123

ROTTERDAM, Boymans Museum
 Leonardo, drawing of kneeling Leda, 19020

III. ANATOMICAL INDEX

Compiled by Doreen Blake and Ruth E. M. Bowden, Professor of Anatomy,
Royal Free Hospital School of Medicine, London University

This index deals with the text and the drawings, and is intended for laymen and others interested in anatomy. Professional anatomists, biologists and physiologists will find that it is not exhaustive. Cross-references have been used to save repetition; if an individual structure is not listed, the drawing or textual entry may be traced by looking in the sections dealing with regions or systems. The terminology used wherever possible is that of the Paris Nomina Anatomica of 1955.

Entries are in alphabetical order, and are usually nominal, not adjectival. General aspects are listed before details. Some examples are given below.

Muscles are entered under the following main subheadings: *Muscles, general*; *Muscles named*; *Muscles of organs and regions.*

Nerves, autonomic, can be found by reference to entries dealing with the *sympathetic chain,* and to the *Vagus.*

Every drawing of the kidney is not included in the section *Kidneys*; but all can be found by using this section, together with sections referring to *Arteries, renal*; *Genito-urinary system*; *Ureter*; *Veins, renal.* Therefore the reader should refer to the last entry under the main heading, which will be 'see also' where appropriate.

lateral view, surface anatomy, 19000r.

three heads schematically represented as single one inserted into olecranon process (2 sketches), 19101v.

right in arm, posterior, antero-inferior and antero-medial views, 19003v.

triceps surae, *see* Muscles of calf; Muscles named, gastrocnemius and soleus

Muscle(s), of organs and regions

of abdomen, 19031v.; 19032r.; 19033r.; 19033v.; 19101r.

and thighs in relation to perineum (female), 19101r.

superficial rough sketch not drawn from observation, ? deep fascia, 19033r.

wall, effects on intestines and lungs, 19032v.

back, 19015r.

buttocks, shoulders, standing male, 19043v.; 19044r.

elevation of ribs, 19015v.

shoulder, arm and forearm, superficial, right, posterior view, 19044.

and right shoulder, deep, 19015r.

superficial, 190155r.

of buttocks, back and shoulders, standing male, 19043v.; 19044r.

thigh, calf, 19008r.

calf, 19002r.; 19016r; 19094r.

action, 19008r.

buttock and thigh, 19008r.

and note on action, 19094r.

of chest, 19001v.; 19003v.

neck and arm, superficial muscles, 19008v.

of face, 19012v.

superficial (right), 19012v.

head, neck and shoulder-girdles, 19075v.

heart, 19085r.; 19116r.

two sketches, 19085r.

intercostal, 19006r.

jaw, lower, 19002v.

limb, lower, left, 19008r.

foot and leg, anterior view (left), 19017r.

left, muscles of calf and tendons, 19016r.

lateral view (left), 19016r.

and note on action, 19094r.

and tendons, 19016r.

foot, sole, muscles, and tendons, 19010r.

foot, and leg, superficial muscles, 19010v.

(superficial), 19035v.

calf and tendons, 19016r.

leg and thigh, superficial muscles, 19036v.

superficial muscles to thigh, 19035v.

(male) and right trunk and right arm, abducted and extended at elbow with clenched fist. Anterior view, except for medial view left lower limb, 19014r.

and limb upper, legs and arms, force, 19020v.

right, 19008r.

and left, male, trunk and right arm, abducted, and extended at elbow with clenched fist, anterior view, except for medial view of left lower limb, 19014r.

muscles of thigh with knee flexed, antero-medial view, 19037r.

leg with knee flexed, postero-medial view, 19037r.

excluding foot, neck, shoulder and trunk (superficial) lateral view, 19014v.

see also Muscles, named; Muscles of regions, e.g., calf, foot, thigh

limb, upper arm, left, showing force, ape and man, 19026v.

and limb, lower, arms and legs, force, 19020v.

right, 19011v.; 19012v.; 19013v.

arm, 19001v.

axilla, forearm, and root of neck (right) anterior view (chalk, faint), 19014r.

chest and neck, superficial muscles, 19008v.

posterior surface of superficial dissection, 19013r.

seen from front, 19005r.

and shoulder, superficial, 19012v.

superficial, 19011v.

right, dissection, shoulder abducted, elbow extended, forearm pronated, anterior view, 19005r.

shoulder adducted, elbow flexed, forearm pronated, anterior view, 19005r.

and forearm and arm, posterior view, 19044r.

of forearm, arm, axilla and root of neck, anterior view (chalk, faint), 19014r.

of forearm and arm, right posterior view, 19013v.

extensors, general view, in mid-prone position, posterior view, and in pronation, anterior view, 19005r.

see also Muscles, named; Muscles of regions, e.g., shoulder

of lips, 19046r.

mouth, notes, 19055v.

neck, 19002v.; 19004v.; 19069r.; 19085r.

back, view, 19008v.

chest and arm, superficial muscles, 19008v.

deep (right), 19011r.

superficial right, lateral view, 19069r.

head and shoulder-girdles, 19075v.

of man facing obliquely forwards and to left, posterior view, 19085r.

of root; arm; axilla; forearm, right anterior view (chalk, faint), 19014r.

superficial, 19011v.

to shin, superficial, 19014v.

Veins of organs and regions

IV. INDEX OF OTHER SUBJECTS